Waiting for the Light

Waiting for the Light
Early Mountain Photography
in British Columbia and Alberta, 1865–1939

Brock V. Silversides

FIFTH
HOUSE
PUBLISHERS

Saskatoon & Calgary

Front cover photograph: "Payne Bluff, K. & S. Ry. Near Sandon, BC," Kaslo-Slocan Railway. Richard Trueman / 1900. City of Vancouver Archives CVA2-99.
Back cover photograph: W. Hanson Boorne, unknown assistant, Charles W. Mathers, all photographers for the firm of Boorne & May. Mission, BC / Autumn 1892. Provincial Archives of Alberta B.993
Cover design by John Luckhurst / GDL
Layout and design by Donald Ward / Ward Fitzgerald editorial design

The publisher gratefully acknowledges the support received from The Canada Council, Heritage Canada, and the Saskatchewan Arts Board.

Printed and bound in Canada by Friesens, Altona, MB
95 96 97 98 99 / 5 4 3 2 1

CANADIAN CATALOGUING IN PUBLICATION DATA
Silversides, Brock V., 1957–

Waiting for the light
ISBN 1-895618-66-5 (bound)
ISBN 1-895618-75-4 (paperback)

1. Rocky Mountains, Canadian (B.C. and Alta.) - History - Pictorial works. 2. Rocky Mountains, Canadian (B.C. and Alta.) - Pictorial works. 3. Photography - Canada, Western - History. I. Title

FC219.S54 1995 971.1'0022'2 C95-920080-0
F1090.S54 1995

FIFTH HOUSE LTD.
620 Duchess Street #9 - 6125 - 11 St. S.E.
Saskatoon, SK S7K 0R1 Calgary, AB T2H 2L6
CANADA

Contents

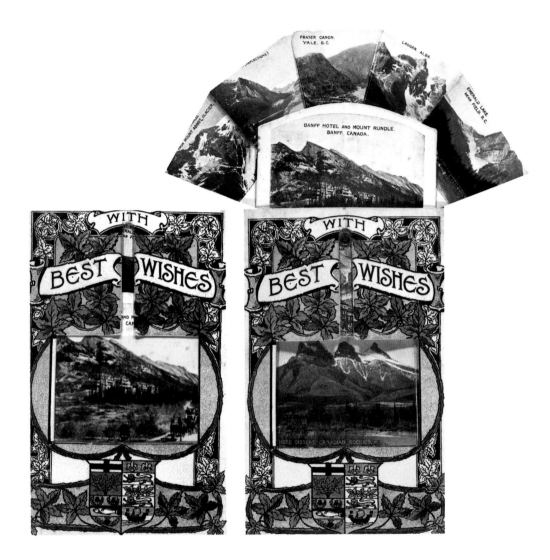

An ingenious tourist postcard turns into a fan when extended. Each leaf of the fan shows one of the attractions along the Canadian Pacific Railway.

CA. 1910

B. SILVERSIDES COLLECTION

Acknowledgements

I would like to thank the staffs of the Glenbow Archives, the Whyte Museum of the Canadian Rockies, the City of Vancouver Archives, and the British Columbia Archives and Records Service for their assistance. David Mattison, in particular, cheerfully shared much of his research into early BC photographers. David Leonard, Provincial Archivist of Alberta, provided encouragement and helpful hints. Karen Rathgeber Mitra completed the data input, and Laurel Wolanski assisted with the archival research and preparation of a number of the images. Last, but certainly not least, Donald Ward edited the text and designed the layout with patience and care.

For Christie Kinread Silversides

It is a common error to refer to the band of mountains extending from the Pacific coast through the interior of British Columbia to western Alberta as "the Rockies." In fact, there are seven separate north-south ranges. The Coast Mountains hug the Pacific Ocean along the western edge of British Columbia and up into the Yukon. Moving east, the Cascade Mountains incorporate the Fraser, Coquihalla, Thompson, and Skagit Valleys north to Lillooet. The Cariboo Mountains rise above Williams Lake, Quesnel, and Barkerville up to Prince George. The Monashee Mountains start at Grand Forks near the American border and run north along the Kettle and Granby Valleys (east of the Okanagan) to Three Valley Gap, Sicamous, and up to Pyramid on the North Thompson River. The Selkirk Mountains extend north from Trail and Castlegar, running between the Arrow Lakes and Kootenay Lake up to Revelstoke and Rogers Pass. The Purcell Mountains span the narrow strip from Kimberley and Cranbrook along the Columbia River to Golden. Finally, the Rocky Mountains proper delineate the Alberta–British Columbia border, incorporating the territory from Fernie and the Crowsnest Pass up to Banff and Jasper and on to Peace River. It is an immense area, roughly a million square kilometres. In times past it was popularly known as the "Switzerland of the Americas," the "Canadian Alps," or "The Wonderland of Canada."

COAST

COAST

CARIBOO

ROCKY MOUNTAINS

PURCELL

SELKIRK

MONASHEE

CASCADE

The Western Ranges

Introduction

CANADA'S western mountains have been avidly photographed for more than 130 years, and there seems no end in sight to this curiously addictive activity. Millions of images are produced annually and disseminated widely, yet they never seem to lose their appeal. The reasons are obvious—the endless variety of scenes, and the awe-inspiring beauty of those scenes.

Photographers have generally approached the mountains from two perspectives. The first tried to reflect the immense wildness and beauty of the landscape. For some, it was almost a mystical experience. James Outram, a renowned climber and writer, described his feelings in 1906:

> There is a wonderful fascination about mountains. Their massive grandeur, majesty of lofty height, splendour of striking outline—crag and pinnacle and precipice—seem to appeal both to the intellect and to the inmost soul of man, and to compel a mingled reverence and love . . . More especially is this the case where snow and glacier combine to add a hundred fold to all the other charms and glories of the peaks. Their inspiration almost overwhelms one . . .[1]

"All the artistic instincts are aroused by the wondrous beauty and grandeur of such scenery as Switzerland or its American counterpart, the Canadian Rockies, so lavishly display," he goes on, explaining the components of his reverential approach:

> Hundreds of pictures, exquisite in form and composition, variety and colouring, charm the eye of the climber amidst the lofty ice-bound peaks, the jagged ruined crags, the glittering glaciers, the dense dark forests, flower-strewn meadows, sunny lakes and streams and waterfalls, that everywhere abound . . . And, added to all, in Canada there still exists that chiefest charm of novelty and adventure, the thrill of climbing virgin peaks, of traversing untrodden valleys, of viewing regions never seen before by human eyes.[2]

The second approach, befitting the spirit of the nineteenth and early twentieth centuries, was motivated by the urge to demonstrate humankind's conquest of nature. Photographers documented in images how people explored, laid out boundaries, built roads and railways, extracted resources, established communities, and attempted to establish control over the wilderness. Implicit in this approach was the attitude that humankind could vanquish any obstacle that nature put in its way. Indeed, by the application of science, logic, and technology, builders and developers performed engineering marvels, and were justifiably proud to have them documented.

Some of the earliest photographers in the mountains were engaged in surveying and fact-finding missions for government or corporate bodies. The first of these was the North American Boundary Commission Survey (1858–1862) whose task was to physically mark the forty-ninth parallel—the boundary between British Columbia and the Oregon Territory as settled in 1846—from the Strait of Juan de Fuca to the eastern slope of the Rocky Mountains. The British half of the commission, acting on behalf of Canada, included a party of Royal Engineers, several of whom were trained in photography. One may have been Charles W. Wilson, secretary to the

commission, although the photographers were not individually identified in official reports. The work of the photographers employed by the commission consisted, in the main, of documenting boundary markings, cut lines, camps, and examples of the varied terrain. They also managed to produce images of the Natives and landmarks along the boundary.

In 1871 the Geological Survey of Canada, under the supervision of Alfred Selwyn, undertook an expedition to explore the resources of the Fraser and Thompson River valleys up to Jasper House. The team included two photographers, Benjamin Baltzly and his assistant, John Hammond, both of whom were employed by the Montreal studio of William Notman. Half their salary was paid by the GSC, the other half by Notman, who retained copyright on all the images with a view to marketing them in central Canada.

Conditions were difficult throughout the four-month trip: travel was arduous and the weather was atrocious. The team got only as far as Tete Jaune Cache before they were overwhelmed by snow and forced to turn back. Nonetheless, they amassed a wealth of geological information about the area, and Baltzly and Hammond managed to produce nearly 150 photographs. Selwyn was delighted with their work, and appended numerous examples of "the very beautiful and interesting photographic illustrations of the route from Yale to the Leather Pass" to his final report. "The beautiful views of the Selkirk Mountains," he wrote, singling out one series for extra praise, "afford a good idea of the grandly picturesque character of the scenery, and the rugged outline of the ice and snow-covered peaks."[3]

The first surveys for a transcontinental railway— the future CPR—were carried out in 1871, 1872, and again in 1875. Charles Horetzky, one of the engineers assigned to the survey, was commissioned to gather information and "take views of objects of interest illustrative of the physical features of the country." The first photographer to approach the Rockies from the east, Horetzky concentrated his efforts on the Howse and Yellowhead Passes, then on into the British Columbia interior along the Skeena, Peace, Wotsonqua, and Homathko Rivers. While most of his photographs were taken solely to illustrate the topography, he produced enough images of general interest to demonstrate that there was room for both a scientific and an artistic approach in photographing mountains.

The next major party to reach the mountains was the Dominion Lands Survey. The areas adjacent to established communities and the CPR line had to be surveyed and mapped before they could be opened to settlement, but the section-by-section hand sketches used on the prairies would be far too time-consuming and expensive in mountainous terrain. Consequently, Surveyor-General Edouard Deville directed his crews to switch to photogrammetry. The technique, already in use in the mountainous regions of Europe, employed multiple, complementary panoramic photographs from fixed triangulated positions to plot maps.

In 1887, J. J. McArthur and W. S. Drewry made the first attempt to use photogrammetry in the Rockies. With amateur cameras and small-format roll film, however, they met with only limited success. The expeditions of 1888 to the Crowsnest Pass and Banff districts, on the other hand, employed view cameras and glass plates, resulting in the first accurate maps of the eastern side of the Rockies.

Federal survey crews also used photogrammetry to delineate the British Columbia–Alaska border in 1892. Photogrammetry was not considered a professional tool by the American members of the International Joint Commission, but the difference in productivity between the two teams was so marked that J. J. McArthur wrote:

> The superiority of the camera over any other instrument for mountain work was strikingly demonstrated. Our American colleagues were equipped with the plane table, and except on very fine days were unable to accomplish anything. We could secure, in a few minutes with our cameras, more topographical data than could be accomplished in this rough country by any other method in as many weeks.[4]

Independent photographers realized the commercial potential of mountain views at an early stage. Charles Gentile and Frederick Dally were the earliest

photographers to work in the interior of British Columbia. Dally, originally from London, England, opened his studio in Victoria in 1866. With the Cariboo gold rush reaching its height, he took two extended trips into the interior during the summers of 1867 and 1868 to secure views of the people and places of the district. In 1868 he set up a branch studio at Barkerville, the most distant centre of population, but lost it in September when a fire destroyed the building. Dally returned to Victoria shortly afterward, and left the field altogether in 1870. Gentile, originally from San Francisco, opened his studio in Victoria in 1863. He accompanied Governor Frederick Seymour's party of inspection to the gold fields during August and September 1865.

Throughout the five-year period the Canadian Pacific Railway was under construction, the western mountains were documented by a veritable flood of photographers. As the population of the British Columbia interior began to grow, a number of photographers started to settle in, but most of them stayed only a few years. It was not until after the turn of the century, with the development of roads and the national parks, and the growth of mining and logging communities, that there was a noticeable increase in resident photographers.

The Crowsnest Pass, on both the British Columbia and Alberta sides, was ably documented by Thomas Gushul. Born in the Ukraine, Gushul emigrated to western Canada in 1906. He originally worked as a labourer on the CPR, including the Spiral Tunnel project in the Illecillewaet Valley, and in a number of mines in the Crowsnest Pass. He started his photography business in 1917 in Coleman. Three

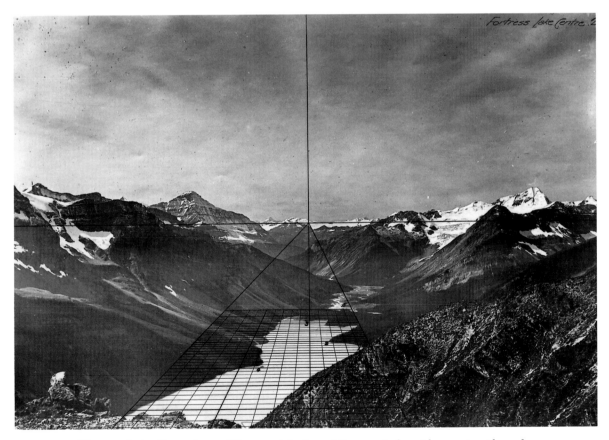

"Fortress Lake Centre"–an oblique aerial view of Fortress Lake with a map grid overlay
HARRY POLLARD / 1930s
H. POLLARD COLLECTION / PROVINCIAL ARCHIVES OF ALBERTA P.6582

years later, he opened a second studio in Blairmore, and by 1928 he had closed the Coleman branch. Throughout a forty-five-year career, Gushul recorded the lives and work of the immigrant miners, the rise and fall of the collieries and related industries, and the labour disputes of the Depression.

One of the best-known photographers of the mountain parks was Byron Harmon. Born and raised in Tacoma, Washington, Harmon started his career as a studio photographer. He moved to Banff in 1906, attracted by the business opportunities. As he became more and more drawn to the landscape, he all but gave up portraiture. He travelled widely, amassing a huge stock of mountain shots. Many of these were turned into postcards, which became hugely popular at his curio and art emporium on Banff Avenue. He was a charter member of the Alpine Club of Canada, and took part in the club's annual climbs, bringing back breathtaking views from the summits of Mounts Robson and Resplendent and other peaks. His services were much in demand among other climbing parties, and he appears in the travel accounts and memoirs of a significant number of visitors to the Rockies.

Harry Pollard did not live in the mountains, but he was closely associated with them throughout his career. Born in Ontario, Pollard came west in 1899, settling in Calgary. He started documenting the mountains in the early part of the twentieth century, when he worked the CPR main line and frequented the national parks on holidays. He was an alpinist by both inclination and disposition and, like Harmon, was an early member of the Alpine Club of Canada. He went on many of their annual expeditions, with camera and glass plates, and contributed regularly to their magazine, *The Canadian Alpine Journal*. He is reputed to have climbed fifty peaks, including Mount Robson as well as Cascade, Victoria, and Assiniboine Mountains.

His photographs of the 1924 Robson Expedition garnered considerable fame. "I would like to get for my personal use," wrote a friend, Osborne Scott of Canadian National Railways, "a snapshot of yourself, and one you took on the top of Mount Robson to frame together, so that I can say I know the guy who carried a 5x7 a couple of miles straight up in the air."[5]

After climbing, Pollard most enjoyed motoring in the mountains. He was in the first automobile to reach Banff National Park in 1906. It was an agonizingly bumpy trip that took a full three days from Calgary. On his arrival, he was arrested for driving down Banff Avenue (cars were illegal in the park until 1915). In the summer of 1927, slightly ahead of the construction crews, Pollard completed the first trip on the Field–Golden Highway. And in the 1930s, he was the proprietor of Castle Mountain Lodge, a group of bungalows intended for motorists on the Banff–Windermere Highway.

In 1924 he was offered the position of chief photographer in the promotional department of Canadian Pacific Railways. Throughout the 1920s, he lived for long periods of time at each of the three major western CPR hotels—the Banff Springs, Chateau Lake Louise, and the Empress Hotel in Victoria—photographing extensively for promotional pamphlets and magazines.

In addition to studio, corporate, and survey photographers, there was another type: the camera-wielding ethnologist/anthropologist. A prime example was James A. Teit, who gathered visual and oral information on the interior Salish bands of British Columbia between 1911 and 1922. A resident of Spences Bridge, where the Nicola River enters the Thompson, Teit cultivated friendly relations with the Atlakya-pamulc, or Thompson, band. He acted as an interpreter, assisted in the formation of both the Allied Tribes of the interior and later the British Columbia Indian Rights Association, and married a member of the band. He spoke fluent Nlaka'pamux as well as Lillooet and Shuswap.

Teit started photographing as early as 1894, although he did not consider himself "professional" until 1911. In that year he joined the staff of the ethnology division of the Geological Survey of Canada, a position he held until the end of World War I. Over a thirty-year period, he specialized in portraiture (his chief interest was in facial types), clothing, types of abode, and scenes from everyday life.

Teit received his training in both anthropology and photography from Franz Boas of the American Museum of Natural History. Boas's first important

work was among the Inuit of Baffin Island, but latterly he made numerous field trips to the British Columbia coastline to study the Haidas.

A large segment of the mountain photographic community were amateurs: the talented and the talentless, drive-by shooters and long-term visitors and inhabitants. While most of their output adds little or nothing to the pictorial record of the western mountains, there are notable exceptions. Walter D. Wilcox was one of them. An American climber, naturalist, and traveller in the various mountain parks, he was as eloquent with the pen as with the camera. A prolific author of mountain-related journal articles, he issued his first major book in 1897, *Camping in the Canadian Rockies*. Three years later he wrote *The Rockies of Canada*, a monumental work published by the Knickerbocker Press of New York. An integral part of his books were photogravure reproductions of his photographs. As he explained in the preface to *The Rockies of Canada*,

The work is illustrated with reproductions of photographs taken by the author. Pictures are an essential, if not the most vital, element of every book of travel, and no pains have been spared to achieve the best possible results in this part of the work. The views have been selected to give a comprehensive idea of the mountains and cover a large variety of subjects. Many of the landscapes, especially the views of lakes, were obtained only after patient effort and long delays, while awaiting the favourable opportunity to secure a photograph. Nature, especially in the mountains, reveals her most inspiring moments and her most beautiful combinations of sky and clouds, of distant peaks, half-veiled in purple haze, of reflected forest trees or sparkling water, so rarely, that only a tireless patience may claim the prize of a perfect picture. Year after year the author has returned to artistic shots, in the effort to get difficult subjects, and amongst these, success and failure have been measured out in a manner as uncertain and capricious as the weather itself. Most of the views have been reproduced with remarkable fidelity to the original negatives, and though a few of the most artistic effects cannot be rendered by any mechanical process, the author hopes that the general standard of illustration has been materially raised.[6]

Amateurs and professionals alike faced almost overwhelming difficulties taking photographs on location in the mountains. Some of the problems were inherent in the process of photography, others resulted from interaction with the terrain and the weather.

In the 1860s, photographers used the wet-plate process: a plate of glass was hand-coated with baths of collodion and silver nitrate, exposed in the camera while still moist, and then developed before it dried, otherwise it would lose its sensitivity. On any field trip, a photographer thus had to take large bottles of emulsion and various processing chemi-

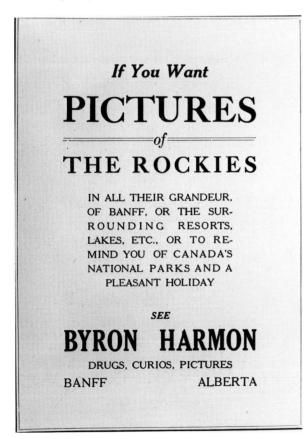

Advertisement for Byron Harmon, photographer
BANFF, AB / 1919
PROVINCIAL ARCHIVES OF ALBERTA A.21109

cals, developing tanks, and a "darkroom"—usually a double-thickness dark canvas tent. These were in addition to the camera itself, which was a large wooden box with bellows and lenses to accommodate twenty-by-twenty-five-centimetre plates, and a heavy tripod—the heavier the better, as keeping the camera steady for the long exposures was vital. In total, the photographer's equipment weighed about 225 kilograms. It could be transported in wagons on the prairies, but in the mountains it had to be taken on packhorses or in knapsacks.

In the early 1870s, photographers began using the new dry-plate process—pre-coated glass plates manufactured in standard sizes which did not have to be developed on the spot. The utmost in convenience, the new plates meant that photographers no longer had to take their darkroom and their chemicals with them. The weight of the view cameras and the boxes of glass plates, however, was still considerable.

The environment presented its own obstacles. The lack of trails and roads, then the lack of *safe* trails and roads, made access to remote peaks and valleys difficult, especially as photographers kept searching for unique and inaccessible viewpoints. In November 1871, Benjamin Baltzly observed a photographer's worst nightmare on the Murchison Rapids of the North Thompson River:

> Immediately below the last night's camp is a dangerous rapid. We walked along the shore, and the guide took the lead . . . Again they went back to bring the "Cedar" down . . . All went well until they got to the lower chute of the rapids; there the canoe capsized, and away went our roll of blankets, etc., skipping over the foaming waters like a feather. Down went the saddle, axes and beans, and my negatives, the fruit of a great portion of my labour. One can imagine my feelings about that time . . .[7]

Mary Schaffer, an American naturalist and amateur photographer, wrote of a particularly dangerous trail near Mount Wilson:

> Fox, a big harmless-looking sorrel, with his full quota of two hundred pounds [ninety kilograms], in lumbering along with his fellow workers, by some unsurprising mistake, fell into the flood . . . His face was the soul of

Harry Pollard photographing the "Three Sisters"
CANMORE, AB / 1930s
PROVINCIAL ARCHIVES
OF ALBERTA
P.10244

serenity as he bobbed cheerfully about in the muddy flow with our two duffel bags acting like a pair of life preservers. As a drowning man is said to recall in a flash all his joys and sins, so through our minds ran an itemized list of the contents of those precious duffel-bags: clothing, glass plates, films, lenses, barometer, thermometer, compass, etc . . . The water was cold and Fox was warm; his burdens had lightened the moment he struck the water which buoyed him, the bags, the hypo, and a bunch of dry blankets (dry no longer) nicely.[8]

Harry Pollard regularly encountered similar set-backs. On the Field–to–Robson exploratory trip in 1924, he lost up to half his photos when a strong river current submerged his carrying cases. "According to Harry Pollard," the *Calgary Herald* reported with commendable understatement, "the trip was a success from every point of view, but owing to the fact that the horse which carried his photograph materials went under the water while crossing one of the rivers, he was greatly handicapped by having to make all of his pictures from 'wet' plates."[9] A number of them were obviously salvaged, for a year later he gave a lantern slide show to the Alpine Club entitled, "Over Unblazed Trails from Rail to Rail."

For those photographers who chose to document the glaciers, crevasses presented many dangers. An account from 1890 described the perils:

Mr. Hanson Boorne has returned from spending several weeks in the Selkirks, taking photographic views of some of the most attractive features, the work having its perilous side. Some time was spent in securing views of the Great Illecillewaet Glacier and the Aluskan [sic], he and two assistants having to be roped together and descending into and crossing the dangerous crevasses. The difficulties of climbing seemed at times almost insuperable, but Mr. Boorne has succeeded in securing views never before obtained by any photographer. He leaves tonight for another expedition to the Selkirks, this time taking in Albert Canyon. He has a

good bear story to tell which ought not to be told at second hand for fear of spoiling it.[10]

Another serious problem was the weather, which was rarely clement around the mountain peaks. The rain, the snow, the cold, the heat, the fog, the clouds, the winds, the smoke from forest fires, and the generally capricious visibility all contributed to the adversities of shooting in the mountains. Mary Schaffer described an excursion to the peak of Mount Wilcox in 1907:

A few minutes later the last summit was reached, a cairn was found, and in it a small bottle whose enclosed paper recorded the above altitude. Our disappointment was keen enough when we looked off to the group of desired peaks and found them too enveloped in mist to be of the slightest use, and so, like the King of France, "we climbed down again."[11]

J. J. McArthur of the Dominion Lands Survey commented on his all-too-similar experiences:

We usually made a camp at the foot of the mountain which we had to ascend, and as soon as the rain ceased and it showed signs of clearing, we started for the summit, sometimes as early as 2 A.M. We often reached the top about 9 o'clock and remained in mist all day hoping it might clear; only to be obliged to descend without having accomplished anything. It sometimes happened that the clouds would lift like magic and the landscape be revealed for a short time, during which we would hasten to take the views . . .[12]

There were rewards for perseverance, however. Again, Mary Schaffer wrote:

It was a great surprise when Pinto wakened me at five o'clock next morning (by chewing our front-door mat), to find the air as keen as Christmas, the frost covering everything, and the lake with not a ripple on it. Photog-

raphy waits for no one, so I bounded forth with camera and tripod, raced hither and yon in the frosty air, and returned breathless, successful, and half frozen to be asked if I had lost my senses.[13]

Photographers, like other visitors to the mountains, had to deal with flies and mosquitos, bears, mountain goats, elk, and other fauna. While photographing at Little Bluff on the Thompson River in the 1860s, for example, Frederick Dally had to retake one shot "as a rattler happened to be under the stone that I rested my plate against to dry in the sun, and licked the water off, marking the plate from

the top to the bottom with its forked tongue."[14]

Another obstacle for many photographers was the non-cooperation of the indigenous mountain people. The Natives, understandably, did not want to be treated as just a part of the landscape. But there were many other reasons for their reluctance to be photographed: an invasive or aggressive approach on the part of the photographer, the knowledge that one was being portrayed as a member of a primitive, backward, or amusing race, distrust of the government's use of their portraits, a misunderstanding of a never-before-seen technology, and even fear of the camera.

An interesting incident occurred during Charles

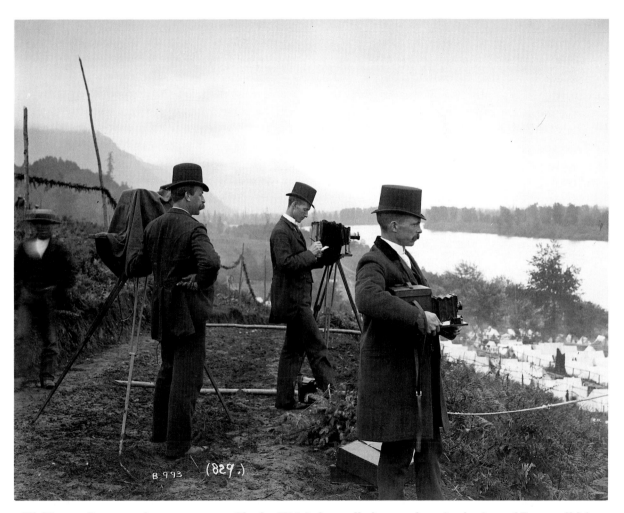

W. Hanson Boorne, unknown assistant, Charles W. Mathers, all photographers for the firm of Boorne & May
MISSION, BC / AUTUMN 1892
PROVINCIAL ARCHIVES OF ALBERTA B.993

Horetzky's expedition to the British Columbia interior in 1872:

> After a short journey up the Skeena in the direction of Kyspyox, with McK— for my companion, when we photographed several places of interest–amongst others, Hazelton and the mountains in its vicinity–Tom Hankin and I, accompanied by Charlie and another Indian, started on a little tour up the Wotsonqua, taking with us my camera, which Tom, facetiously, and as it turned out, unfortunately, chose to designate by the rather inappropriate name of the "Cholera Box." In order to explain, it is necessary to remark that a few months previous Mr. T., the gentleman in charge of the Mission Station at the mouth of the Naas River, had paid a pastoral visit to the Achwylget Indians. With his other *impedimenta* he had brought a small magic lantern and slides, which were duly exhibited to their wondering gaze, not without a certain amount of pomp and ceremony. After the reverend gentleman's departure, however, it most unfortunately happened that a species of cholera broke out among the native Hazeltonians; the origin of which they most illogically attributed to the "one-eyed devil" in the lantern and its exhibitor. Once possessed of the idea, which the native medicine men did their utmost to encourage, the reasoning and arguments of the whites were unavailing; and as the disease spread, so did the belief in the occult powers of Mr. T— gain ground . . . With this unfortunate precedent the reader may imagine that I was not unnaturally a little shy of parading the camera, an instrument bearing a certain family likeness to the hated lantern, and which my friend Tom would persist in calling by such an obnoxious name. As luck would have it, after we were out a couple of days, the Indian, who made the photographic apparatus his particular burden, was taken suddenly ill one evening in camp. We had noticed certain peculiarities in his behaviour, and had, on several occasions, observed him eyeing the dreaded box with looks of evident aversion. When turning in on that particular evening, Tom remarked in his sententious way: "I'll bet the treats that fellow's berth will be vacant tomorrow morning." And when we got up the following day, we found his prophetic speech verified, for no Indian was to be seen but Charlie, who said the fellow had gone off, evidently in mortal terror of the box and its mysterious contents.[15]

Occasionally a photographer had to choose between doing his job or helping a fellow mountaineer. Benjamin Baltzly made this decision in late 1871 near the Canoe River south of Tete Jaune Cache:

> After travelling eight miles [thirteen kilometres] we came to Mr. Green's, and his party's mountain home on McLennan River. They had a cache built of heavy logs about completed. They had also a large hut in course of erection, which, no doubt, was completed in a short time. I left them some of my 8x10 plate glass, to put windows in their mountain house, thus in a short time they will be quite comfortably situated . . .[16]

Life for the mountain photographer was not always fraught with difficulties. Otto Buell's trip through the mountains in the summer of 1886 was comparatively luxurious, thanks to the backing of the Canadian Pacific Railway. "Their special car," the *Victoria Colonist* reported, "is very conveniently fixed with operating rooms, bedroom, kitchen, dining room, etc. so that their work can be proceeded with as they move from place to place. Their views will be used by the CPR in their guide books and advertisements."[17]

In 1887, William McFarlane Notman was similarly provided with a private car for his journey on the CPR. Known as Photographic Car No. 1, it contained a parlour, state rooms, a kitchen, and a darkroom, complete with water tanks on the roof.

These few examples aside, the requirements to be a successful mountain photographer were considerable. At the very least one needed technical expertise, physi-

cal health, strength to carry heavy loads up steep in- clines (sometimes in snowshoes), stamina, and a sense of adventure, including an urge to explore new places and experiences, and fortitude in the face of pro- longed isolation and dizzying heights. On top of this, one needed an appreciation of abstract forms, a feel for the ever-changing nature of mountain light, and an acute appreciation of the beauties of nature. Most of all, one needed patience—what Byron Harmon called "waiting for the light"—and skill in arranging the ele- ments of a picture. Walter Wilcox described the proc- ess and the attitude superbly in *The Rockies of Canada*:

I usually spend the first few days composing my pictures, devoting much time to that most important part, the foreground, for it seems to me that a landscape without a foreground is hardly a picture at all, and certainly not to be regarded as a work of art. The foreground takes away that feeling of being suspended somewhere in space, gives you confidence that you are really standing on something, helps interpret the subject, and adds another element of distance and perspective. Yet, of all parts of the picture, this is the hardest to arrange. Every line, every mass of light and shade, that you succeed in harmonizing with the idea of your picture, means, by the very fact that you have shifted your point of view to right or left, or up or down, that many an- other element of your picture has been lost. It is an absorbing puzzle that often requires days to solve, even for the experienced worker, and must always end in many compromises. The painter has an immense advantage, for he can adapt nature to his requirements, but the photographer has to take her nearly as she is.[18]

He went on to emphasize the importance of patience:

I have been trying for many years to get away from the hard, black and white, ordinary photograph, endeavouring to portray the atmosphere and distance of the mountains, the glory of the sky and clouds in a soft artistic medium so as to interpret nature as

she appears at her best. And the first thing I learned was to break all the rules of the old- fashioned photographer. The brilliantly clear day and cloudless sky no longer appeal to me, and I boldly point my lens into the sun till my eyes are dazzled. I welcome the rolling thun- der clouds and the fleecy cirrus, the purple haze before a storm, and the smoke of distant forest fires, when each receding ridge and mountain mass stands out clearly from the other, yet shows its true magnitude and gran- deur as never happens in a clear atmosphere.

But to work thus means enthusiasm for the art of landscape photography and tireless patience. However intensely eager you may be to secure a coveted picture, and however worried as the precious days slip by without result, you must hold yourself patient to wait for days and weeks, even to return year after year. The final reward for such an attitude is always adequate . . .

Taking such a lake as this . . . which in a way lends itself remarkably well to photography, it is easy to prove that in an entire year there are only a few minutes, or at most, a few hours, in which the conditions are perfect for exposing a plate. Let us say that only during three months is the ground free of snow. Of these ninety days the large majority will be either stormy, or overcast, or very windy and of the remainder some will be densely smoky, or too brilliant, so that the problem quickly narrows down to a possible ten perfect days. In each of these there will be only one or two hours in which the direction of sunlight is favourable for any given picture, and during these hours only a short time in which the ever-drifting clouds are properly grouped, the water surface unruffled, and the sunlight falling on foreground, or distance, or wherever you desire it to be. Ruskin says, "Though nature is constantly beautiful, she does not exhibit her highest powers of beauty con- stantly. Her finest touches are things which must be watched for" . . .

But this waiting for the crucial moment is

pleasant work. It would not be easy to describe the excitement and expectancy, when after weeks of delay, the several elements of light and air, of sky and sparkling water, are as favourable as they ever will be, and you wait for the culminating moment of time when nature has concentrated her powers. Now must you use skill, and be favoured by fortune besides. For a single second there is a prize to grasp, which if not seized with boldness, may be withdrawn forever. It is hard to say which is the more bitter disappointment, to expose your last available plate a moment too soon, and see shortly afterwards, in your helplessness, far more beautiful combinations, or in expectation of greater things to come, overstay your opportunity and have the curtain fall, as it were, perhaps for another year on nature's drama.[19]

Mountain photography had many practical uses: to provide illustrations for travel memoirs and corporate promotions, to track the progress of construction projects, for scientific and cartographic/topographic information, and for the gathering of ethno-

graphic data. By far the most common use of mountain photography was for the production of tourist souvenirs: twenty-by-twenty-five centimetre mounted "views"; limited edition gravures; calendars; photo albums which might contain real photos, gravures, or photo lithographs; and, beginning in the 1890s, postcards. These became curios, collectibles, and reminders of vacation trips. They also served as lures to attract other potential visitors.

Since the 1860s, then, the Canadian Rockies have been the subject of an immense body of photographic documentation. Yet it is doubtful that the full picture has ever emerged—or whether one could even do justice to the mountains with a camera lens. As one prescient writer observed in 1928:

> The magnificence of the mountain ranges, the immensity of the scale on which they have been laid out, refuse to be put into words. Something is left out in every picture or photograph. Only the eye can gather the sense of height and vastness, the infinite serenity and majesty, which thrill the beholder on his first glimpse of the Canadian Rockies.[20]

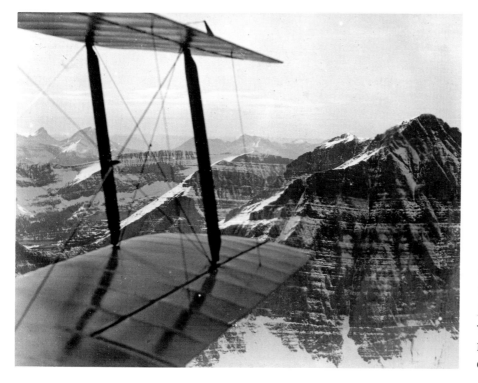

"Continental Divide, Waterton National Park," AB
W. J. OLIVER / 1920s
PROVINCIAL ARCHIVES
OF ALBERTA A.21004

The Photographers

During construction of the CPR and for several years afterward, a flood of photographers came to the western mountains. Itinerants from the east such as Otto B. Buell, William McFarlane Notman, Alexander Henderson, A. B. Thom, Fred Bingham, the team of Boorne and May, Alex Ross, Frederick Steele, and Cornelius J. Soule were joined by colleagues from the west coast such as Stephen J. Thompson, Richard Maynard, the Bailey Brothers, Edward Brooks, Norman Caple, and Richard Trueman who opened branch studios at Kaslo, Sandon, and Revelstoke.

After the railway was completed, a number of photographers set up shop in the region. Along the main line, John Henry Blome operated a studio in Ashcroft in 1895–1896, and J. R. Evans practised in Revelstoke in 1894. Kamloops, a divisional point, attracted numerous photographers: John L. Brown from 1885–1891, James D. Reid in 1889, Charles H. Watson in 1890, Miss Mina Gale from 1891–1893, William Russell Lang's Royal Studio from 1893–1898, Wah Lee throughout the 1890s, and Edward C. Thomas in 1899–1901.

The Okanagan Valley attracted several photographers after the 1891 spur line was built from Sicamous down to Okanagan Landing. Vernon was home to Alfred Dashwood Worgan from 1891–1896, Charles W. Holliday from 1892–1899, and Reginald

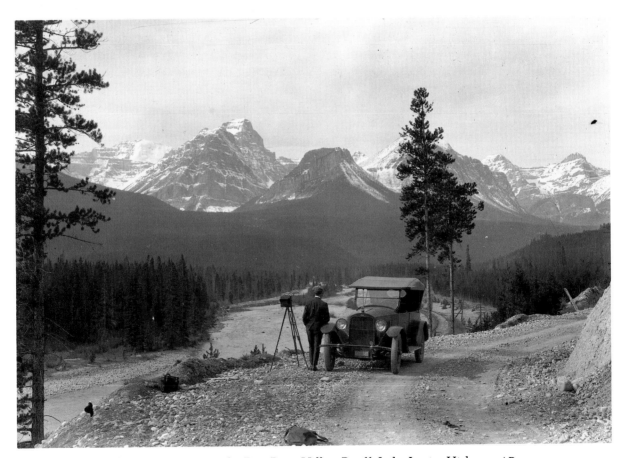

Photographing Down the Bow River Valley, Banff–Lake Louise Highway, AB
BYRON HARMON / 1921
WHYTE MUSEUM OF THE CANADIAN ROCKIES V263 NA-71-4483

J. Cooke in 1900. Frank Rice became Kelowna's first resident photographer in 1899.

The Kootenays saw a gradual increase in photographers during the early 1890s, with a noticeable quickening during 1897-1898 as the railways were completed. Fernie was home to Henry and Thomas Hammond through the 1890s, and a branch of Steele & Co from 1898-1900. The Hammonds were also active at Fort Steele. Daniel Sinclair operated out of Sandon from 1898-1900, while Trail boasted Edward C. Hendee during 1896 and 1897 and William Hall in 1898. Nelson was a particularly busy centre, with O. B. Benson working there during 1890-1891, the Neeland Brothers (James, H. G., and Samuel) from 1891-1897, the Stanley Brothers (George and Gilbert) from 1893-1895, Andrew Johnson in 1897, and James Hoag in 1899 and 1900. J. B. Stormer worked out of the town of Midway in 1897-1898, while Rossland was home to eight studios: George M. Eddie's Elite Photo Studio in 1898, Robert A. McBeth, George Mortimer, the Itter Brothers (Julian and William), Mrs. J. Hogan, and W. J. Carpenter all in 1897-1898, Ben Snell in 1898-1899, and Thomas H. Cowan in 1900.

The number of resident photographers increased after the turn of the century. Byron Harmon and George Noble competed for business in Banff while F. H. Slark and William H. Robinson did likewise in Jasper. Along the CPR, A. C. Taylor, H. E. Dudley, John Scales, Charles Watson, J. J. Embury, and Mary Spencer worked out of Kamloops; R. M. Chenuz, Rex Lingford, and Charles E. Woodbridge at Salmon Arm; W. J. Gould in Golden, William Barton, E. F. Tucker, W. B. Fleming, and Gabriel Taylor at Revelstoke; and Arthur Percival at Field. Along the Grand Trunk Pacific Railway, Norman Lihon practised at Lucerne, Peter Hilmo near Tete Jaune Cache, and J. E. Mogensen at Hazelton.

In the Okanagan, J. W. Bacon was at Enderby; J. H. Hunter, B. R. LeBlond, E. G. Pontin, and F. G. Salt were at Vernon; George Hudson, Samuel Gray, W. McEwan, Sydney H. Old, and C. F. Tupper were at Kelowna; H. W. Handford, W. G. Maxwell, the Pell Studio, the Ribelin Studio, and Hudson, Stacks & Co were at Penticton, and C. P. Nelson was at Summerland. To the west, Princeton boasted three photographers in that period—H. McInroy, Archie Murchie, and A. N. Reston—Thomas Aikman and Harry Priest worked out of Merritt.

The Kootenay district was home to William G. Asher and John H. James at Creston; G. Elliott, R. J. Hughes, and the Progress Studio at Trail; F. J. Lake, Elmer Rice, and Albert Simpson at Grand Forks; Henry Calvert and W. B. Smith at Kaslo; E. J. Campbell, G. A. Meeres, and Allan Lean at Nelson; David Wadds, Thomas Gowan, L. M. Roberts, and Carpenter and Co at Rossland; W. E. Mullen at Arrowhead; and R. J. Binning, F. Nelson, Vincent Russell, William A. Prest, the Star Studio, and Braam C. Van at Cranbrook.

The southeast district of British Columbia supplied business to Oliver Plagle of Blairmore, William Robson of Hosmer, the Somerton Brothers of Michel, as well as James Milner, J. F. Spalding, T. Barton, F. R. Haigh, and the McCarthy Studio at Fernie.

Notes

1. J. Outram, *In the Heart of the Canadian Rockies* (London: MacMillan & Co Ltd, 1906), 1.
2. *Ibid*, 20.
3. As quoted in Birrell, *Benjamin Baltzly: Photographs and Journal of an Expedition Through British Columbia 1871* (Toronto: Coach House Press, 1978).
4. J. J. McArthur, "Memorandum on the Photographic Surveys of the Canadian Section of the International Boundary Commission," as quoted in Birrell, "Survey Photography in British Columbia 1858-1900." *BC Studies* 52 (Winter 1981—82), 60.
5. Scott to Pollard, 8 September 1924, "Pollard Scrapbook," Provincial Archives of Alberta, 64.33/1.
6. W. Wilcox, *The Rockies of Canada* (New York: Knickerbocker Press, 1909), iii.

7. Birrell, *Benjamin Baltzly*, 149.
8. E. Hart, *A Hunter of Peace* (Banff: Whyte Foundation, 1980), 27.
9. *Calgary Herald*, "Exploration Trip Field to Robson is Accomplished," August 1924, "Pollard Scrapbook."
10. *Calgary Herald*, 1 November 1890, 5.
11. Hart, 47.
12. J. J. McArthur, "Memorandum on the Photographic Surveys of the Canadian Section of the International Boundary Commission," quoted in Birrell, *Into the Silent Land*, (Ottawa: Information Canada, 1975), plate 104.
13. Hart, 56.
14. J. Schwartz, *Images of Early British Columbia: Landscape Photography 1858–1888*, unpublished Masters thesis (Vancouver: University of British Columbia, 1977), 39.
15. C. Horetzky, *Canada on the Pacific* (Montreal: Dawson Brothers, 1874), 108–109.
16. Birrell, *Benjamin Baltzly*, 146.
17. Quoted in Dempsey, *Nineteenth Century Photographers on the Canadian Prairies*, unpublished manuscript (Calgary: Glenbow-Alberta Institute, 1978), 11–12.
18. Wilcox, 211–212.
19. *Ibid*, 212.
20. M. Williams, *Kootenay National Park and the Banff–Windermere Highway* (Ottawa: Dept of the Interior, 1928).

Suggested Readings

Babaian, S., ed. *The Coal Mining Industry in the Crow's Nest Pass.* Edmonton: Alberta Culture, 1985.

Barman, J. *The West Beyond the West: A History of British Columbia.* Toronto: University of Toronto Press, 1991.

Birrell, A. "Fortunes of a Misfit; Charles Horetzky." *Alberta Historical Review* (Winter 1971).

_____. "Frederick Dally: Photo Chronicler of BC a Century Ago." *Canadian Photography* (February 1977).

_____. *Benjamin Baltzly: Photographs and Journal of an Expedition Through British Columbia 1871.* Toronto: Coach House Press, 1978.

_____. "Survey Photography in British Columbia 1858–1900." *BC Studies* 52 (Winter 1981–82).

Cautley, R. et al. *Report of the Commission to Delimit the Boundary between the Provinces of Alberta and British Columbia.* Part I: 1913–1916; Part II: 1917–1921; Part III: 1918–1924. Ottawa: Office of the Surveyor General, 1917, 1924, 1925.

Cavell, E. *Legacy in Ice: The Vaux Family and the Canadian Alps.* Banff: The Whyte Foundation, 1983.

_____ & J. Whyte. *Rocky Mountain Madness: A Bittersweet Romance.* Banff: Altitude Publishing, 1982.

Cobb, M. & D. Duffy. "A Picture of Prosperity: The British Columbia Interior in Promotional Photography 1890–1914." *BC Studies* 52 (Winter 1981–82).

Crisafio, R., ed. *Backtracking.* Fernie: Fernie Historical Association, 1967.

Dempsey, H. *Nineteenth Century Photographers on the Canadian Prairies.* Unpublished manuscript. Calgary: Glenbow-Alberta Institute, 1978.

Finch, D. *Glacier House Rediscovered.* Revelstoke: Friends of Mount Revelstoke and Glacier, 1991.

Fraser, E. *The Canadian Rockies: Early Travels and Explorations.* Edmonton: Hurtig Publishers, 1969.

Hadley, M. "Photography, Tourism and the CPR: Western Canada, 1884–1914." *Essays on the Historical Geography of the Canadian West: Regional Perspectives of the Settlement Process.* Calgary: University of Calgary, 1987.

Harmon, C., ed. *Great Days in the Rockies: The Photographs of Byron Harmon 1906–1934.* Toronto: Oxford University Press, 1978.

Hart, E., ed. *A Hunter of Peace.* Banff: Whyte Museum of the Canadian Rockies, 1980.

Hill, B. *Sappers: The Royal Engineers in British Columbia.* Ganges: Horsdal & Schubart Publishers Ltd, 1987.

_____. *Exploring the Kettle Valley Railway*. Winlaw: Polestar Press Ltd, 1989.

Horetzky, C. *Canada On The Pacific*. Montreal: Dawson Brothers, 1874.

Lanz, W. *The Trans-Canada Highway: Victoria to Calgary*. Vancouver: Oak House Publishing, 1992.

Lavallee, O. *Van Horne's Road*. Toronto: Railfare Enterprises Ltd, 1974.

Marsh, J., M. Miller, and M. Lindsay. *Glacier National Park*. Peterborough: Canadian Recreation Services, 1971.

Marty, S. *A Grand and Fabulous Nation: The First Century of Canada's Parks*. Toronto: New Canada Publications/Minister of Supply and Services Canada, 1984.

Mattison, D. *Camera Workers: The British Columbia Photographers Directory 1858–1900*. Victoria: Camera Workers Press, 1985.

_____. *Camera Workers 1901–1929: Checklist*. Unpublished manuscript, 1986.

McDougall, M. "R. H. Trueman, Artist and Documentarian." *BC Studies* 52 (Winter 1981–82).

Monaghan, D. *Oliver Buell 1844–1910: Photographer*. Montreal: Concordia Art Gallery, 1984.

Outram, J. *In the Heart of the Canadian Rockies*. London: Macmillan & Co Ltd, 1906.

Palmer, H. & T. *Alberta: A New History*. Edmonton: Hurtig Publishers, 1990.

Pole, G. *The Canadian Rockies: A History in Photographs*. Banff: Altitude Publishing, 1991.

Roe, J. *The Columbia River*. Golden: Fulcrum Publishing, 1992.

Roth, M. "Mary Schaffer Warren: Explorer." *Canadian Women's Studies* 2.3 (1980).

Sandford, R. W. *The Canadian Alps: The History of Mountaineering in Canada*. Banff: Altitude Publishing, 1990.

Sanford, B. *Steel Rails and Iron Men: A Pictorial History of the Kettle Valley Railway*. Vancouver: Whitecap Books, 1990.

Schwartz, J. "The Photographic Record of Pre-Confederation British Columbia." *Archivaria* 5 (1977–78).

Smyth, F. *Tales of the Kootenays*. Cranbrook: The Courier, 1938.

Tepper, L., ed. *The Interior Salish Tribes of British Columbia: A Photographic Collection*. Ottawa: Canadian Museum of Civilization, 1987.

Triggs, S. *William Notman: The Stamp of a Studio*. Toronto: Coach House Press/Art Gallery of Ontario, 1985.

Wheeler, A. *The Selkirk Range*, Vol. 1. Ottawa: Government Printing Bureau, 1905.

Wilcox, W. *The Rockies of Canada*. 3rd ed. New York: Knickerbocker Press, 1909.

Woodcock, G. *A Picture History of British Columbia*. Edmonton: Hurtig Publishers, 1980.

Woodward, M. *The Fraser Canyon: Valley of Death*. Calgary: Frontiers Unlimited, n.d.

Woodward, M. B. *Land of Dreams: A History in Photographs of the British Columbia Interior*. Banff: Altitude Publishing, 1993.

First Inroads

PHOTOGRAPHY came to the Canadian Rockies in 1865 when Charles Gentile entered the Fraser Canyon in search of people and places connected with the Gold Rush. For the next fifteen years, mountain photography concentrated on three themes: the scenery, the indigenous peoples, and the incoming miners.

The subject that demanded the most attention was, of course, the geography, the seemingly infinite vistas of peaks and valleys. In his promotional material, Otto B. Buell advertised "Towering Mountains, Grand Canyons, Bounding Streams and . . . incomparable scenery." All photographers delivered much the same thing, differing only in artistic approach. The vastness, the newness, and the never-ending variety of the mountains were imprinted on countless sensitized glass plates and, later, plastic film.

The Natives were equally fascinating to early photographers. The largest indigenous group in the British Columbia interior were the Interior Salish, comprising four distinct bands: the Atlakyapamulc, or Thompson, band lived along the Fraser Canyon; the Lillooet occupied the northern Fraser River and up into the Williams Lake area; the Shuswap lived near Kamloops around the lake that bears their name; and the Okanagan in the valley that bears their name. They were chiefly a fishing and gathering culture, but since the beginning of the nineteenth century they had also engaged in placer mining, selling gold nuggets to the Hudson's Bay Company posts.

The Chilcotin band, a branch of the Athapaskan Nation, were located in the Cariboo district. The Kootenay lived on either side of the Kootenay Mountains, and were unrelated to any other interior band. They had originally occupied parts of southern Alberta as well as the interior of British Columbia, but had been driven west by the superior numbers and weaponry of the Blackfoot Confederacy. The Lower Kootenay lived near what was to become Bonners Ferry, Creston, and Nelson. The Upper, or Eastern, Kootenay lived on the upper waters of the Kootenay River near Fort Steele, Fernie, and Tobacco Plains. Although they would eat fish, they never lost their taste for buffalo meat, and made annual forays through the Crowsnest Pass to join the hunt.

The Stoneys, known as the Assiniboine on the prairies, were the only Alberta band to play a significant role in the Rocky Mountains. Originally a part of the Dakota Nation, they had split off from the main tribe in the 1600s and crossed the forty-ninth parallel to settle in the Lake Winnipeg district. They slowly drifted west, and by the early 1800s were hunting on the eastern slopes of the Rockies. The Stoneys maintained their nomadic lifestyle until the 1870s, when a Methodist Mission was built at Morley on the Bow River, around which they congregated. There were three separate bands: the Bearspaw lived along the Kananaskis Valley up to the Crowsnest Pass, the Chiniki resided in the Canmore corridor up the Bow River Valley, and the Goodstoney, or Wesley, band lived on the Kootenay Plains near Rocky Mountain House. All three were signatories to Treaty #7.

The first push of settlers into the interior coincided with the gold rush of 1858. That spring, large quantities of the precious metal were discovered at Yale and Emory in the Fraser Canyon, and a horde of prospectors and miners—some from Vancouver and Victoria, although most were from Washington and California—started pushing up the Fraser River in search of larger deposits. By the end of the

year, over 10,000 men had moved upriver as far as Lytton. Such an influx of outsiders in such a brief period inevitably resulted in conflicts with the Natives, drownings and other accidents, and crimes of various kinds. The colonial government felt it had to intervene to keep the peace.

At the behest of the BC governor, James Douglas, a mule road was started in 1860. Two years later, to ensure its safety, Douglas requested the Royal Engineers to plan and complete it. The "Great Wagon Road," as it became known, began at Yale, the farthest point up the Fraser River that steamboats could safely venture. It continued north to Spuzzum, past Boston Bar, North Bend, Lytton, Lillooet, Clinton, 100 Mile House, Williams Lake, Soda Creek, and Quesnel, terminating at Barkerville in the Cariboo Mountains.

A second link to the interior, this one straight east from the lower mainland, was built in 1865 to link up with the Kootenay district, where a smaller gold rush had occurred. Taking its name from the chief surveyor, Edgar Dewdney, a member of the Royal Engineers, the Dewdney Trail extended some 470 kilometres through valleys and across mountain ranges. Starting at Hope, it ran east through Princeton, Grand Forks, Rossland, and Trail, then turned south to the head of Kootenay Lake, from where it extended along the Moyie River to Yahk, ending at Cranbrook. The trail fell into disuse within a couple of years, as the gold rush at Wild Horse evaporated. Parts of the grade were later used for railways. The rest was reclaimed by nature.

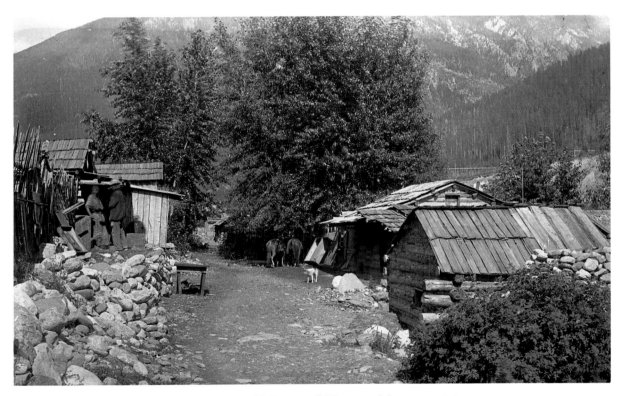

"Wild Horse Gold Diggings," Kootenay Mountains, BC
W. HANSON BOORNE / 1887
PROVINCIAL ARCHIVES OF ALBERTA B.5295

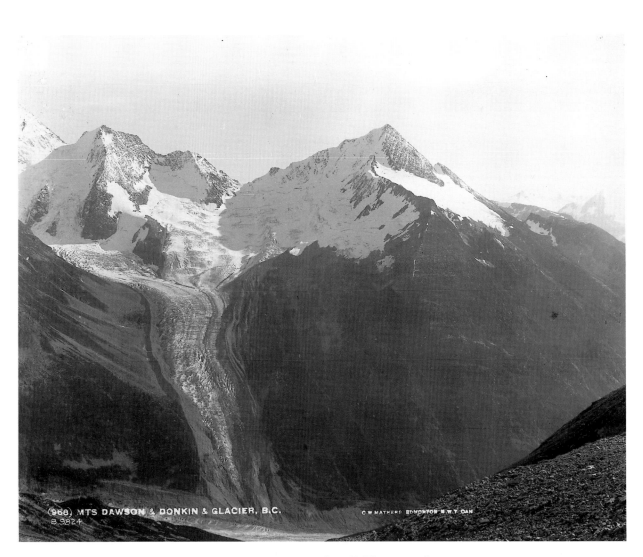

"Mts Dawson & Donkin & Glacier, BC"
Glacier National Park
W. HANSON BOORNE / 1886–1892
PROVINCIAL ARCHIVES OF ALBERTA B.9824

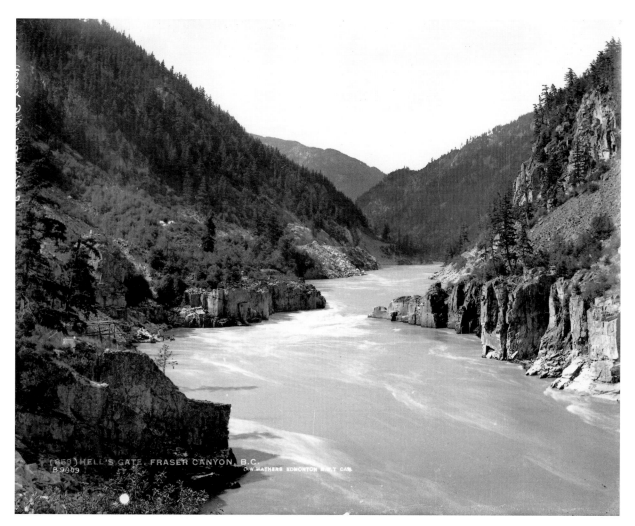

"Hell's Gate, Fraser Canyon, BC"
This particularly treacherous stretch of the river is only thirty-four metres wide, extremely deep,
and has a deceptively powerful current. It was named by Simon Fraser himself in 1808.
W. HANSON BOORNE / 1886–1892
PROVINCIAL ARCHIVES OF ALBERTA B.9809

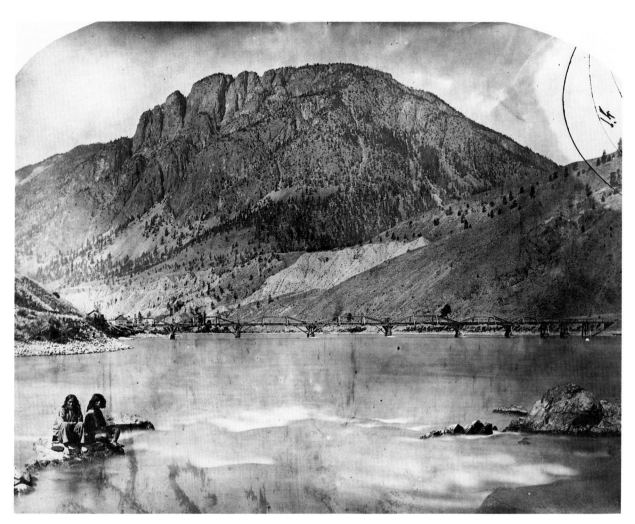

Spence's Bridge, at the confluence of the Nicola and Thompson Rivers, BC
CHARLES GENTILE / 1865
NATIONAL ARCHIVES OF CANADA C-88895

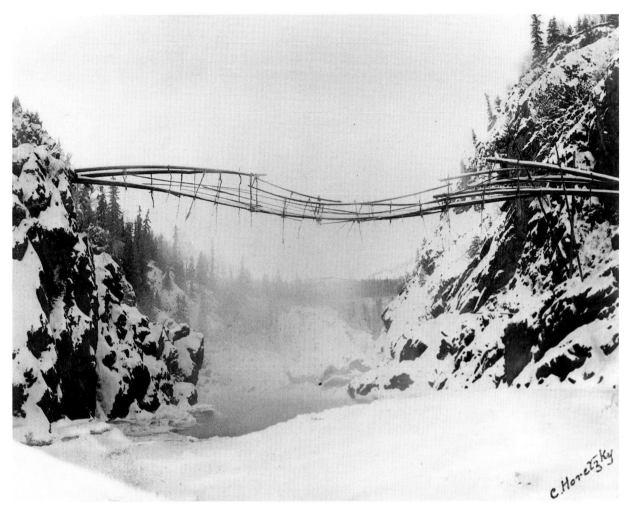

Indian Suspension bridge, Wotsonqua River, near Hazelton, BC
The structure was described by photographer Charles Horetzky in his book Canada on the Pacific *(1874)*:

About three miles from Hazelton, and three hundred feet down in the rocky bed of the Wotsonqua, there is a large Indian ranche, or village, of some twenty houses . . . Immediately in front of it the Indians have thrown a suspension bridge across the rocky chasm, through which the waters of the Wotsonqua rush . . . The bridge is built entirely of wood, fastened together by withes and branches; its height above the roaring waters beneath is fifty feet, and it sways under the weight of a man, to try even the nerves of a Blondin.

CHARLES HORETZKY / 28 DECEMBER 1872
NATIONAL ARCHIVES OF CANADA PA-9133

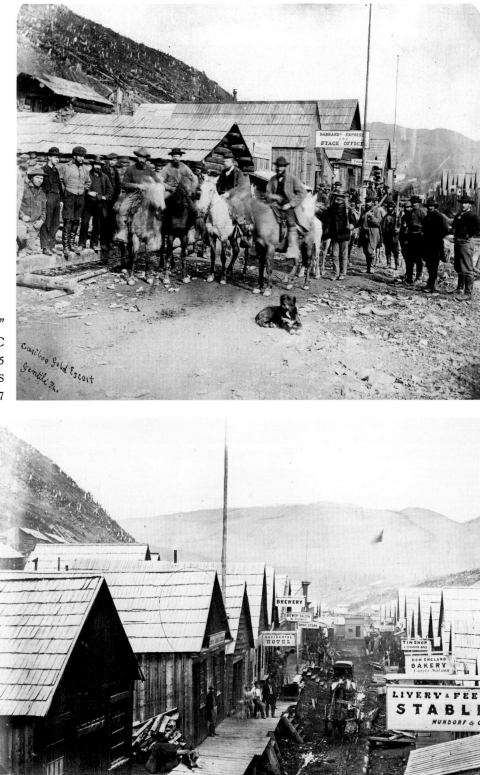

"Cariboo Gold Escort,"
Barkerville, BC
CHARLES GENTILE / 1865
NATIONAL ARCHIVES
OF CANADA C-88917

Main Street,
Barkerville, BC
FREDERICK DALLY
1866
GLENBOW ARCHIVES
NA-674-45

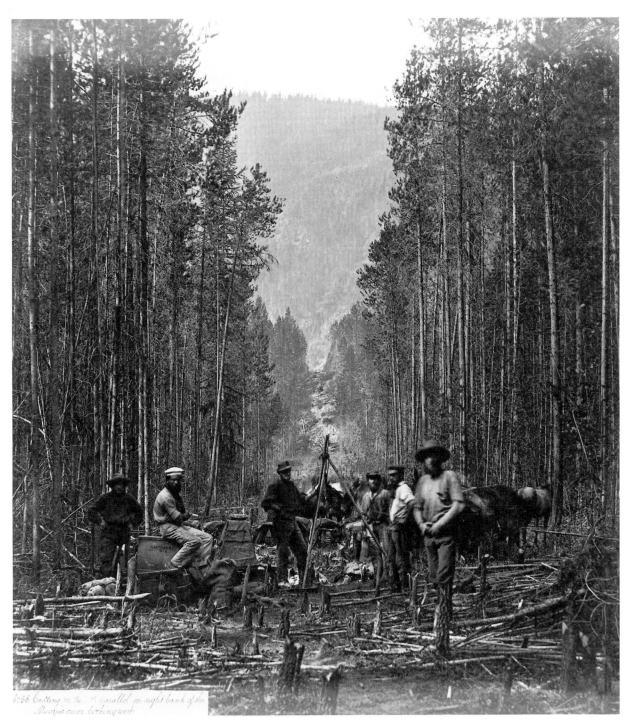

"Cutting on the 49th Parallel, on right bank of Mooyie [sic] River, looking west."
Members of the Royal Engineers cutting the Canadian–United States border
in southeast British Columbia just east of Creston.

PHOTOGRAPHER UNKNOWN / 1860-1861

NATIONAL ARCHIVES OF CANADA C-78979

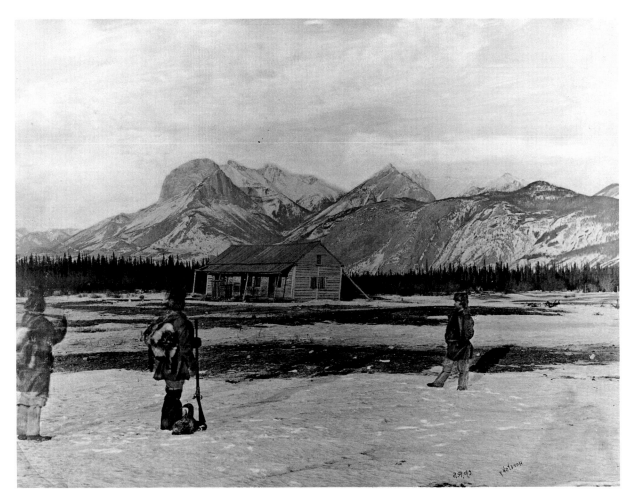

Jasper House, AB

In 1800, the North West Company established its first trading post in the valley of the Athabaska. Named after its clerk, Jasper Hawse, the post was not much more than a cabin in the wilderness, but it was a welcome starting point for traders about to enter the Yellowhead Pass. Roche Ronde can be seen in the background.

CHARLES HORETZKY / 1872

NATIONAL ARCHIVES OF CANADA PA-9173

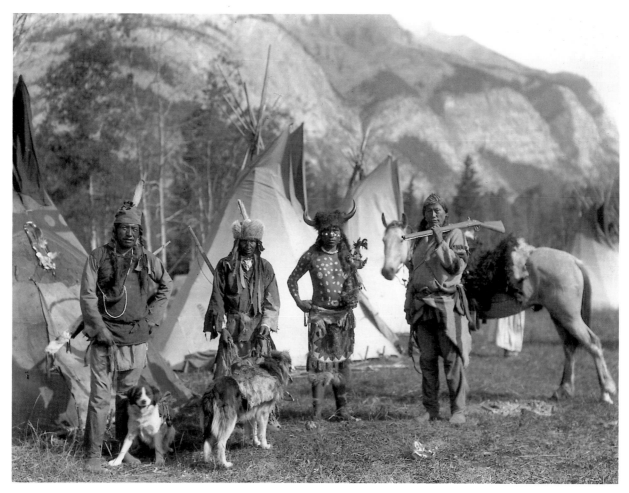

A group of Stoney Indians from the eastern slope of the Rockies near Morley, AB
Dressed in traditional garb are John Simeon, Eli Rider, John Salter, and Ben Kaquitts.
BYRON HARMON / 1920s
WHYTE MUSEUM OF THE CANADIAN ROCKIES V263 NA-71-3253

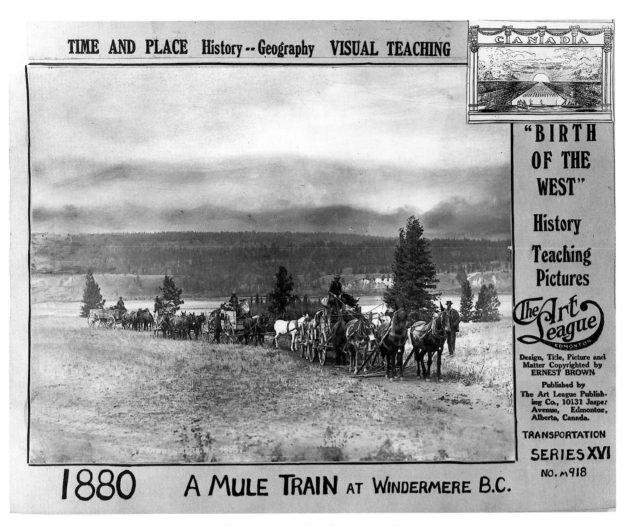

TIME AND PLACE History -- Geography VISUAL TEACHING

CANADA

"BIRTH OF THE WEST" History Teaching Pictures

The Art League
EDMONTON

Design, Title, Picture and Matter Copyrighted by ERNEST BROWN

Published by The Art League Publishing Co., 10131 Jasper Avenue, Edmonton, Alberta, Canada.

TRANSPORTATION

SERIES XVI

NO. M918

1880 A MULE TRAIN AT WINDERMERE B.C.

"Mule Train at Windermere, BC"
ORIGINAL IMAGE 1887 BY W. HANSON BOORNE
MOCKUP 1920s BY ERNEST BROWN FOR "BIRTH OF THE WEST" TEACHING SERIES
PROVINCIAL ARCHIVES OF ALBERTA B.10599

OPPOSITE TOP
Hope, BC
The town of Hope was situated on the eastern Fraser River at the point where it left the Cascade Mountains
to head west for Vancouver and the Pacific Ocean. As such, it was the original gateway to the Rocky Mountains.
CHARLES GENTILE or FREDERICK DALLY / 1865
UNIVERSITY OF BRITISH COLUMBIA SPECIAL COLLECTIONS SC-BC-557

OPPOSITE BOTTOM
"Hotel, Harrison Lake, BC"
This was the first of many resorts to be attached to a hot springs.
OTTO B. BUELL / 1886
CANADIAN RAILWAY MUSEUM (GLENBOW ARCHIVES NEG. NA-4967-52)

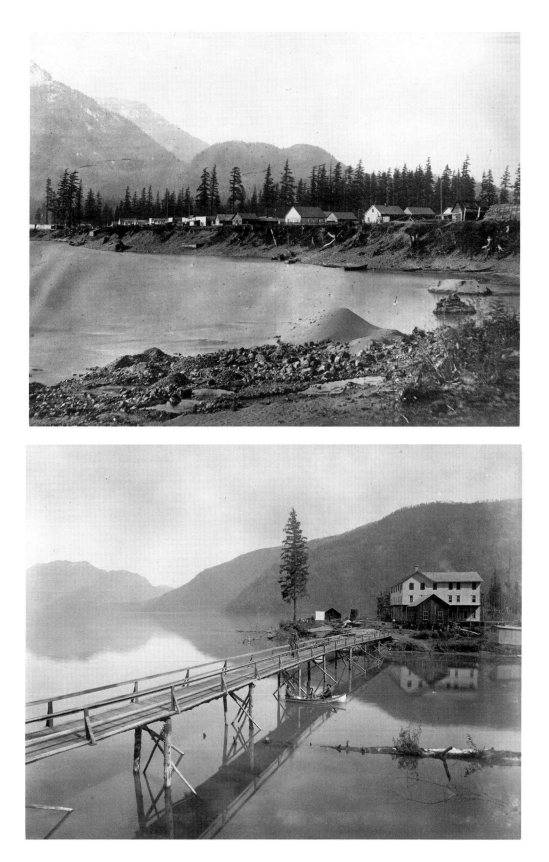

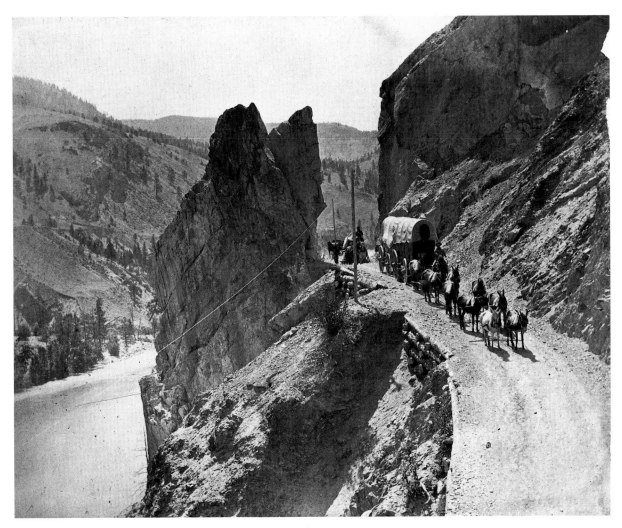

The Great Bluff, Cariboo Road, 142 kilometres north of Yale, Fraser Canyon, BC
FREDERICK DALLY / 1867
BRITISH COLUMBIA ARCHIVES AND RECORDS SERVICE HPO763 A-350

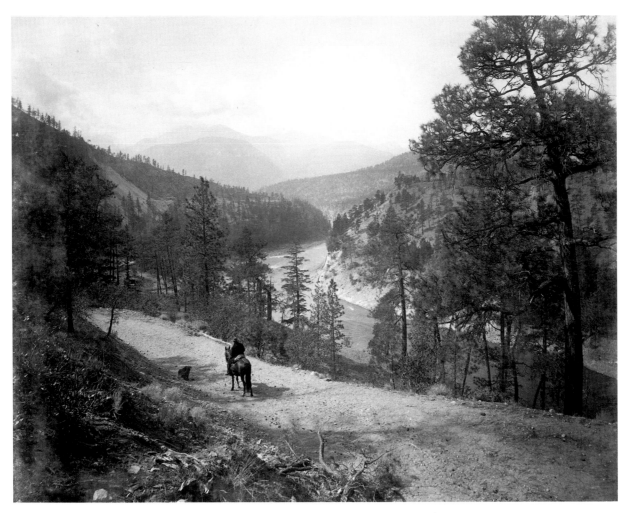

"Horseman on Cariboo Road near Lytton, BC"
OTTO B. BUELL / 1886
CANADIAN RAILWAY MUSEUM (GLENBOW ARCHIVES NEG. NA-4967-85)

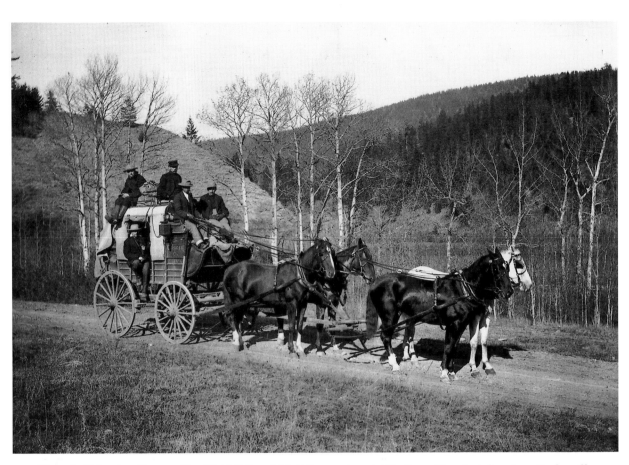

"British Columbia Express Co. ('B.X.') Royal Mail Stage, circa 1900. Stage No. 6. Ashcroft to Barkerville,
via Clinton, The Chasm, 150 Mile House, Soda Creek, and Quesnelle.
Fine drivers, fine horses, fine services; expensive, but efficient & fast."
FRASER VALLEY, BC
PHOTOGRAPHER UNKNOWN
CITY OF VANCOUVER ARCHIVES TRANS.N.77, P.103

OPPOSITE
"Making portage of canoes over the bluff at the Upper Gate of Murchison's Rapids, North Thompson River," BC
A view from the Geological Survey of Canada expedition
BENJAMIN BALTZLY / 7 NOVEMBER 1871
NATIONAL ARCHIVES OF CANADA PA-22618

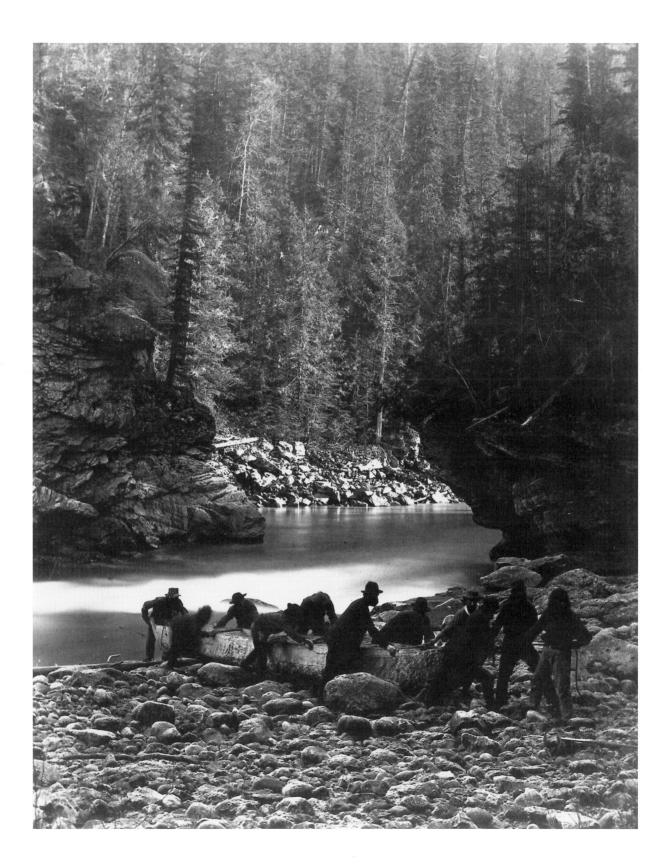

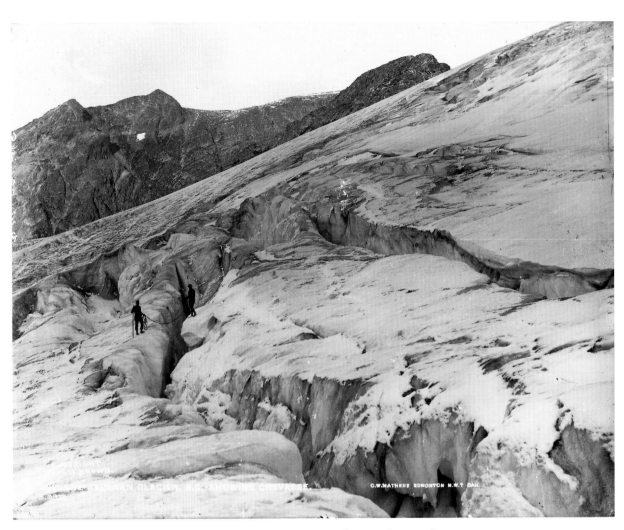

"The Asulkan Glacier, BC–Showing Crevasse"
W. HANSON BOORNE / 1886–1892
PROVINCIAL ARCHIVES OF ALBERTA B.9822

OPPOSITE
"Natural Rock Bridge, Field, BC"
A unique natural formation, the Kicking Horse River forced its way through a submerged crevasse in the rock
barrier and started flowing under rather than over this obstacle.
W. HANSON BOORNE / 1886–1892
PROVINCIAL ARCHIVES OF ALBERTA B.9804

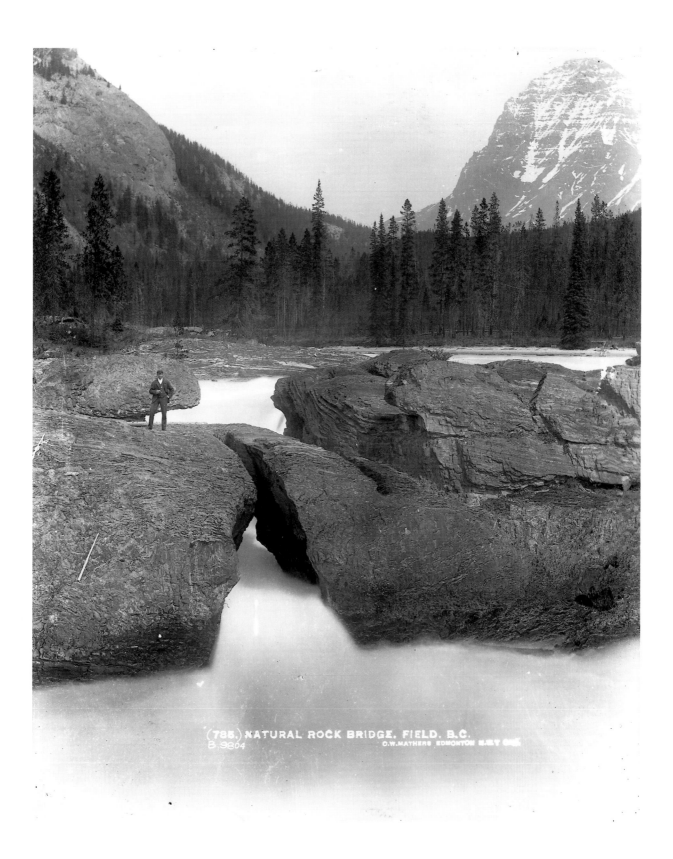

(785.) NATURAL ROCK BRIDGE. FIELD. B.C.
B.9804 C.W.MATHERS EDMONTON & N.W.T.

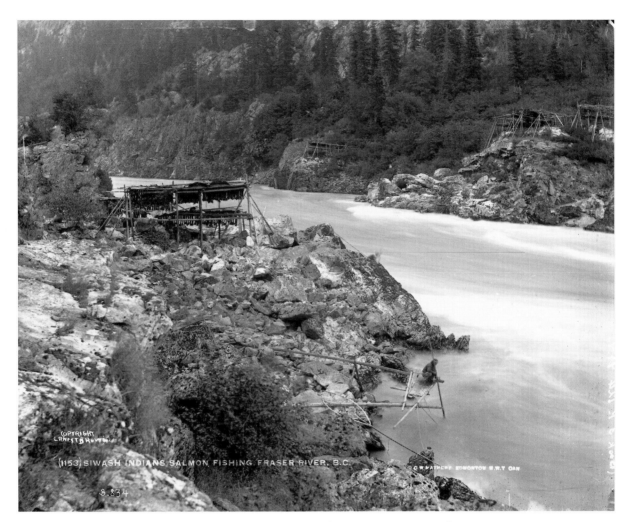

"*Siwash Indians Salmon Fishing, Fraser River, BC*"
The Natives would build platforms out and over the rapids so they could spear or net
the spawning fish as they were in mid-leap.
W. HANSON BOORNE / 1886–1893
PROVINCIAL ARCHIVES OF ALBERTA B.834

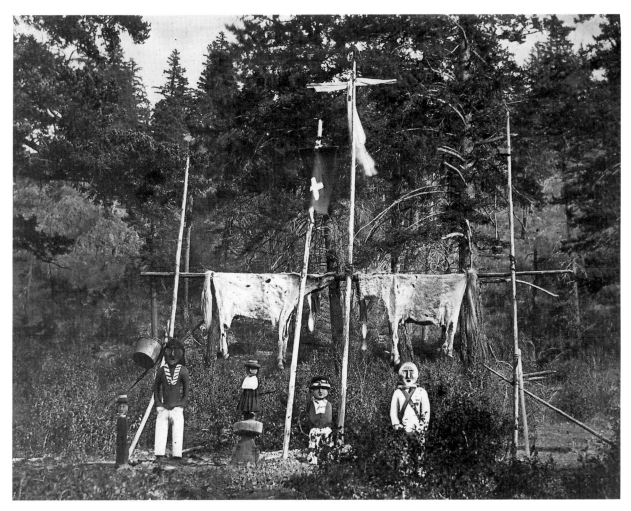

Couteau (or Thompson) Indian chief's grave, Lytton, BC
FREDERICK DALLY / 1867
GLENBOW ARCHIVES NA-674-16

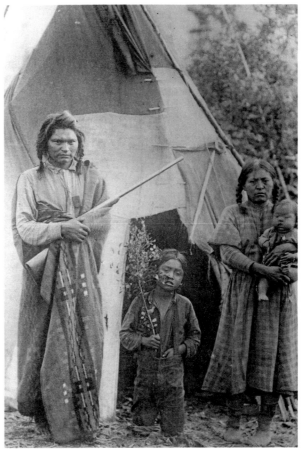

Family of Kootenay Indians, BC
PHOTOGRAPHER UNKNOWN
CA. 1900
GLENBOW ARCHIVES NA-1141-2

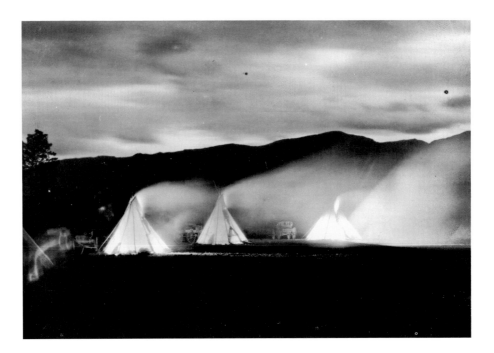

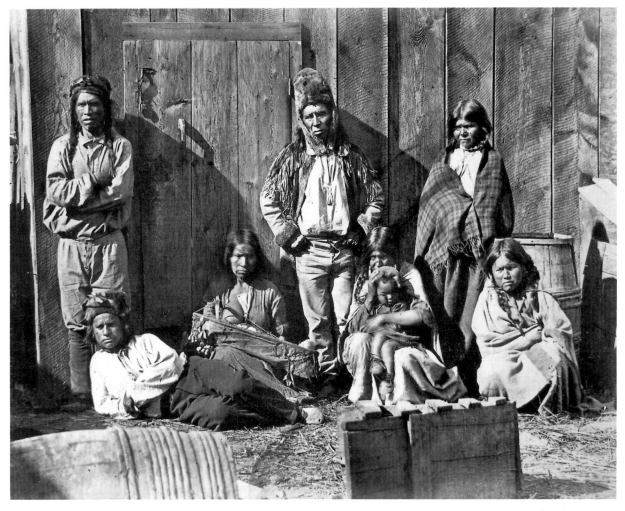

Group of Couteau Indians, Lytton, BC. In the centre is Siseanjute, Chief of the Bonaparte band.
FREDERICK DALLY / 1867–1868
GLENBOW ARCHIVES NA-674-15

OPPOSITE
Kootenay teepees at night, near Invermere, BC
PHOTOGRAPHER UNKNOWN / 1922
UNIVERSITY OF BRITISH COLUMBIA SPECIAL COLLECTIONS BC-188/11

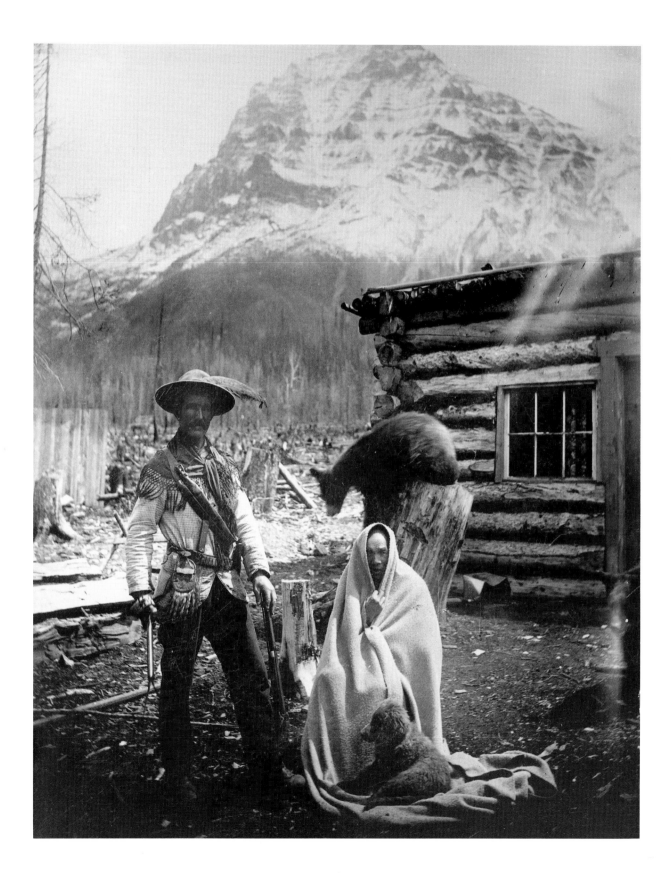

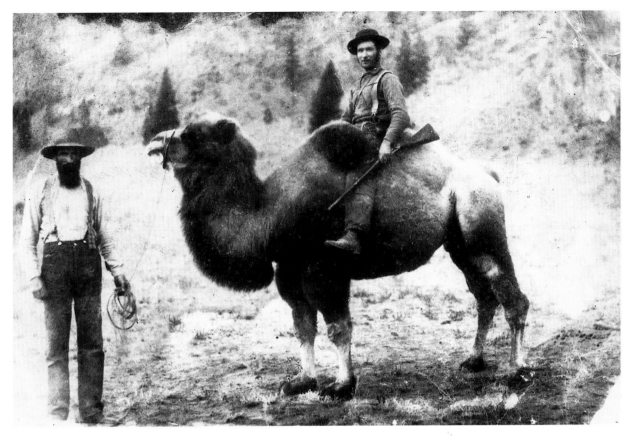

A camel on the Cariboo Trail near Lillooet, BC
These animals were brought to British Columbia in 1862 as an alternative to pack mules. While they could carry heavier loads, their soft feet were ripped apart by the rocks on the wagon trail. Within a few years, they were turned loose in the Thompson River Valley, where they frequently startled new residents.
PHOTOGRAPHER UNKNOWN / CA. 1866
BRITISH COLUMBIA ARCHIVES AND RECORDS SERVICE A-347

OPPOSITE
"Life in the Rocky Mountains, Showing Mt Stephen, CPR, Field, BC"
Cabin fever may be showing its effects on these two residents of the mountains. With bears for pets, they greet the photographer in their Sunday finest.
TRUEMAN & CAPLE / 1889-1894
MEDICINE HAT MUSEUM AND ART GALLERY

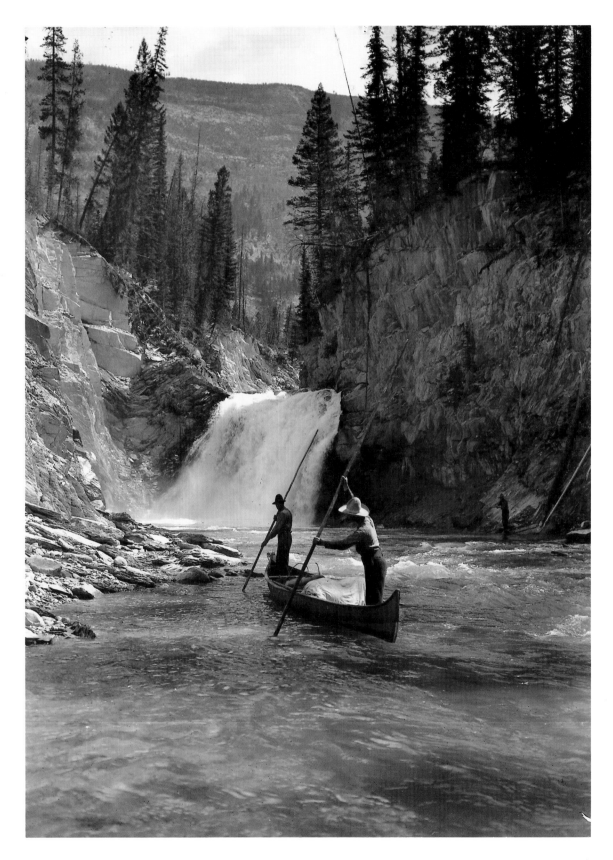

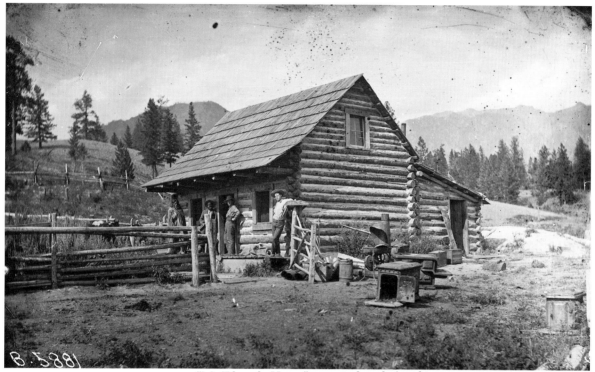

"M. Edwards House"–a typical settler's cabin
W. HANSON BOORNE / 1886–1891
PROVINCIAL ARCHIVES OF ALBERTA B.5881

OPPOSITE
Canoeists on the Cross River, Kootenay Mountains, BC
BYRON HARMON / 1923
WHYTE MUSEUM OF THE CANADIAN ROCKIES V263 NA-71-0331

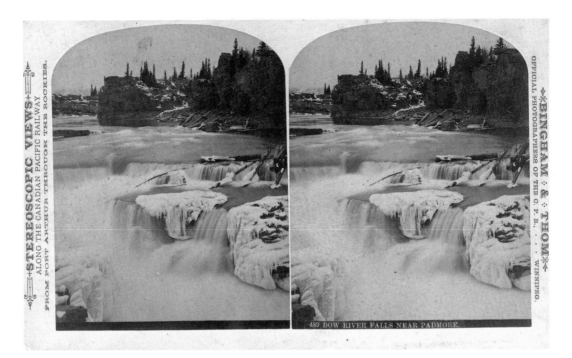

"Bow River Falls Near Padmore" (now Canmore, AB)–stereograph
BINGHAM & THOM / 1884-1886
PROVINCIAL ARCHIVES OF ALBERTA A.15502

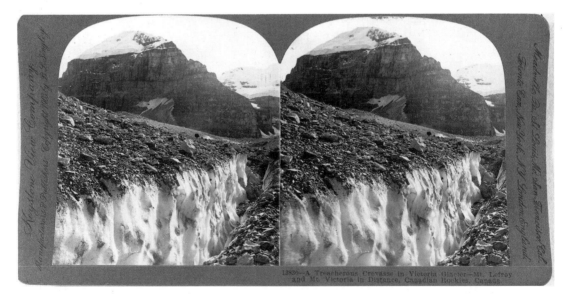

"A Treacherous Crevasse in Victoria Glacier–Mt Lefroy and Mt Victoria in Distance,
Canadian Rockies, Canada," AB
B.L. SINGLEY, KEYSTONE VIEW COMPANY/ 1903
B. SILVERSIDES COLLECTION

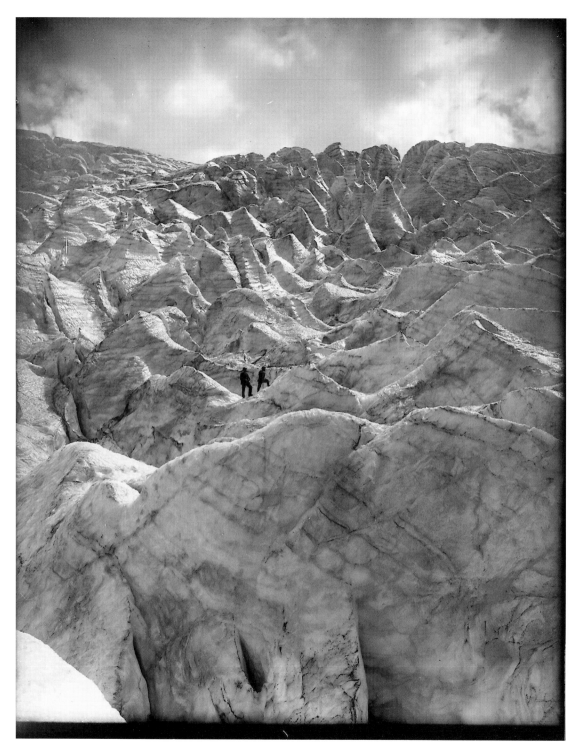

Seracs on the Illecillewaet Glacier, BC
VAUX FAMILY / AUGUST 1901
WHYTE MUSEUM OF THE CANADIAN ROCKIES V653 NG-4-858

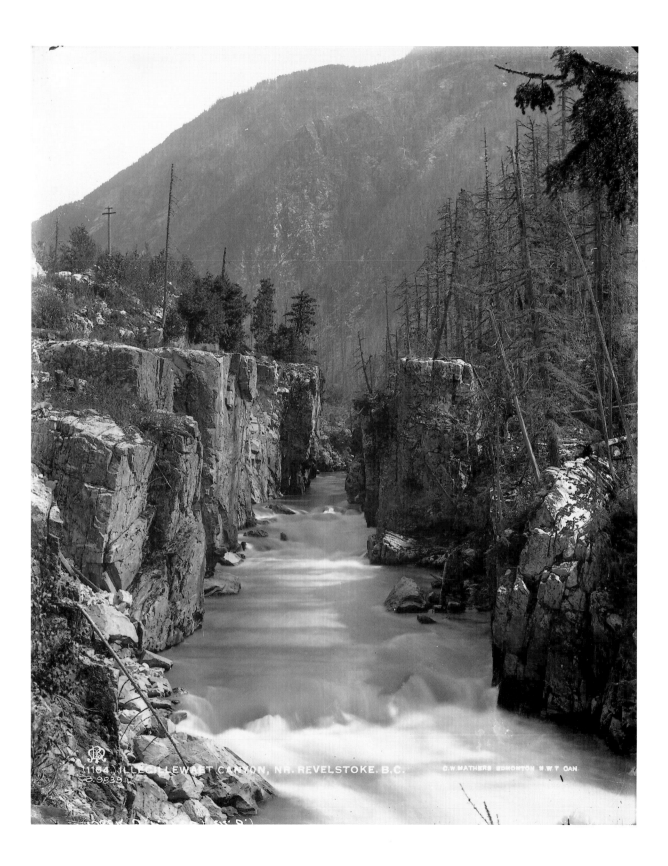

ILLECILLEWAET CANYON, NR. REVELSTOKE. B.C. C.W. MATHERS EDMONTON N.W.T. CAN

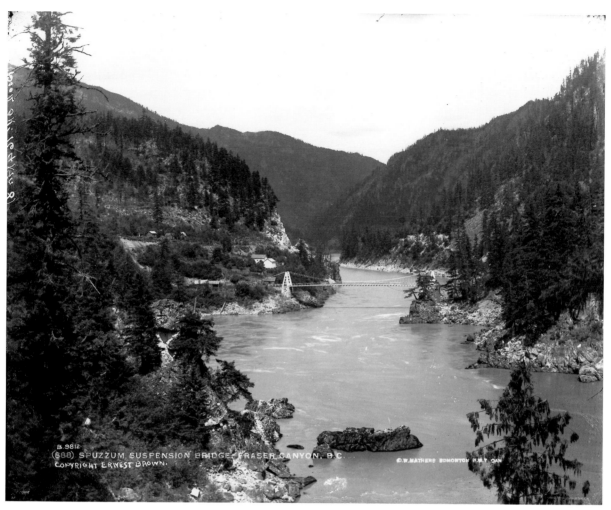

"*Spuzzum Suspension Bridge, Fraser Canyon, BC*"
The bridge, built in 1861 by Joseph Trutch (later the first lieutenant–governor of British Columbia),
was also known as the Alexandra Bridge, and was an integral part of the Cariboo Road.
W. HANSON BOORNE / 1886–1892
PROVINCIAL ARCHIVES OF ALBERTA B.9812

OPPOSITE
"*Illecillewaet Canyon, Nr. Revelstoke, BC*"
W. HANSON BOORNE / 1886–1892
PROVINCIAL ARCHIVES OF ALBERTA B.9839

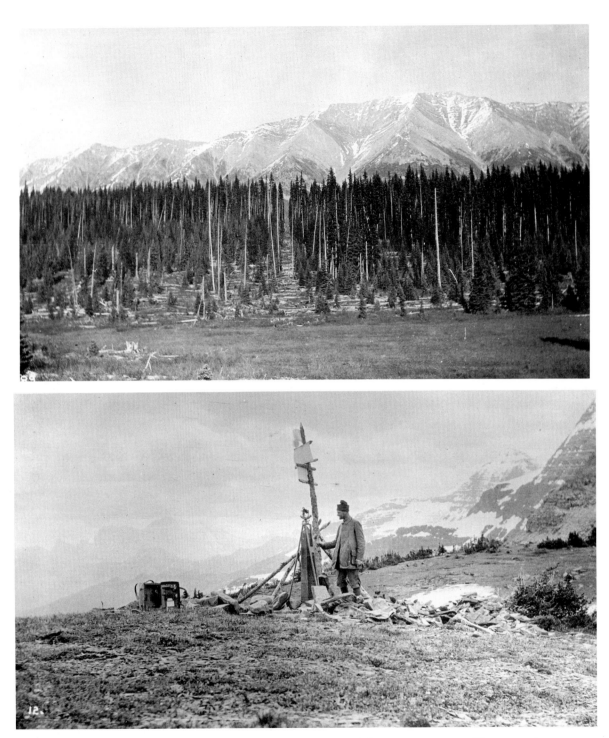

Two views from the Alberta–British Columbia Boundary and Survey 1913–1914. The man adjusting the level is R.W. Cautley, chief surveyor. The process of delineating all 970 kilometres of the continental divide took a total of eleven years.

PHOTOGRAPHER UNKNOWN

PROVINCIAL ARCHIVES OF ALBERTA A.9958 / A.9954

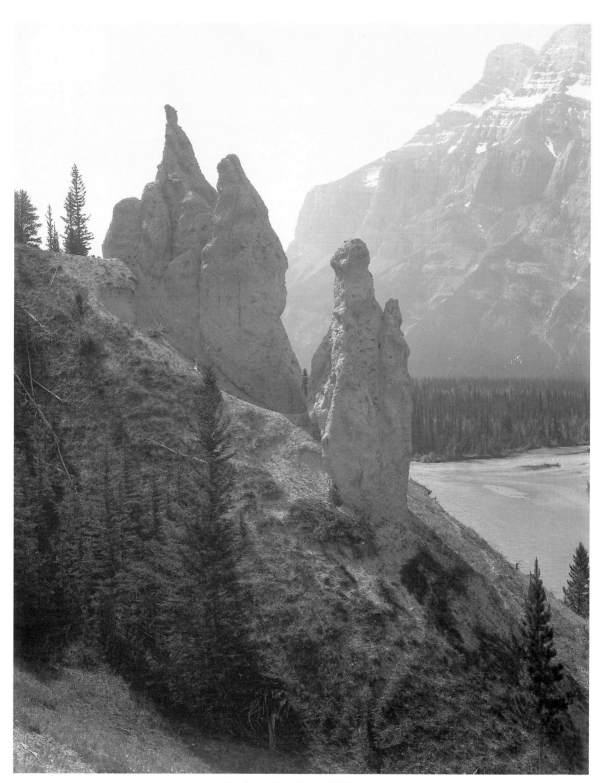

Hoodoos, Bow River Valley, AB
HARRY POLLARD / 1920s
PROVINCIAL ARCHIVES OF ALBERTA P.6767

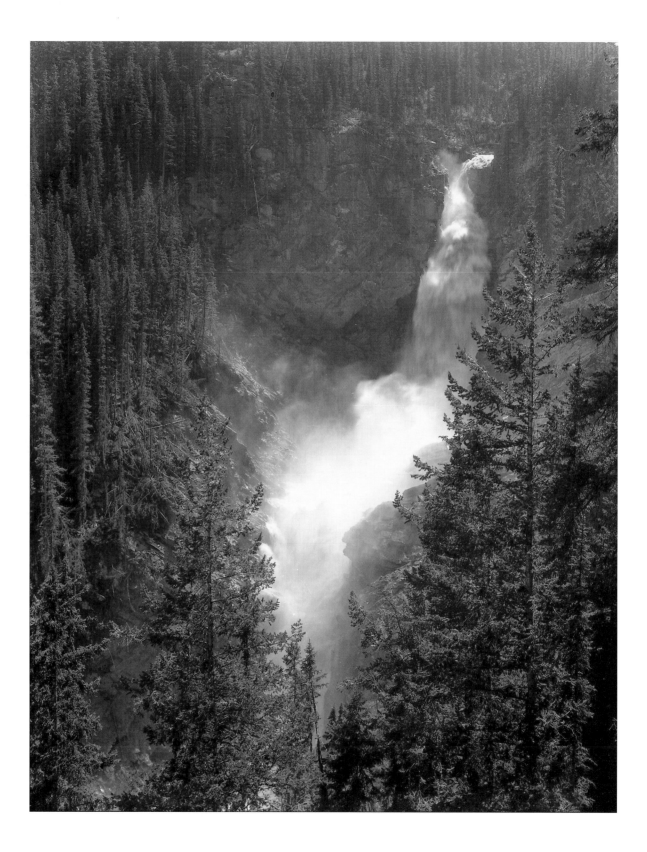

Mount Stephen and Kicking Horse Valley, BC
VAUX FAMILY / JULY 1899
WHYTE MUSEUM OF THE CANADIAN ROCKIES V653 NG-4-517

OPPOSITE
Horsethief Creek Falls, BC
Starting in the Selkirk Mountains, the creek empties with a dramatic drop into the Columbia River
north of what is now Invermere.
HARRY POLLARD / 1920s
PROVINCIAL ARCHIVES OF ALBERTA P.6713

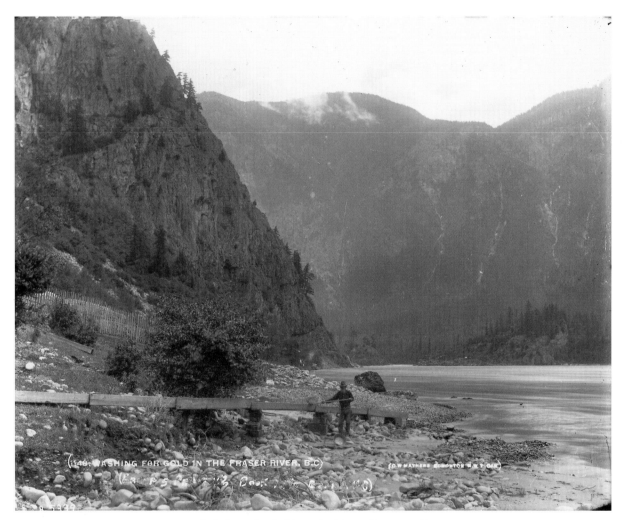

"Washing for Gold in the Fraser River, BC"
Long after the gold rush was over, hopeful miners still strained the waters of the Fraser looking for nuggets.
W. HANSON BOORNE / 1886–1891
PROVINCIAL ARCHIVES OF ALBERTA B.5339

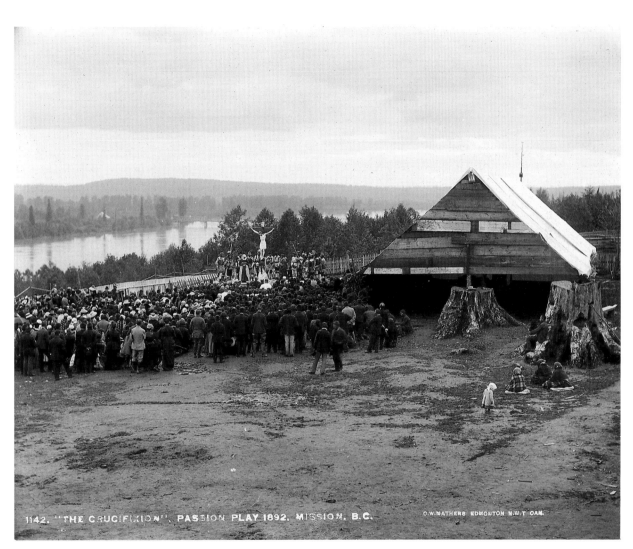

"The Crucifixion, Passion Play 1892, Mission, BC"
A religious gathering of Natives beside the Fraser River gave rise to a reenactment of the crucifixion of Jesus Christ.
W. HANSON BOORNE / AUTUMN 1892
PROVINCIAL ARCHIVES OF ALBERTA B.994

Building the Railways

BRITISH Columbia entered the Canadian Confederation in 1871 under a number of conditions. One of these was the completion of a transcontinental railway to connect the former colony to central Canada. The original survey was carried out in 1871-72 under the supervision of Sanford Fleming. Eleven different routes were examined before a recommendation was made to go through the Yellowhead Pass. (It was later decided to take a more southerly route.)

It was not until 1880, however, and after a series of complaints from the government of British Columbia, that construction started on the Fraser Valley section. Under the management of Andrew Onderdonk, the project took four years and immense amounts of money, not to mention numerous human casualties. Between Yale and Savona the crews had to blast out twenty-seven tunnels and 600 bridges and trestles to maintain a relatively even grade. Many portions of the old Cariboo Road were appropriated where it was suitable, without regard for the needs of wagon travellers.

The western section of the CPR continued from Savona along the southern shore of Kamloops Lake to Kamloops, then headed straight east to Chase and Salmon Arm, continuing around Shuswap Lake to Sicamous and up the Eagle River. The eastern section proceeded west from Calgary, reaching Banff in late 1883. From Banff it ran to Lake Louise, down the Kicking Horse Pass to Field, on to Golden on the Columbia River, over the Selkirks via Rogers Pass and Glacier, southwest to Revelstoke, and on to Three Valley Gap and down the Eagle River. The two lines met at Craigellachie, British Columbia, on 7 November 1885, when Sir Donald Smith drove the last spike.

In 1888 the Crowsnest & Kootenay Railway Co received a charter to ship silver and lead ores from the Kootenay mines, as well as coal from the Crowsnest Pass mines, east to prairie markets. Neither the C&KR nor its successor, the British Columbia Southern Railway, however, were able to raise the required money to extend the rail line east and thus fulfil their purpose.

In 1897, the Canadian Pacific Railway became convinced that a branch line to the south could be profitable. The company was also concerned about competition from the United States-based Great Northern Railway, which was building a branch line north from Rexford, Montana, to Fernie and Michel in BC. The CPR consequently purchased the charter of the BCSR and, with a sizeable grant from the federal government (in return for which the railway promised a lower freight rate to grain customers—the recently abolished Crow Rate), completed a line from Lethbridge through Pincher Creek, Bellevue, Coleman, Michel, Sparwood, Fernie, Elko, Wardner, and Cranbrook to Kootenay Lake. By 1900 the CPR had acquired several other small lines—such as the Columbia & Western Railway connecting to Nelson, Rossland, and Grand Forks—and soon extended all the way into the town of Midway in the Kettle Valley.

Early in the new century, a second Canadian transcontinental railway was planned. Like the CPR, it would connect the Prairies with the Pacific coast, and it would break the monopoly of the older company. In 1903 the Grand Trunk Railway—the rail giant of central Canada—formed a subsidiary called the Grand Trunk Pacific. Working hand-in-glove with the administration of Wilfrid Laurier in Ottawa, the GTP was constructed under the provisions of the

National Transcontinental Railway Bill of 1903. The new line was to follow the original 1871 survey: west from Edmonton, through Jasper and the Yellowhead Pass to Tete Jaune Cache, up the Fraser River to Fort George (now Prince George), down the Nechako and Bulkley Valleys to Hazelton at the head of the Skeena River, and downriver to Prince Rupert.

Construction started east from Prince Rupert as early as 1908. The Alberta link started west from Edmonton in 1911, and by 1912 had crossed the border to Tete Jaune Cache. The two sections were joined outside Prince George in April 1914. The Grand Trunk Pacific went into receivership in 1919,

however, and its management was taken over by the Government of Canada. In 1923 it was incorporated into a new entity, the crown corporation called Canadian National Railways.

During the years 1910–1912, keeping pace with a country-wide optimism, public sentiment was in favour of additional railways to tie the nation together. The industrial and agricultural sectors were also anxious to find additional means of transportation for their products to Pacific ports and other Canadian markets. Consequently, when William Mackenzie and Donald Mann founded the Canadian Northern Railway, a third transcontinental route did not

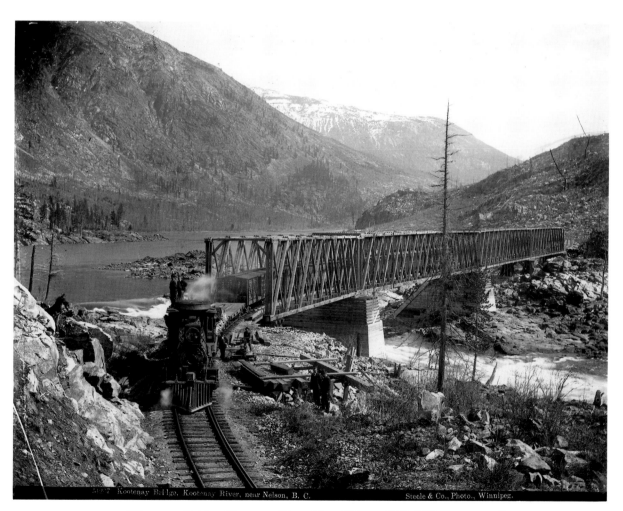

"Kootenay Bridge, Kootenay River, Near Nelson, BC"–CPR Crowsnest line
FREDERICK STEELE (FOR STEELE & CO) / 1890s
SASKATCHEWAN ARCHIVES BOARD R-B.2261

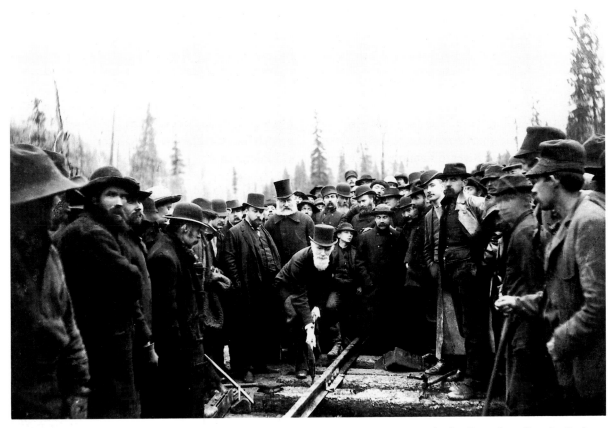

The task accomplished. Less than five years after the company was incorporated, the Canadian Pacific Railway completed its Montreal–Vancouver railway with the driving of the last spike, pictured here, at Craigellachie in Eagle Pass of the Gold Range, Rocky Mountains, at 9:30 AM, 7 November 1885. Contrary to popular belief, the spike was not a gold one. It was an ordinary iron spike, "just as good," said Sir William Van Horne, "as any of the other iron spikes which have been used to build this railway." Through rail service commenced the following July.

ALEX J. ROSS

PROVINCIAL ARCHIVES OF ALBERTA A.3996

1. Major A.B. Rogers
2. Michael J. Haney–contractor with A. Onderdonk
3. Sir William Cornelius Van Horne
4. Sir Sandford Fleming
5. Sir Donald A. Smith
6. Edward Mallandaine
7. Henry J. Cambie–engineer
8. John H. McTavish–land commissioner
9. John M. Egan–general superintendant, western division
10. James Ross–manager of construction

seem outrageous. Starting with a small obscure rail line in Manitoba, Mackenzie and Mann brought together a nation-wide system through mergers, take-overs, and government grants for new construction.

The Canadian Northern was to be routed west of Edmonton through Jasper to Tete Jaune Cache, its tracks paralleling those of the GTP through the Yellowhead Pass, at which point it veered south down the North Thompson River to Kamloops, then criss-crossed the CPR through the Fraser Valley to Vancouver. Construction began in 1910 in British Columbia and in 1911 in Alberta. By 1912 the line had been completed between Edmonton and Lucerne, BC. It was finished in 1914, the last spike driven in 1915.

The costs of construction had been raised by the sale of government guaranteed bonds, but the financial base of the railway gave way during the Great War and, like the GTP, it was incorporated into Canadian National Railways in 1923.

In 1910 another CPR branch, the Kettle Valley Railway, was created to forestall an American railway presence in southwest British Columbia. The BC government wanted in particular to be able to bring the mineral wealth of the Kootenays and the lumber and fruit of the Okanagan out to a Pacific port. The KVR began construction immediately upon receiving its charter. Starting at Hope, the line ran northwest along the Coquihalla Valley to Brodie, following much the same route

as the present Coquihalla Highway. From Brodie it veered southwest to Manning and Princeton, then northwest again to Jellicoe and Osprey Lake. Rounding the southern end of Okanagan Lake to reach Penticton, it then ran north again to Adra and Myra, south through Lois and Kettle Valley, and ended at Midway, where it connected up with the Crowsnest branch line. Completed in 1916, it ran for a total of 475 kilometres.

Although it received generous tax breaks from British Columbia, the Kettle Valley Railway was extremely expensive to build, and its costs were never recovered. Its many tunnels and long wooden trestles needed constant maintenance, and often had to be replaced entirely owing to the ravages of forest fires, washouts, and ice breakups. An unprofitable route from the beginning, it was finally closed in 1962.

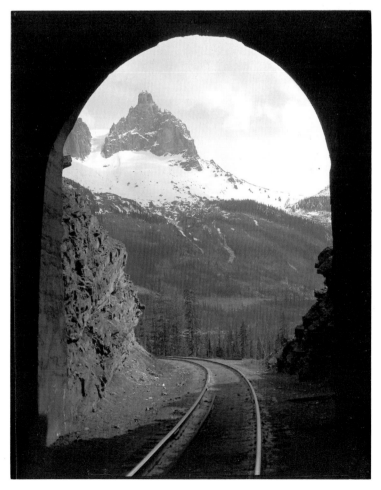

Cathedral Mountain from the entrance to the Lower Spiral Tunnel in "The Loop"–CPR line
ILLECILLEWAET VALLEY, BC
HARRY POLLARD / 1920s
PROVINCIAL ARCHIVES OF ALBERTA P.6656

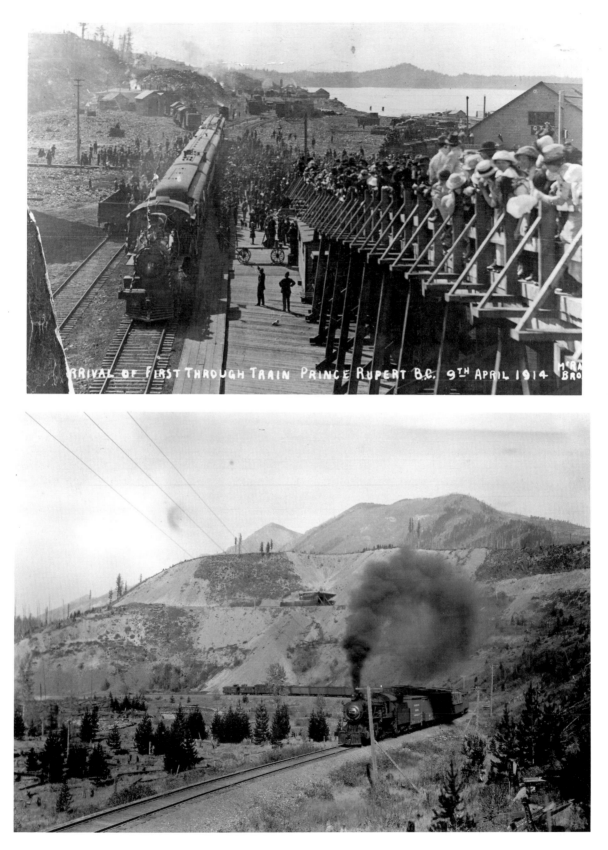

ARRIVAL OF FIRST THROUGH TRAIN PRINCE RUPERT B.C. 9TH APRIL 1914

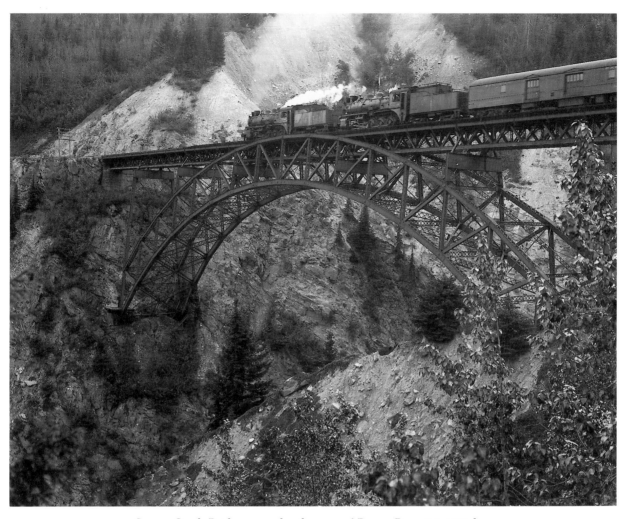

Stoney Creek Bridge, several miles east of Rogers Pass, BC, CPR line
HARRY POLLARD / 1920s
PROVINCIAL ARCHIVES OF ALBERTA P.6703

OPPOSITE TOP
"Arrival of First Through Train, Prince Rupert, BC. 9th April 1914"
PHOTOGRAPHER UNKNOWN
PROVINCIAL ARCHIVES OF ALBERTA A.21132

OPPOSITE BOTTOM
Canadian Pacific Railway train in the Crowsnest Pass, AB
BYRON HARMON / CA. 1910
WHYTE MUSEUM OF THE CANADIAN ROCKIES V263 NA-71-5757

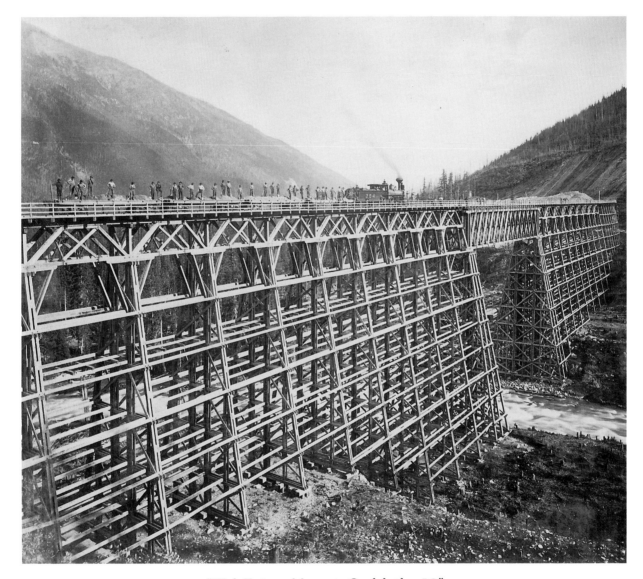

"Work Train on Mountain Creek bridge, BC"
CPR line along the Beaver Valley in the Selkirk Range
OTTO B. BUELL / 1885
CANADIAN RAILWAY MUSEUM (GLENBOW ARCHIVES NEG. NA-4967-111)

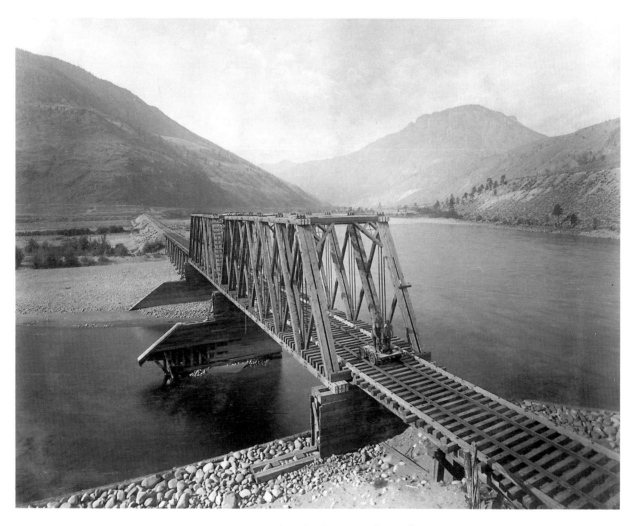

"Bridge over Nicola River, BC," CPR line
OTTO B. BUELL / 1886
CANADIAN RAILWAY MUSEUM (GLENBOW ARCHIVES NEG. NA-4967-99)

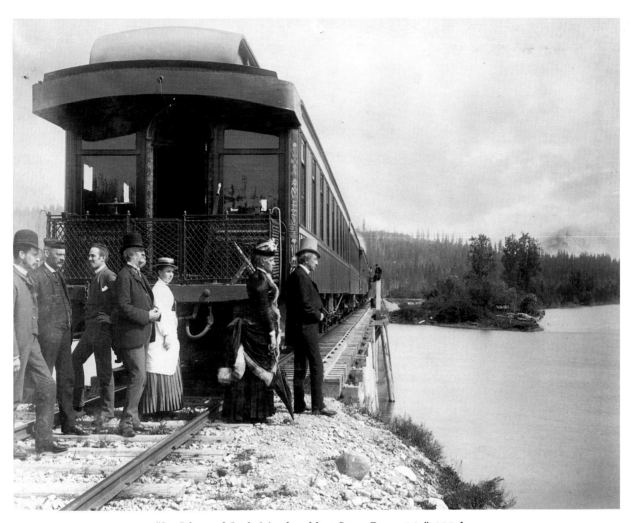

"Sir John and Lady Macdonald at Stave River, BC," CPR line
A fitting portrait of Canada's first prime minister on the railway that he fathered.
This was Macdonald's only trip to the mountains.
OTTO B. BUELL / 24 JULY 1886
CANADIAN RAILWAY MUSEUM (GLENBOW ARCHIVES NEG. NA-4967-132)

OPPOSITE
At the invitation of the Grand Trunk Pacific Railway, Sir Arthur Conan Doyle visited Jasper National Park
in June 1914. In this shot the inveterate Victorian traveller and creator of Sherlock Holmes is brandishing the
Union Jack at the summit of the Yellowhead Pass on the British Columbia–Alberta border.
PHOTOGRAPHER UNKNOWN
PROVINCIAL ARCHIVES OF ALBERTA A.2925

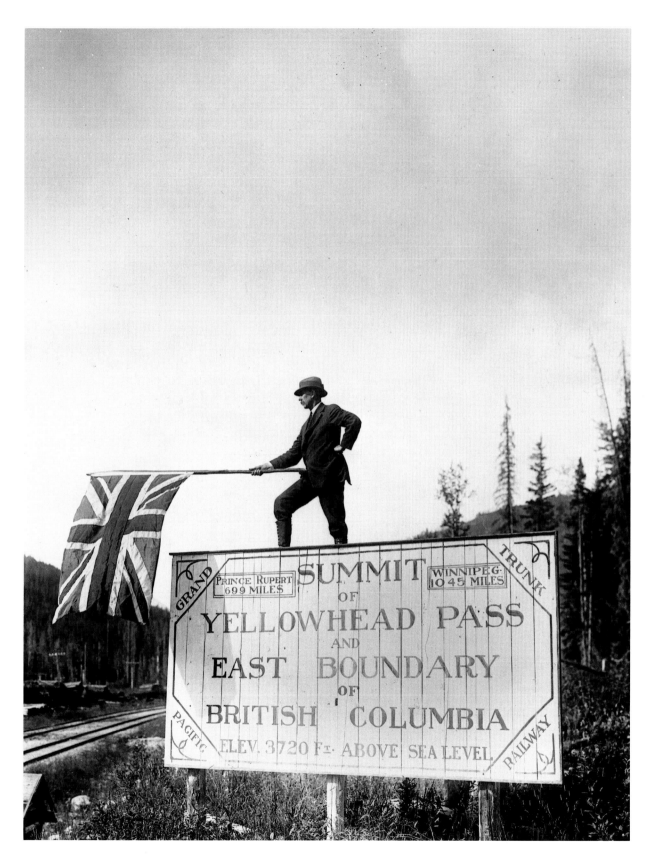

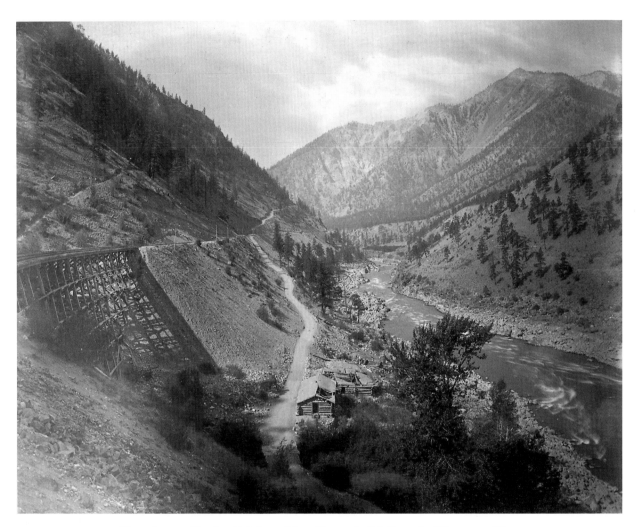

"Grasshopper Trestle, CPR Line, Near Drynoch, BC," on the Thompson River

OTTO B. BUELL / 1885

CANADIAN RAILWAY MUSEUM (GLENBOW ARCHIVES NEG. NA-4967-35)

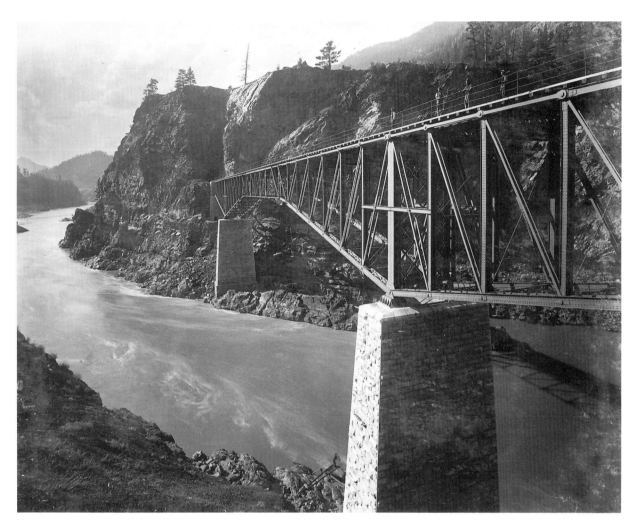

"Cantilever Bridge, Cisco, BC" crossing the Fraser River on the CPR line
The steel structure was prefabricated in the United Kingdom and shipped to Canada in 1883. The bridge
assembly was completed in June 1884.
OTTO B. BUELL / 1885
CANADIAN RAILWAY MUSEUM (GLENBOW ARCHIVES NEG. NA-4967-33)

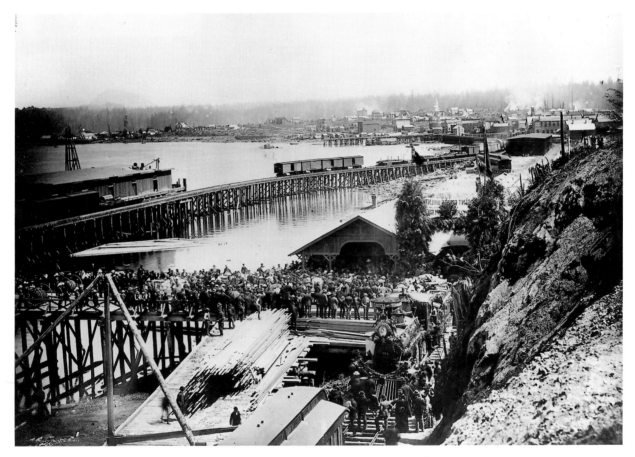

Arrival of First Transcontinental train, CPR line
PORT MOODY, BC / 23 MAY 1887
HARRY T. DEVINE
CITY OF VANCOUVER ARCHIVES CAN.P.78, N.52

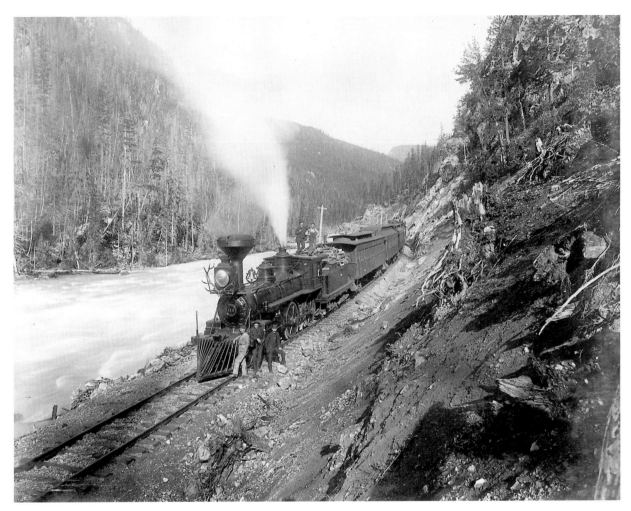

"Canadian Pacific Railway Locomotive 144 on Lower Kicking Horse near Palliser, BC," CPR line
OTTO B. BUELL / 1885
CANADIAN RAILWAY MUSEUM (GLENBOW ARCHIVES NEG. NA-4967-69)

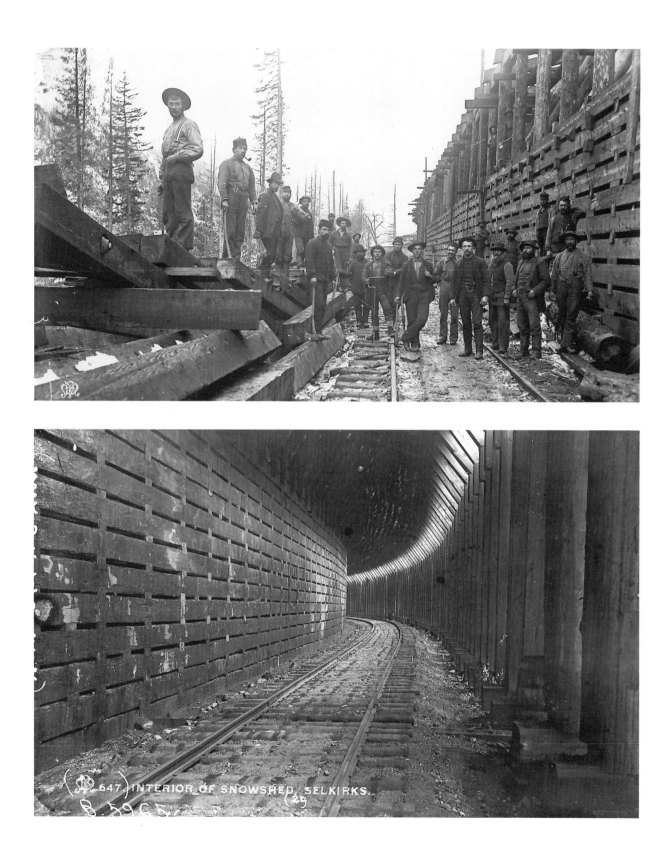

~ 66 ~

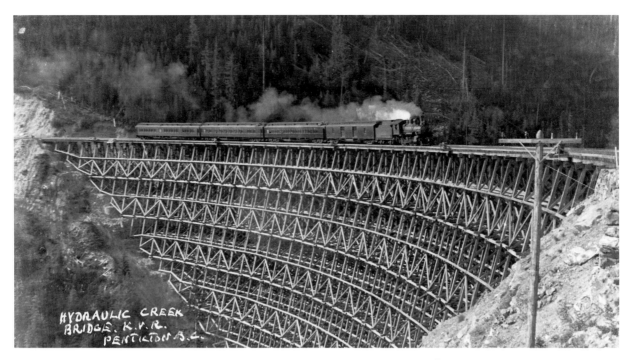

"Hydraulic Creek Bridge, KVR, Penticton, BC"
PHOTOGRAPHER UNKNOWN
PENTICTON MUSEUM AND ARCHIVES 37-2565

OPPOSITE TOP
"Snowshed Construction, Rogers Pass"–Glacier National Park, BC, CPR line
In the Rogers Pass, the average annual snowfall was 10–13 metres, which meant regular avalanches and train delays. In response, the CPR built thirty-one snowsheds between Bear Creek and the Loop at Illecillewaet–a distance of twenty-six kilometres. Most were rendered irrelevant when the Connaught Tunnel bypassed them in 1916.
W. HANSON BOORNE / 1886-1888
PROVINCIAL ARCHIVES OF ALBERTA B.6014

OPPOSITE BOTTOM
"Interior of Snowshed, Selkirks" CPR line
W. HANSON BOORNE / 1886-1892
PROVINCIAL ARCHIVES OF ALBERTA B.5965

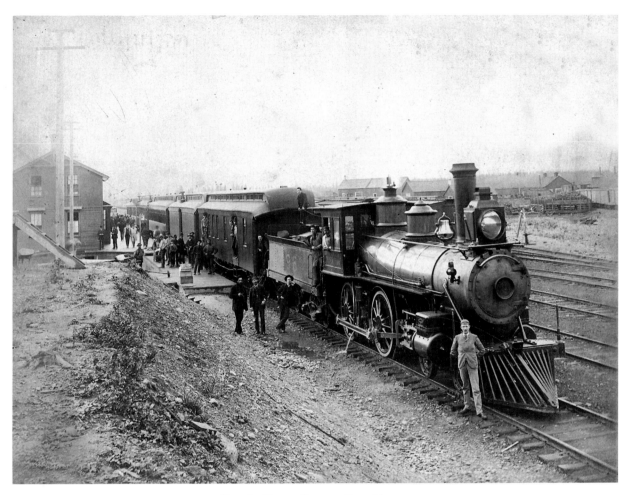

"Pacific Express"–CPR, Donald, BC
A. B. THOM / 1886
B. SILVERSIDES COLLECTION

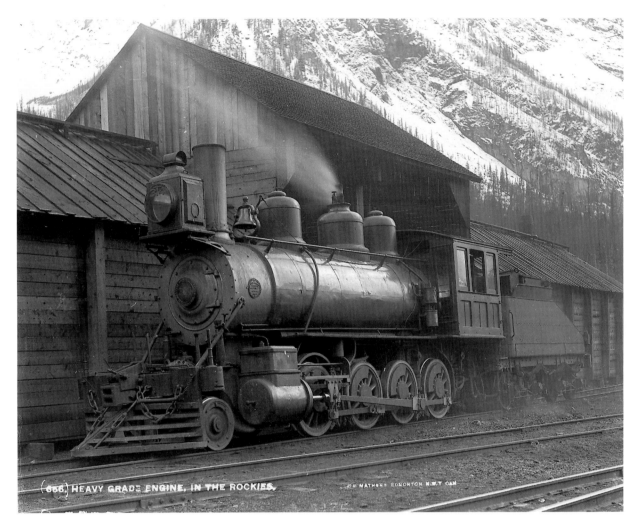

"Heavy Grade Engine, In the Rockies"
W. HANSON BOORNE / 1887–1888
PROVINCIAL ARCHIVES OF ALBERTA B.5975

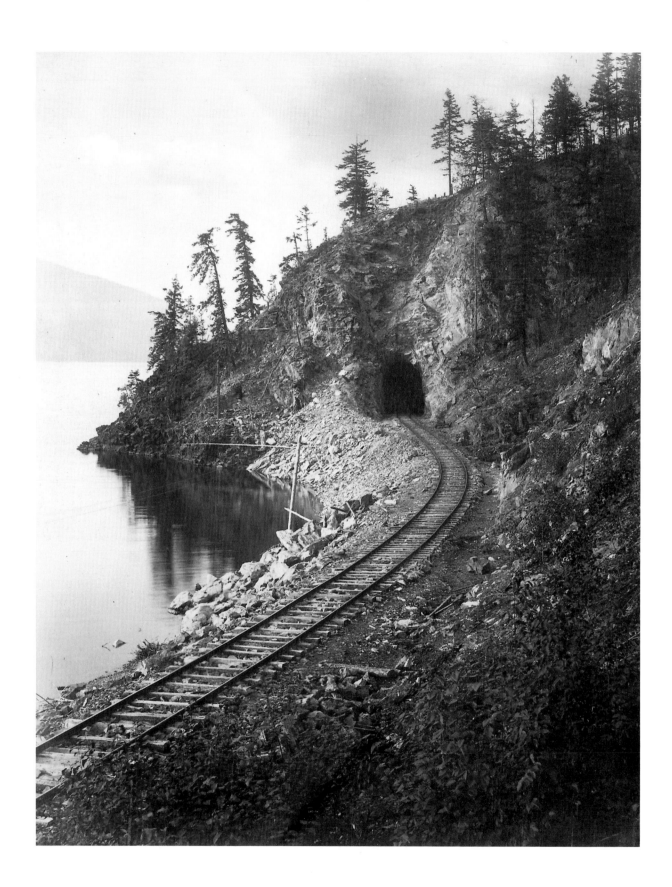

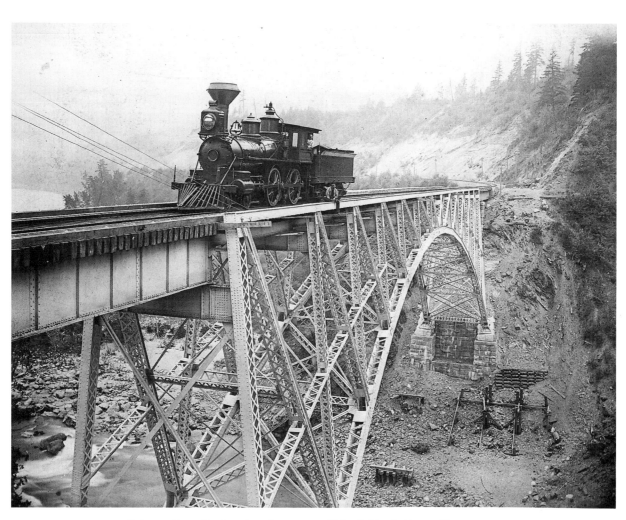

Salmon River Bridge, CPR line, east of North Bend, Fraser Canyon, BC
PHOTOGRAPHER UNKNOWN / 1892–1893
CITY OF VANCOUVER ARCHIVES OUT.P.188

OPPOSITE
"Shuswap Lake and Tunnel, BC," CPR line
OTTO B. BUELL / 1886
CANADIAN RAILWAY MUSEUM (GLENBOW ARCHIVES NEG. NA-4967-106)

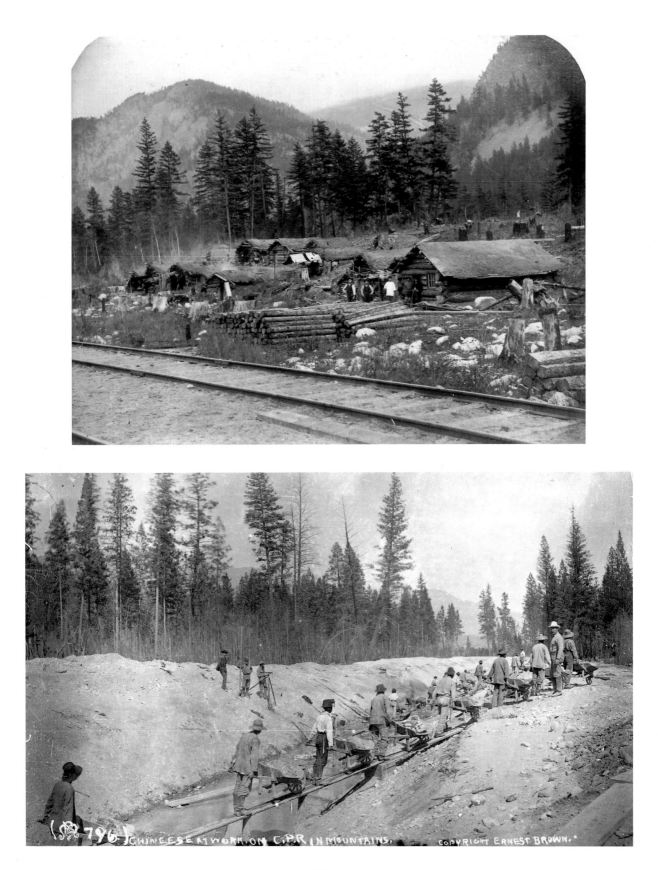

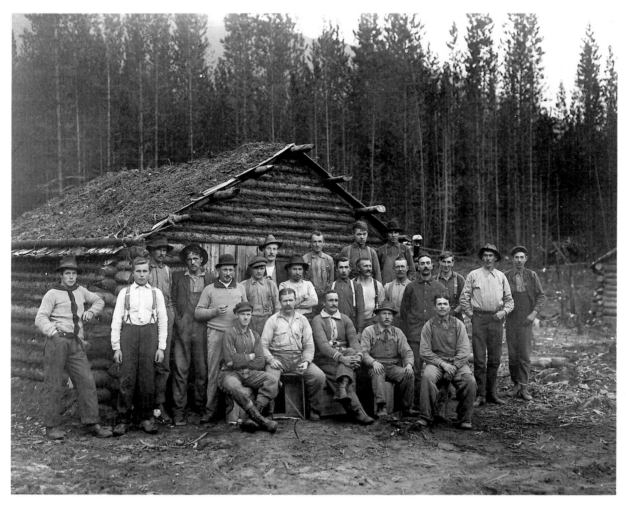

Martin Rude's station gang, Canadian Northern Railway, near Albreda, BC
PETER O. HILMO / 1913–1914
PROVINCIAL ARCHIVES OF ALBERTA A.21027

OPPOSITE TOP
"Chinese Village opposite Keefers," Fraser Canyon, BC, CPR line
PHOTOGRAPHER UNKNOWN / 1885
CITY OF VANCOUVER ARCHIVES CAN.P.140, N.107

OPPOSITE BOTTOM
"Chineese [sic] at work on CPR in Mountains," Kootenay, BC
The real heroes of the construction of the CPR were the uncounted and anonymous Chinese labourers, many
of whom were chosen for the most dangerous tasks, and frequently paid with their lives.
W. HANSON BOORNE / 1886–1892
PROVINCIAL ARCHIVES OF ALBERTA B.6022

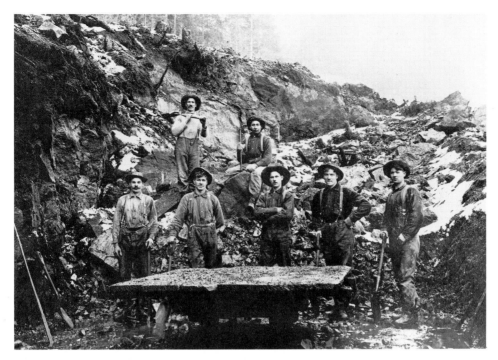

Excavating rock on railway grade, Crowsnest Pass
PHOTOGRAPHER UNKNOWN / 1897–1898
PROVINCIAL ARCHIVES OF ALBERTA A.21015

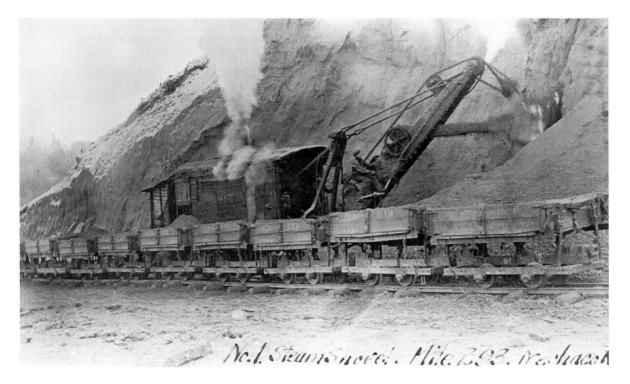

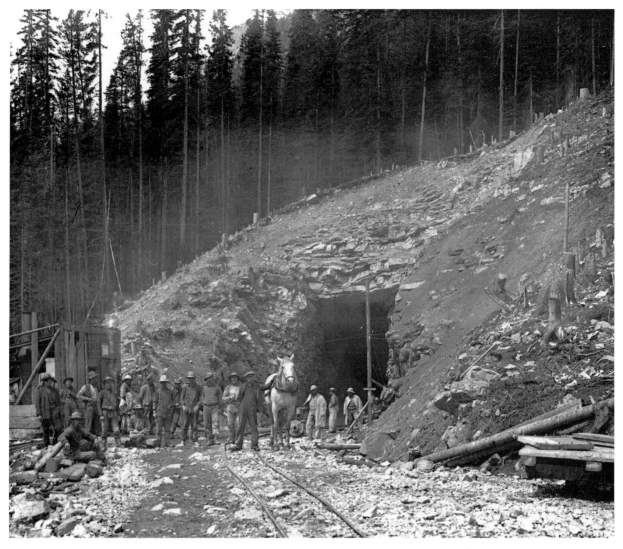

"Workmen at portal to lower Spiral Tunnel, BC," CPR line

The Spiral Tunnels were part of an engineering oddity constructed in the Illecillewaet Valley. In order to maintain a 2.2% grade while descending the west slope of the Selkirks (which could not have been done if the line had run straight) the CPR ran the tracks in an elongated figure-eight shape. Four wooden trestles were required—two over the Illecillewaet River and two over Five Mile Creek—as well as two tunnels carved out of Cathedral and Ogden Mountains.

PHOTOGRAPHER UNKNOWN / 1913-1916

GLENBOW ARCHIVES NA-4598-7

OPPOSITE

"No.1 Steamshovel, Mile 293, Nechacok," Grand Trunk Pacific line, BC

H. J. GREEN / CA. 1911

GLENBOW ARCHIVES NA-915-19

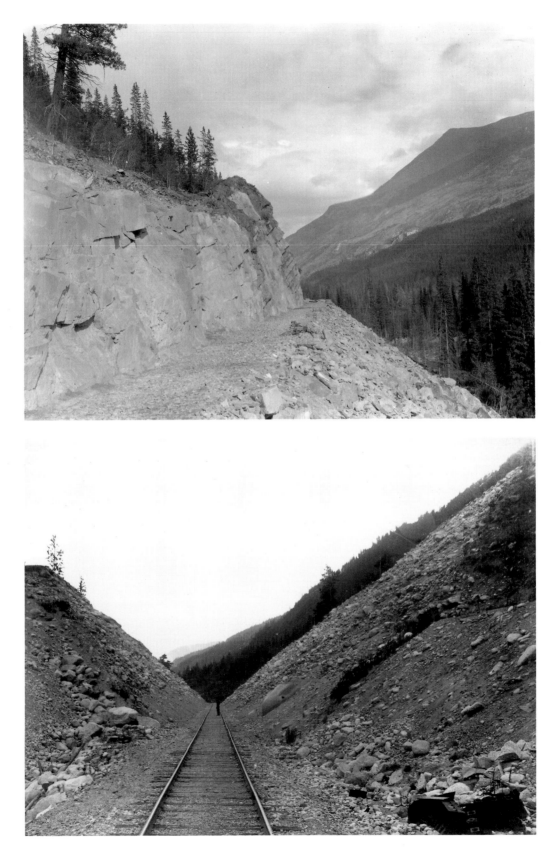

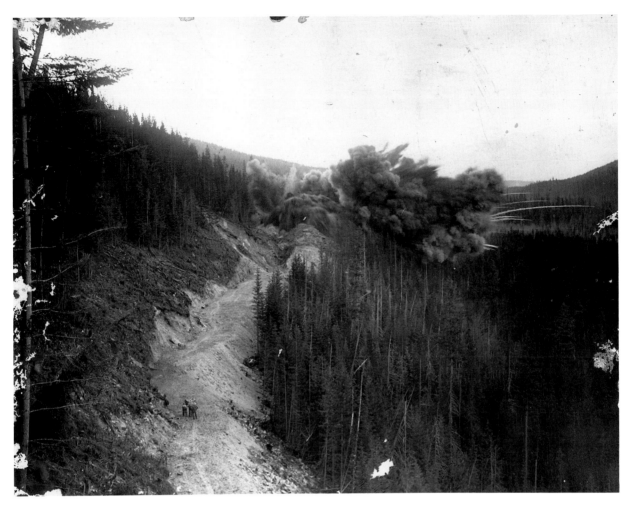

"Big Blast of 750 kegs black powder and dynamite"
Construction of Canadian Northern Railway, Camp 69 near Conor River, BC.
PETER O. HILMO / 1913-1914
PROVINCIAL ARCHIVES OF ALBERTA A-21023

OPPOSITE TOP
Clearing the grade for the Grand Trunk Pacific line, near Yellowhead Pass, AB
BYRON HARMON / 1911
WHYTE MUSEUM OF THE CANADIAN ROCKIES V263 NA-71-1214

OPPOSITE BOTTOM
"The Quoi Ek Cutting, 55 feet Deep"
This excavation was made by Chinese labourers carrying baskets on their heads.
PHOTOGRAPHER UNKNOWN / 1885
CITY OF VANCOUVER ARCHIVES CAN.P.145, N.112

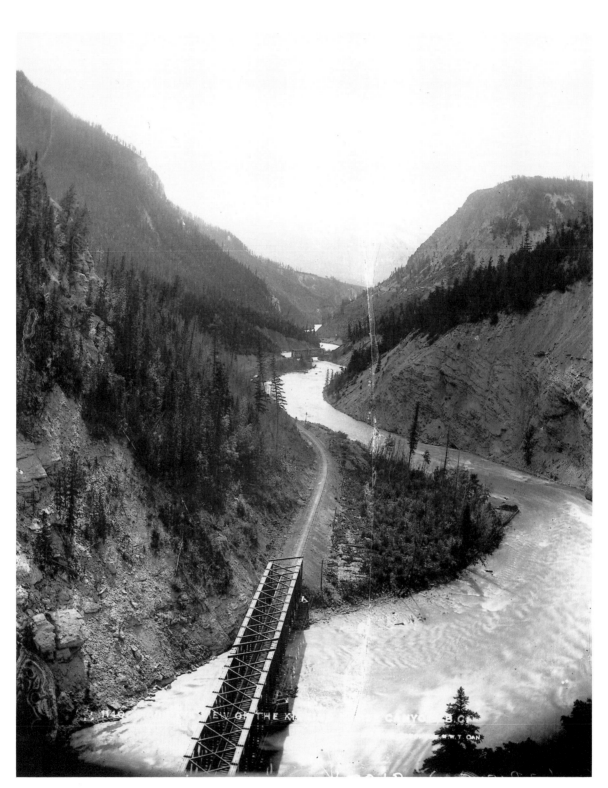

"Bird's Eye View of the Kicking Horse Canyon, BC"–CPR line
W. HANSON BOORNE / 1886–1891
PROVINCIAL ARCHIVES OF ALBERTA B.7018

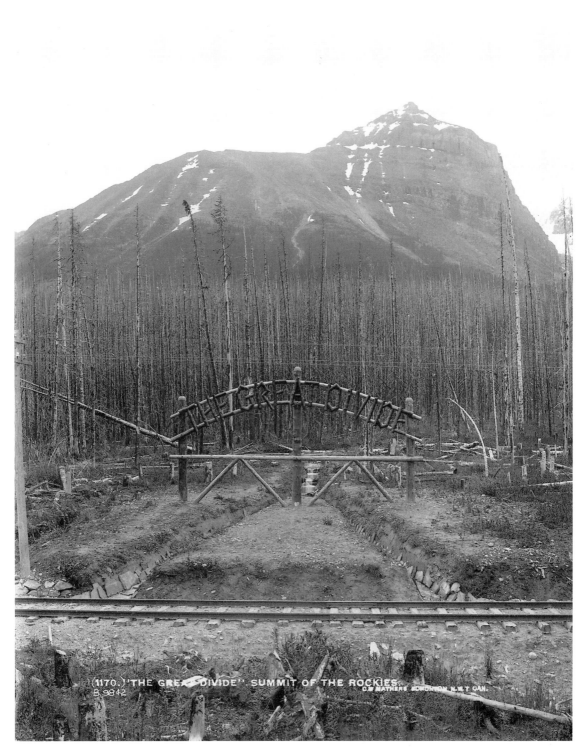

"The Great Divide, Summit of the Rockies"–CPR line just west of Lake Louise on Mount Niblock
At this location (altitude 1,625 metres) a small stream divides in two: one branch eventually empties into
the Pacific Ocean, the other into Hudson Bay. It also marks the Alberta–British Columbia border.
W. HANSON BOORNE / 1886–1892
PROVINCIAL ARCHIVES OF ALBERTA B.9842

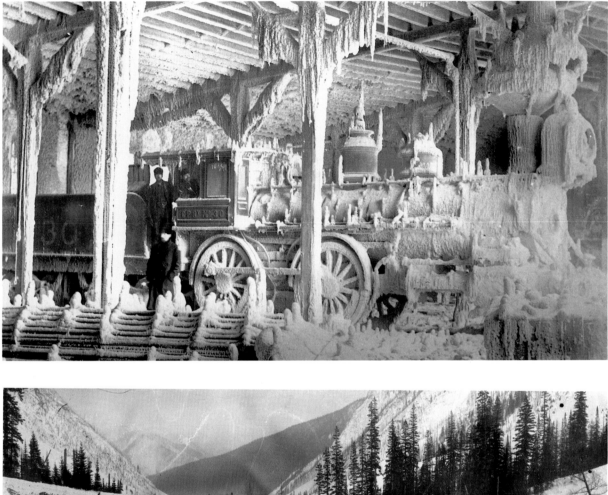

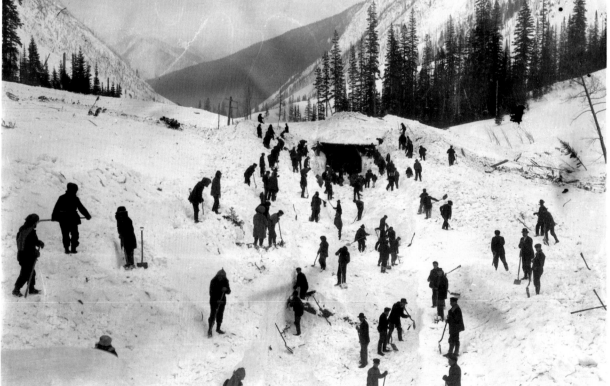

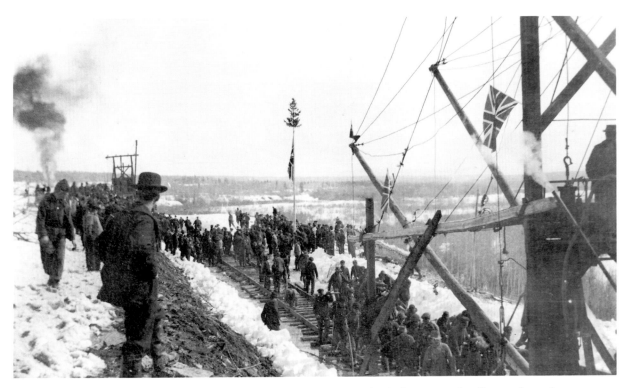

The eastern and western sections of the Grand Trunk Pacific Railway were finally joined together
1½ kilometres east of Fort George (now Prince George, BC) on 7 April 1914
PHOTOGRAPHER UNKNOWN
GLENBOW ARCHIVES NA-3658-101

OPPOSITE TOP
A frozen CPR locomotive in the roundhouse of Rogers Pass, BC
PHOTOGRAPHER UNKNOWN / 1883
COURTESY CANADIAN PACIFIC LTD

OPPPOSITE BOTTOM
Clearing avalanche for CPR line in the Selkirk Mountains, at Snowshed #14, BC
BYRON HARMON / 5 MARCH 1910
WHYTE MUSEUM OF THE CANADIAN ROCKIES V263 NA-71-6123

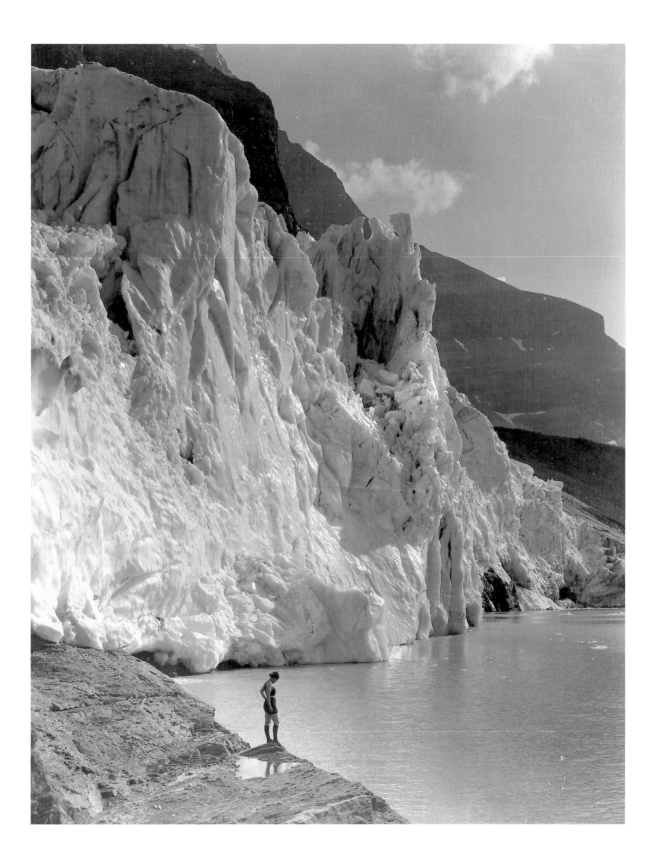

The National Parks and Tourism

THERE are seven national parks in the western mountains. Mount Revelstoke, Glacier, Yoho, and Banff are on the main line of the Canadian Pacific Railway; Kootenay National Park follows the Banff-Windermere Highway; Waterton Lakes abuts the British Columbia and Montana borders in Alberta; and Jasper follows the Athabasca river system.

Banff was the first national park set aside by the federal government. Situated entirely in Alberta, it started in 1885 as twenty-six square kilometres surrounding the Cave and Basin Hot Springs. Its status was made official by the Rocky Mountains Park Act of 1887. The forest reserve surrounding Lake Louise and part of the Kananaskis Valley was added in 1902, and at present the park takes in some 6,640 square kilometres. Its name was changed from Rocky Mountains Park to Banff National Park in 1930. Its attractions are well known, from Mount Rundle to the Beehive, from Lake Louise to the Bow River, Johnson Canyon, Crowfoot Glacier, and the Valley of the Ten Peaks.

Yoho National Park, located immediately west of the Continental Divide and touching the western boundary of Banff National Park, began in 1886 as a small reserve around Mount Stephen and the town of Field, British Columbia. In 1911 it was expanded to include the Kicking Horse Pass. Its administrative centre was Field, and the CPR provided the first tourist accommodations at Mount Stephen Lodge, Yoho Camp, and Emerald Lake Lodge.

Yoho, a Cree word meaning "awe," or "how wonderful," includes among its attractions Canada's highest waterfall, Takakkaw, as well as Laughing Falls and Twin Falls; Mount Burgess and Mount Stephen, among other peaks, Emerald Lake, the Kicking Horse Canyon, the Natural Bridge, and the twenty-three-kilometre Yoho Valley leading up to the Yoho Glacier.

Glacier National Park, west of Yoho, is centred around Rogers Pass in the Selkirks. It was founded in 1886 when two smaller reserves were joined, and expanded in 1903. It now comprises some 1,350 square kilometres. There are roughly 400 glaciers within the boundaries of the park and half a dozen well-known peaks, including Mount Sir Donald, Mount Abbott, and Mounts Castor and Pollux. Other attractions include the Illecillewaet and Asulkan Valleys.

Waterton Lakes National Park was created in 1895 as a forest reserve, and upgraded to national park status in 1911. It takes in 525 square kilometres, and sits entirely within Alberta. It borders on the continental divide to the west and the American Glacier National Park to the south. In 1932 it was united with Glacier to form the world's first international peace park. Originally called Omoksikimi by the Kootenay Indians, it was first mapped in 1858

OPPOSITE
Tumbling Glacier and Berg Lake, at the base of Mount Robson, BC
HARRY POLLARD / 1924
PROVINCIAL ARCHIVES OF ALBERTA P.10365

by Thomas Blakiston, a member of the Palliser Expedition, and subsequently renamed after the English naturalist Charles Waterton.

Aside from the Upper, Middle, and Lower Waterton Lakes, each running to depths of 150 metres, the park also contains Mount Vimy and four other notable peaks, as well as the Hell Roaring Canyon and Akamina Pass. In the early 1900s, southern Alberta's first oil well was drilled near Cameron Creek within what was to become the park boundaries. A settlement grew up there called Oil City, but it was soon eclipsed by the Turner Valley finds.

Jasper National Park, based around the headwaters of five great rivers—the Saskatchewan, the Athabasca, the Thompson, the Columbia, and the Fraser—was set aside in 1907. The park is located on the eastern slope of the Rocky Mountain Range and takes in some 10,878 square kilometres of territory. Although it is entirely in Alberta, it is bordered on the west by two British Columbia provincial parks: Hamber and Mount Robson.

The park was named after Jasper Hawse, who established a trading post near the present site of Jasper in the first decade of the nineteenth century. The Grand Trunk Pacific and Canadian Northern Railways serviced the site up to the 1920s; it has been on the Canadian National line since 1923. Its attractions include Mount Edith Cavell, at 3,363 metres the highest in the park, the Columbia Ice Fields, and Emperor Falls.

Mount Revelstoke National Park, just eighteen kilometres west of Glacier National Park, was established in 1914. Situated around the peak of Mount Revelstoke in the Selkirk range, it is the highest national park in Canada. Its western border touches on the city of Revelstoke while its southern border is the Illecillewaet River. It is small, a mere 263 square kilometres, and from the start its emphasis has been on snow sports, particularly downhill skiing.

Kootenay National Park, created in 1920 as Canada's tenth federal reserve, is situated entirely within British Columbia on the western slope of the Rocky Mountains. Sixteen kilometres wide and nearly 100 long, it was the first mountain park deliberately attached to a road—the Banff-Windermere Highway—rather than a railway. Its eastern and northern boundaries abut Banff National Park and Yoho National Park, respectively, while its southern tip runs into the Windermere Valley. Its attractions include the Vermilion and Kootenay Rivers, the Marble and Sinclair Canyons, and Radium Hot Springs.

These national parks have become the best guarantee that unspoiled scenery and the natural mountain habitat will continue to be a subject for the photographers of western Canada for a long time to come.

OPPOSITE
"Lake Louise & Chalet From the Road," Banff National Park, AB
Lake Louise was first charted in 1882 by Tom Wilson, who named it Emerald Lake.
The first hotel in this location was a ten-person log bungalow built by the CPR in 1890.
It burned down in 1893.
W. HANSON BOORNE / 1891
PROVINCIAL ARCHIVES OF ALBERTA B.9785

(1179) LAKE LOUISE & CHALET FROM THE ROAD. G. WEATHERS EDMONTON ALB'T CAN.
B. 9785

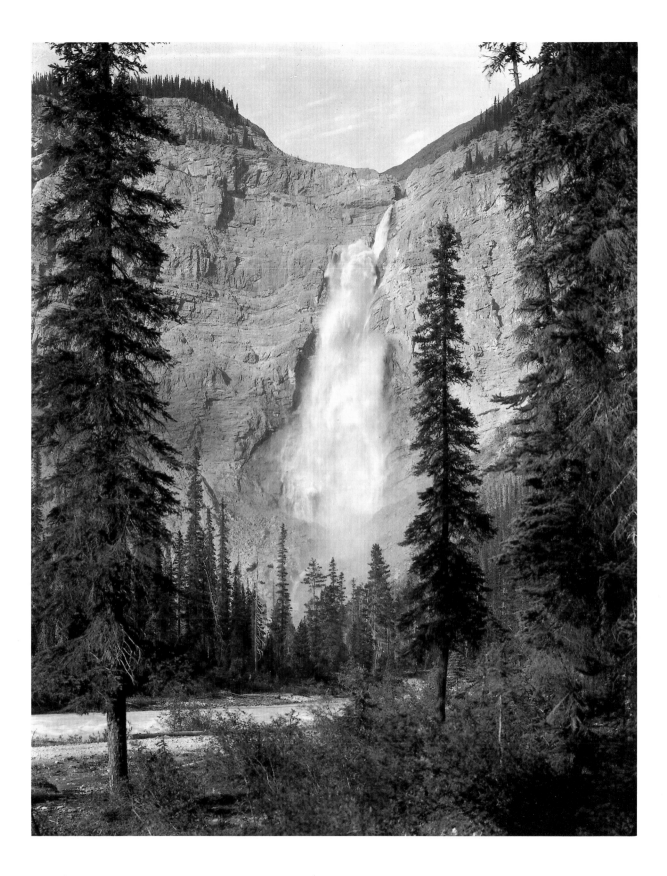

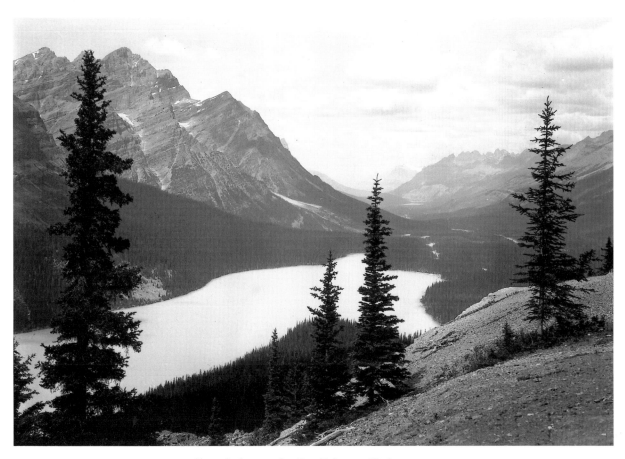

Peyto Lake, on the Banff–Jasper Highway, AB
HARRY POLLARD / 1930s
PROVINCIAL ARCHIVES OF ALBERTA P.6599

OPPOSITE
Takakkaw Falls, Yoho National Park, BC
These falls, the highest in North America (at 460 metres they are eight times the height of Niagara),
have been a staggering site for tourists for over a century.
HARRY POLLARD / 1915
PROVINCIAL ARCHIVES OF ALBERTA P.6634

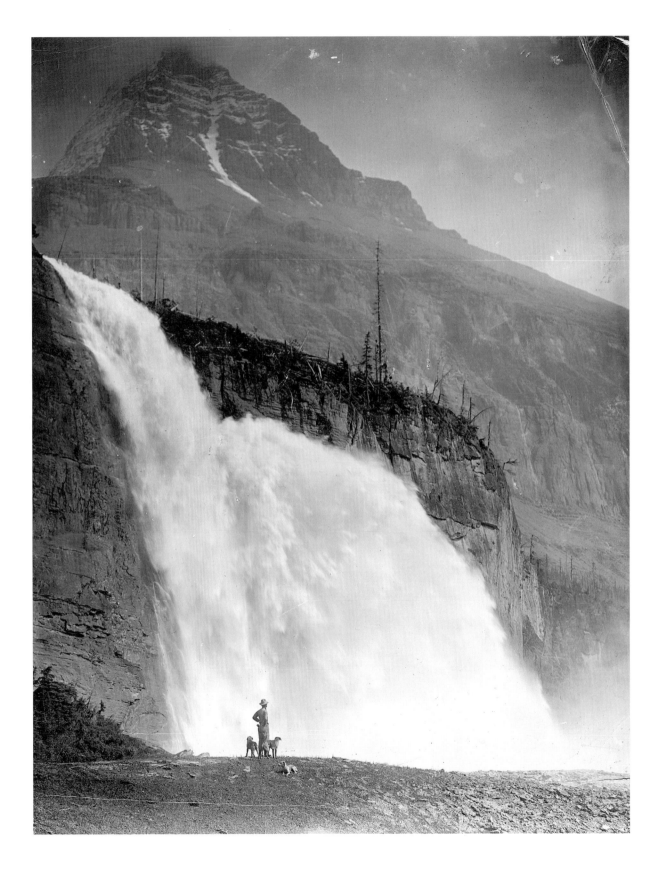

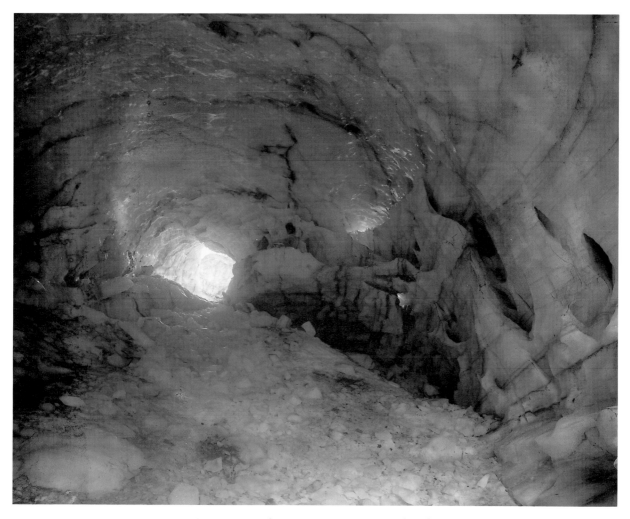

Ice Cave, near Lake Louise, Banff National Park, AB
HARRY POLLARD / 1930s
PROVINCIAL ARCHIVES OF ALBERTA P.6742

OPPOSITE
Emperor Falls, Jasper National Park, AB
R. LETT / CA. 1920
B. SILVERSIDES COLLECTION

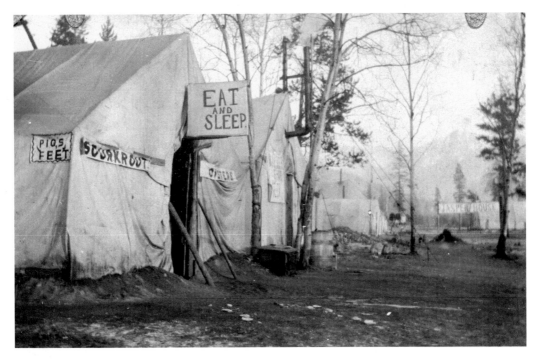

Jasper was originally a community of tents at the confluence of the Miette and Athabasca Rivers. The tents, all intended for tourists (at $2.50 a day) were erected by the Grand Trunk Pacific Railway with the assistance of the Edmonton Tent and Mattress Company.
EDGAR SPURGEON / SUMMER 1915
GLENBOW ARCHIVES NA-1679-12

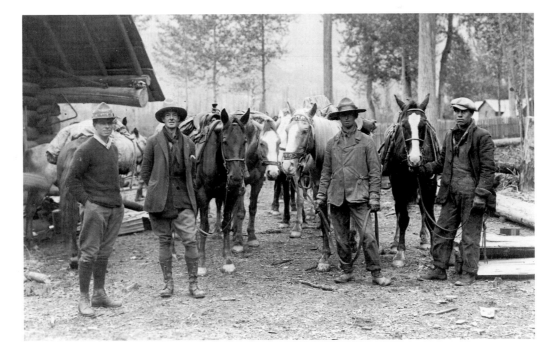

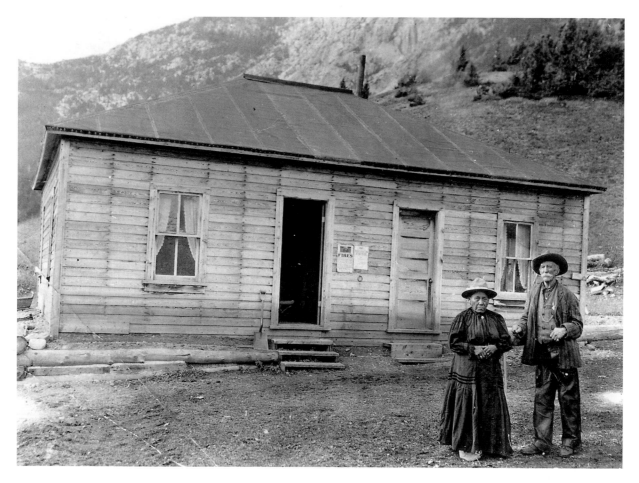

John George "Kootenai" Brown and his wife, Cheepaythaquaka, outside their home in Waterton Lakes National Park, AB. Brown, a born and bred Englishman (he graduated from Eton and Oxford) married into and adopted the Indian culture. He first saw the Waterton Lakes—then known as the Kootenay Lakes—in 1865 and knew this was his home. He subsequently became the first warden and later superintendent of the park. He was remembered as "a clean fighter, a straight shot, loyal to his friends, respected by his enemies, ready to face any danger, hardship or deprivation without a murmur, and to defend the region . . . from the ruthless attack of poacher and vandal."

PHOTOGRAPHER UNKNOWN / 1910-1916

GLENBOW ARCHIVES NA-2373-5

OPPOSITE

Pack Horse Outfit, including left to right, Curly Phillips, Dick Dickenson, Al Norris, Dave Moberly

JASPER NATIONAL PARK, AB / CA. 1919

GLENBOW ARCHIVES NA-445-12

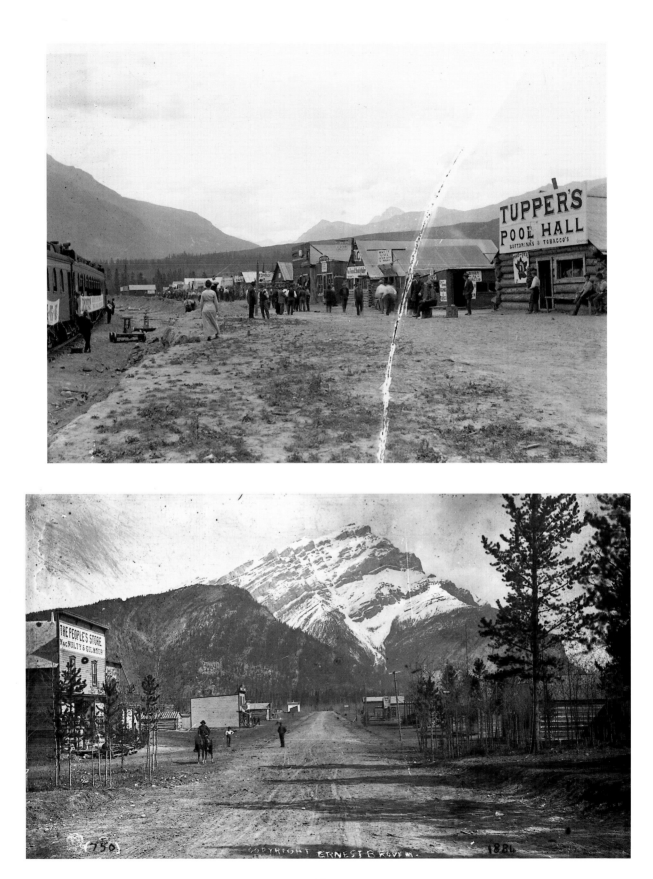

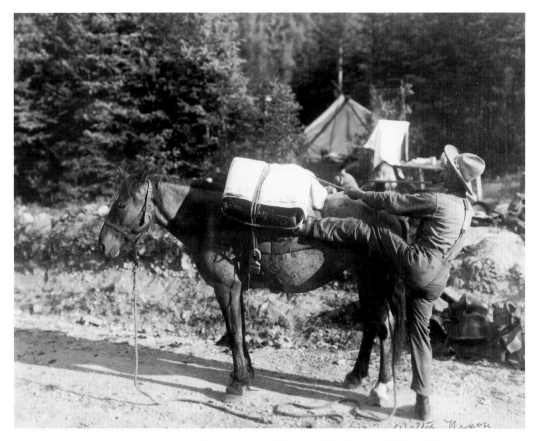

Walter Nixon, guide, secures pack horse, Windermere Valley, BC
PHOTOGRAPHER UNKNOWN / N.D.
GLENBOW ARCHIVES NA-1135-56

OPPOSITE TOP
Jasper Townsite, Jasper National Park, AB
Situated near the confluence of the Athabasca and Miette rivers, Jasper was not only the administrative centre
of the national park, but it also became a divisional point on the Grand Trunk Pacific Railway.
ERNEST BROWN / 1912–1914
PROVINCIAL ARCHIVES OF ALBERTA B.6140

OPPOSITE BOTTOM
"Banff Avenue, Looking N," with Cascade Mountain in rear, Banff National Park, AB
W. HANSON BOORNE / 1887
PROVINCIAL ARCHIVES OF ALBERTA B.2396

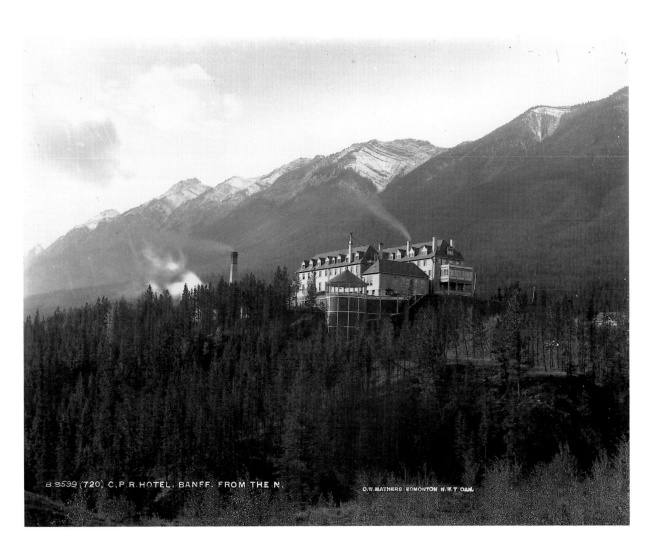

"CPR Hotel, Banff, From the N," Banff National Park, AB
The stately Banff Springs Hotel, located at the confluence of the Bow and the Spray Rivers, was started
in 1886 and was opened to the public on 1 June 1888. With 250 rooms, it was the largest hotel
in the world at the time. It was enlarged to 500 rooms in 1903.
W. HANSON BOORNE / 1888–1889
PROVINCIAL ARCHIVES OF ALBERTA B.9599

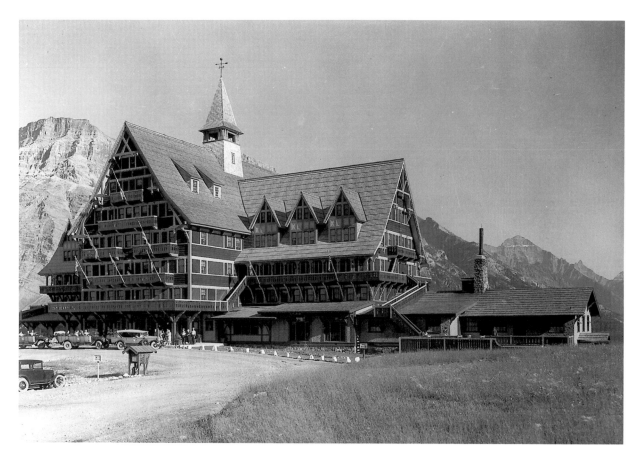

Prince of Wales Hotel, Waterton Lakes National Park, AB
PHOTOGRAPHER UNKNOWN / CA. 1930
GLENBOW ARCHIVES NB-32-4

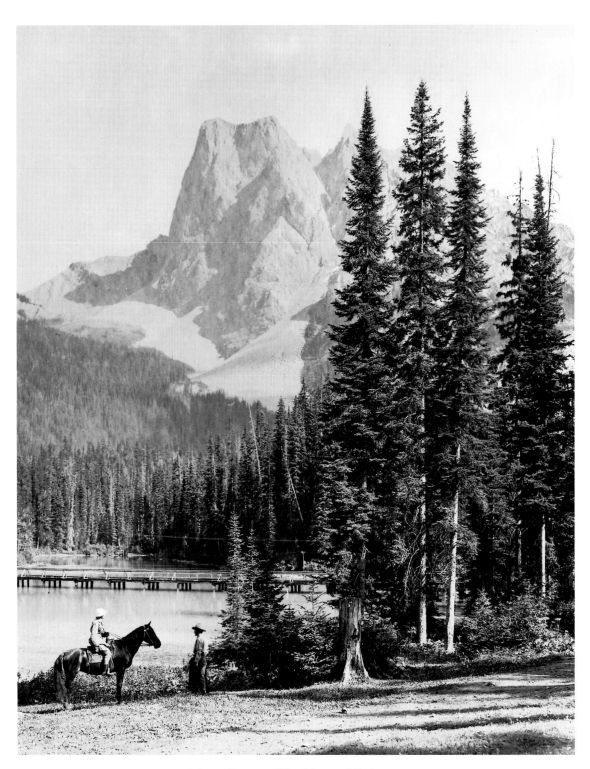

Mount Burgess, Yoho National Park, BC
PHOTOGRAPHER UNKNOWN / 1920s
GLENBOW ARCHIVES NA-4917-17

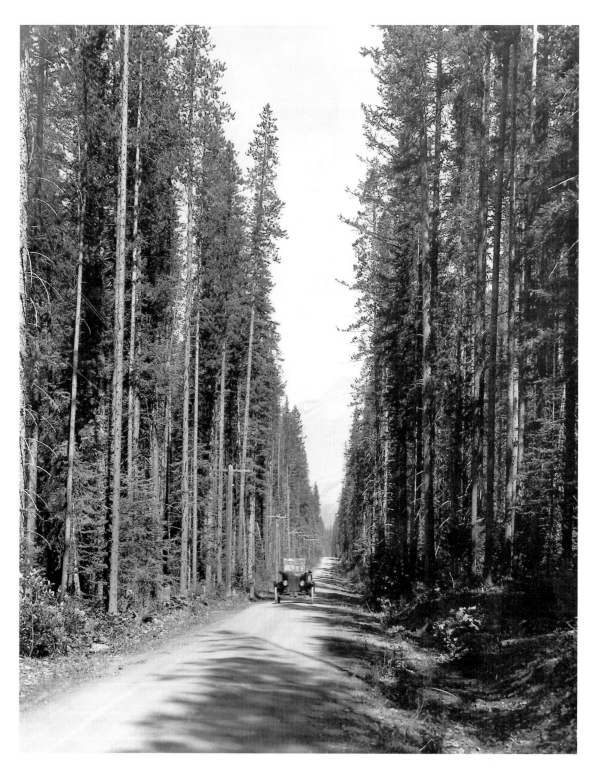

Automobile on Snowpeak Avenue, the road between Field and Emerald Lake
which was cut through primeval forest. Yoho National Park, BC.
PHOTOGRAPHER UNKNOWN / 1920S
GLENBOW ARCHIVES NA-4917-21

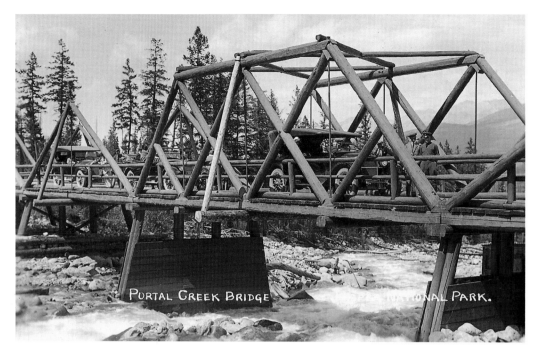

"Portal Creek Bridge, Jasper National Park," AB
F. H. SLARK / CA. 1920
B. SILVERSIDES COLLECTION

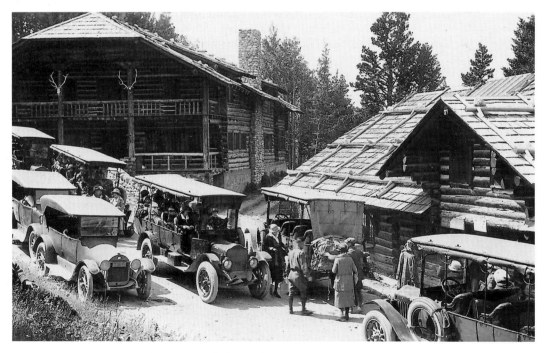

"St. Mary Chalets, Glacier National Park," BC
PHOTOGRAPHER UNKNOWN / CA. 1925
B. SILVERSIDES COLLECTION

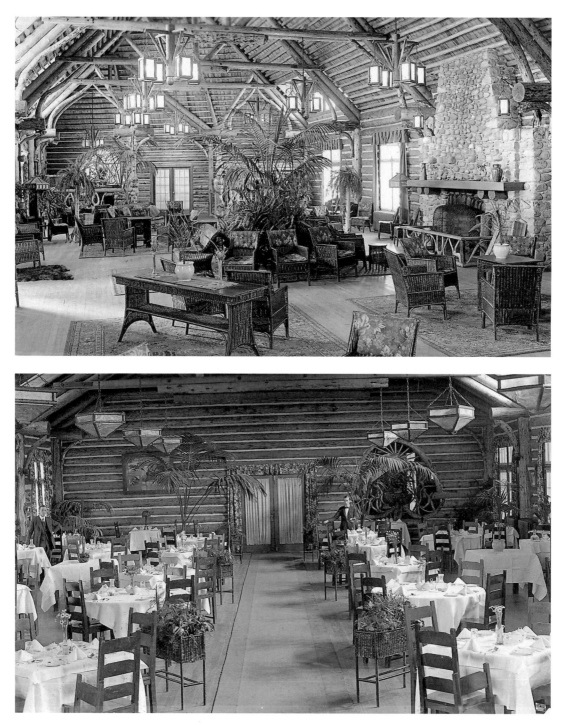

These two images show the combination of rustic and luxurious ambience of the Jasper Park Lodge, Jasper National Park, AB. The lodge, a main log building surrounded by outlying cabins of varying sizes, was constructed by Canadian National Railways. Situated on the shores of Lac Beauvert, it was opened in June 1922 and expanded in 1928 to keep up with the tourist boom.

F. H. SLARK / 1922

PROVINCIAL ARCHIVES OF ALBERTA A.5004 / A.5001

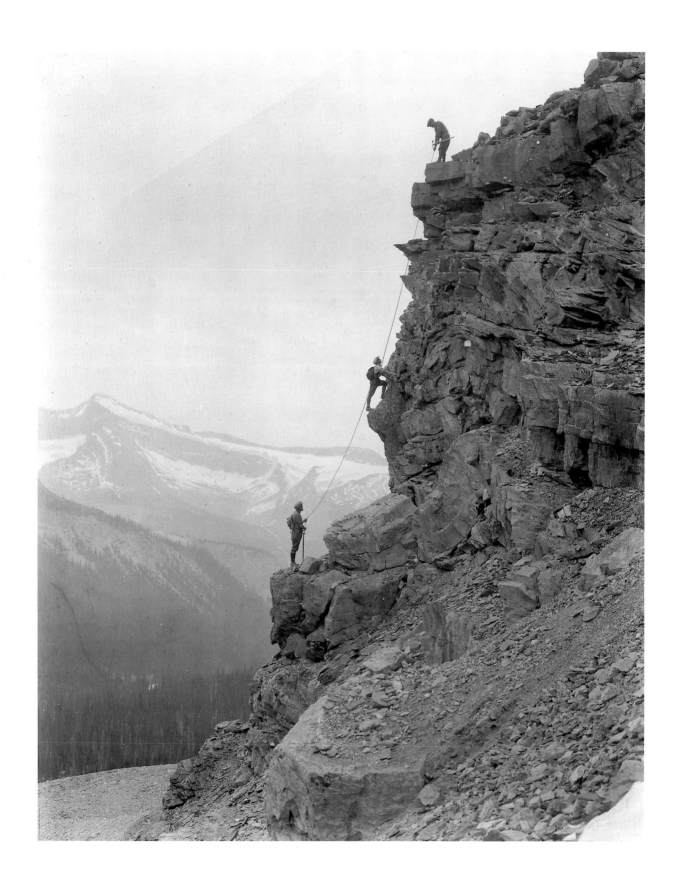

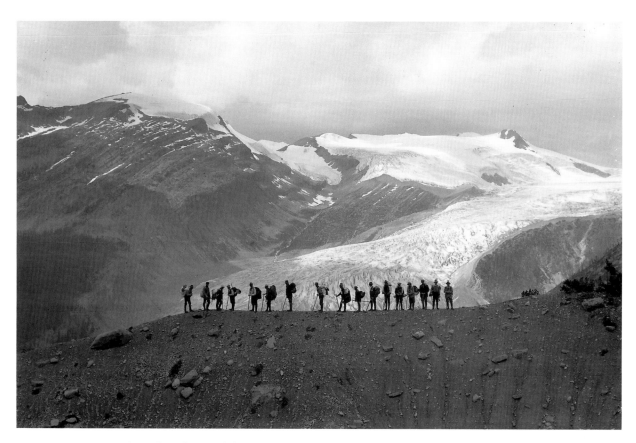

A group from the Alpine Club of Canada, climbing Yoho Glacier, Yoho National Park, BC
BYRON HARMON / CA. 1919
WHYTE MUSEUM OF THE CANADIAN ROCKIES V263 NA-71-153

OPPOSITE
Members of the Alpine Club of Canada halfway up a mountain–a precarious position
for both climbers and photographer
HARRY POLLARD / 1920
PROVINCIAL ARCHIVES OF ALBERTA P.5013

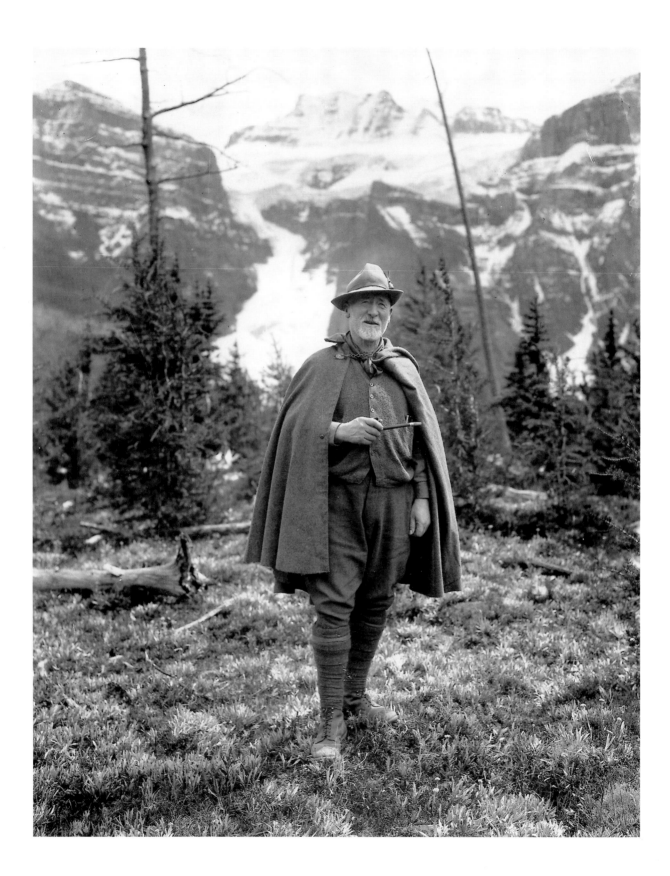

Five members of Alpine Club of Canada, expedition to Consolation Alley
BYRON HARMON / 1910
WHYTE MUSEUM OF THE CANADIAN ROCKIES V263 NA-71-0083

OPPOSITE
A candid portrait of Arthur O. Wheeler, known as "the old man of the mountains." A member of the Dominion Lands Survey, he carried out extensive photogrammetry in the Crowsnest Pass and in the Selkirk Mountains in 1900 and 1901. To do so, he had to learn how to climb. Educated by Swiss guides, Wheeler became so enthusiastic about climbing that he founded the Alpine Club of Canada in 1906, and went on to participate in the Alberta–British Columbia Boundary Commission from 1913–1924.
HARRY POLLARD / 1920
PROVINCIAL ARCHIVES OF ALBERTA P.5018

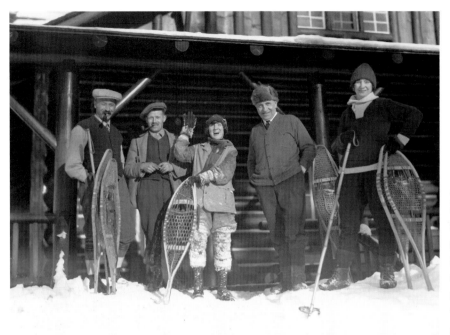

*Banff National Park, AB
Snow was obviously good news
to these mountain visitors. A
good fall meant that they could
indulge in their favourite
winter activity–snowshoeing.*
GEORGE NOBLE / CA. 1920
WHYTE MUSEUM OF THE
CANADIAN ROCKIES V469-1346

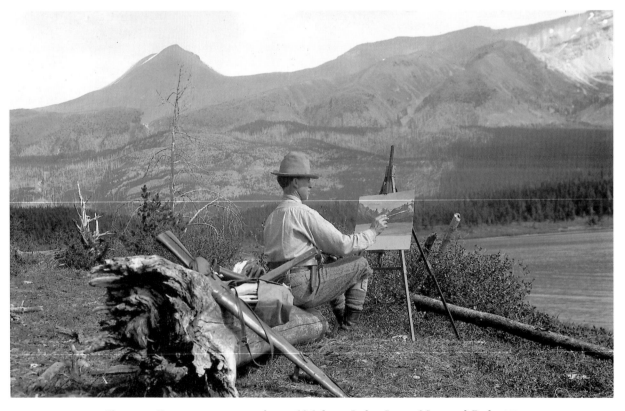

*Phimister Proctor painting on shore of Maligne Lake, Jasper National Park, AB
Alpine Club of Canada expedition to Mount Robson.*
BYRON HARMON / 1911
WHYTE MUSEUM OF THE CANADIAN ROCKIES V263 NA-71-1139

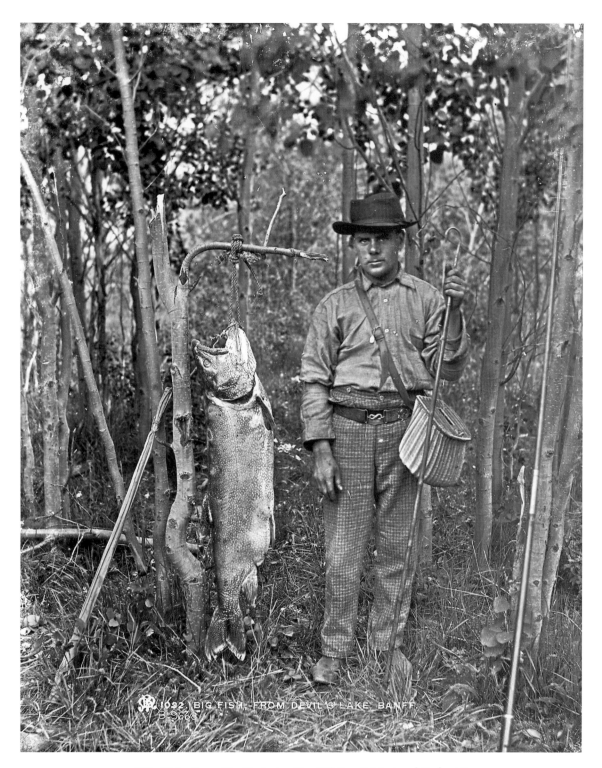

"Big Fish, From Devil's Lake, Banff," Banff National Park, AB
Devil's Lake is now known as Lake Minnewanka.
W. HANSON BOORNE / 1886–1892
PROVINCIAL ARCHIVES OF ALBERTA B.9668

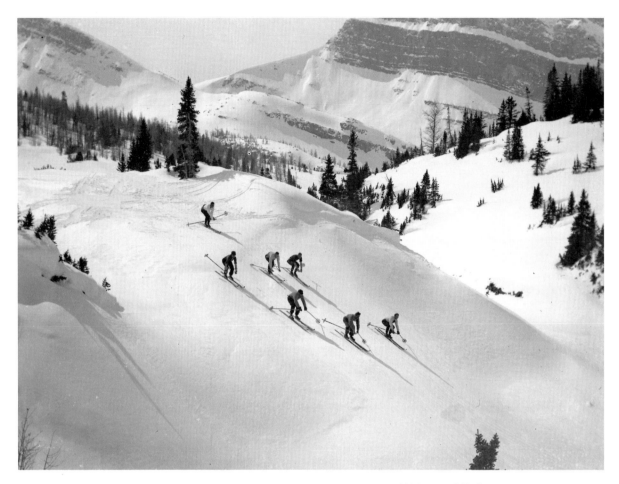

Group of skiers at Skoki Lodge, near Lake Louise, Banff National Park, AB
BYRON HARMON / CA. 1932
WHYTE MUSEUM OF THE CANADIAN ROCKIES V263 NA-71-806

OPPOSITE TOP
Camping at Waterton Lakes National Park, AB
W. J. OLIVER / 1920s
GLENBOW ARCHIVES NA-4868-145

OPPOSITE BOTTOM
"Regina Alpinists Put on a Minstrel around the Campfire," Jasper National Park, AB
PHOTOGRAPHER UNKNOWN / 1923-1924
B. SILVERSIDES COLLECTION

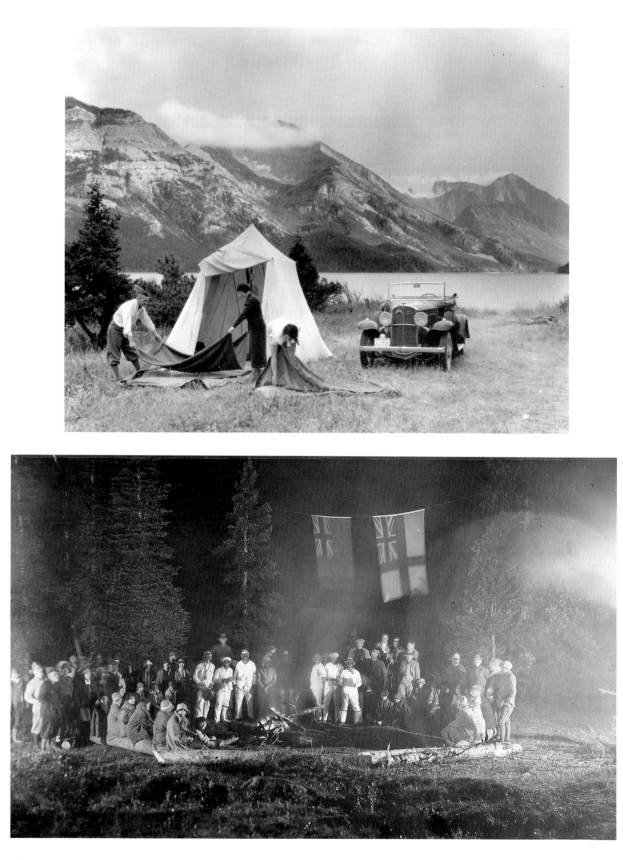

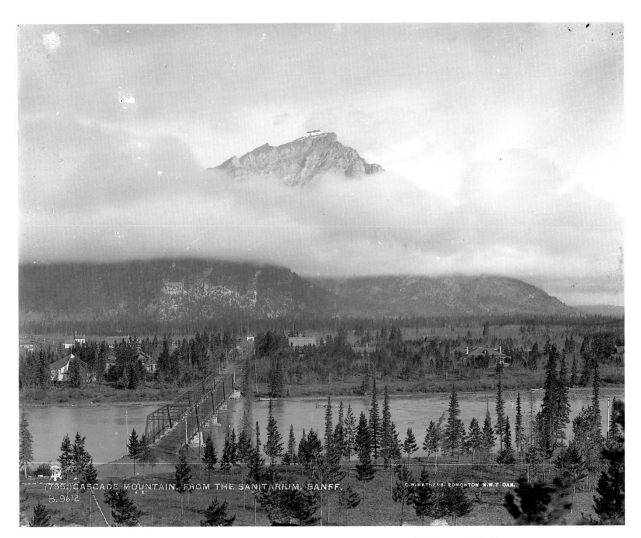

"Cascade Mountain, From the Sanitarium, Banff," Banff National Park, AB
W. HANSON BOORNE / 1886–1892
PROVINCIAL ARCHIVES OF ALBERTA B.9612

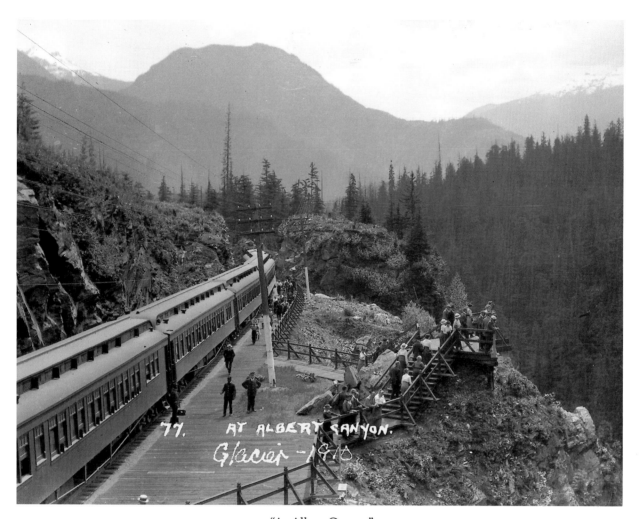

"At Albert Canyon"
One of the most impressive whistle stops along the CPR was Albert Canyon where a stairway and observation
platform were constructed to let tourists gaze down the deep valley of the Illecillewaet.
BYRON HARMON / 1910
WHYTE MUSEUM OF THE CANADIAN ROCKIES V263 NA-71-1657

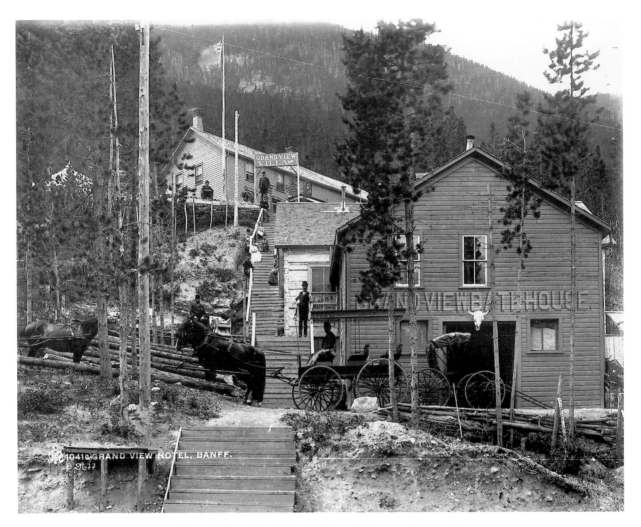

"Grand View Hotel, Banff," Banff National Park, AB
The first hotel in the park was owned by Dr. R. G. Brett, who also ran a sanatorium, an apothecary shop, and a bottling company.
W. HANSON BOORNE / 1887–1888
PROVINCIAL ARCHIVES OF ALBERTA B.9677

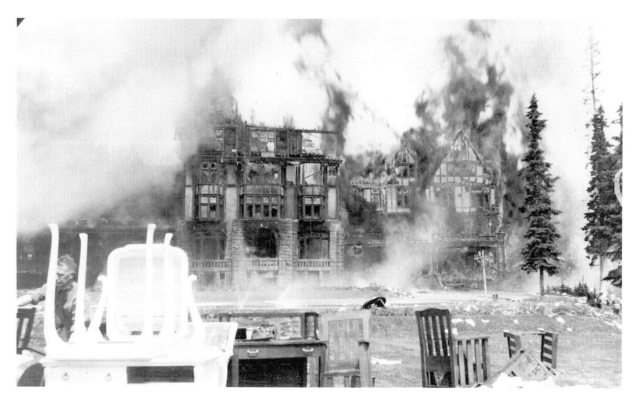

The original Chateau Lake Louise succumbs to flames, Banff National Park, AB
PHOTOGRAPHER UNKNOWN / SUMMER 1924
GLENBOW ARCHIVES NA-3342-5

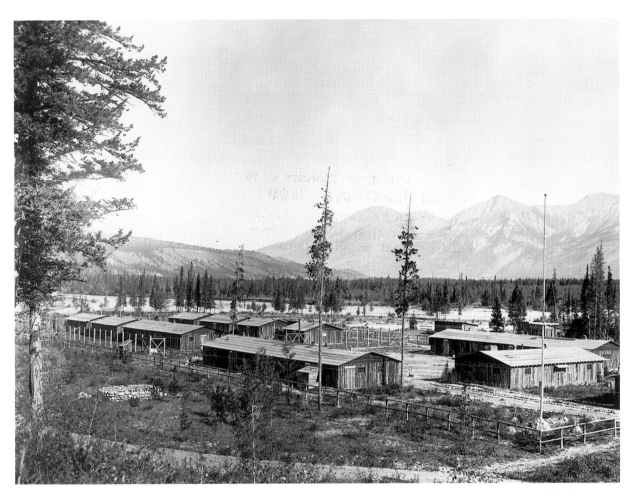

Internment Camp for prisoners of war, six kilometres southwest of Jasper townsite, Jasper National Park, AB
PHOTOGRAPHER UNKNOWN / 1914-1918
PROVINCIAL ARCHIVES OF ALBERTA A.2926

OPPOSITE TOP
Prisoners at Castle Mountain Internment Camp, Banff National Park, AB
PHOTOGRAPHER UNKNOWN / 1915
GLENBOW ARCHIVES NA-3959-2

OPPOSITE BOTTOM
Prisoners and guards at Castle Mountain Internment Camp, Banff National Park, AB
PHOTOGRAPHER UNKNOWN / CA. 1915
GLENBOW ARCHIVES NA-5263-1

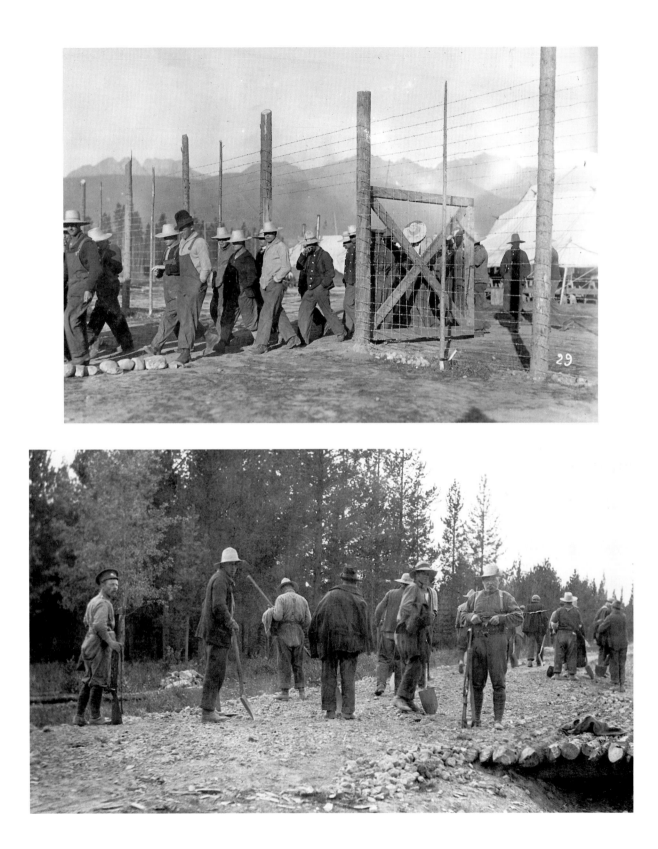

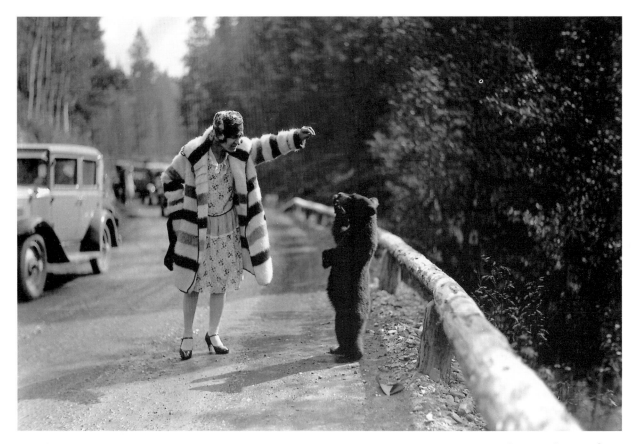

Ignoring the obvious dangers, a tourist at Banff National Park, AB, engages in an unwise but time-honoured National Parks tradition—feeding the wildlife on the roadside.
GEORGE NOBLE / CA. 1925
WHYTE MUSEUM OF THE CANADIAN ROCKIES V469-1558

OPPOSITE
Cameron Falls, Waterton Lakes National Park, AB
HARRY POLLARD / 1920S
PROVINCIAL ARCHIVES OF ALBERTA P.6700

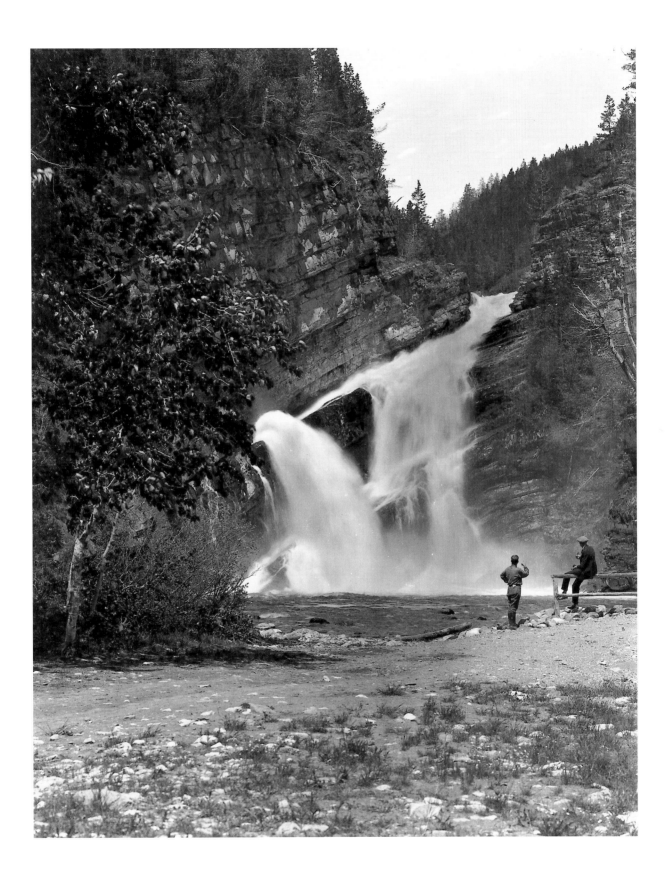

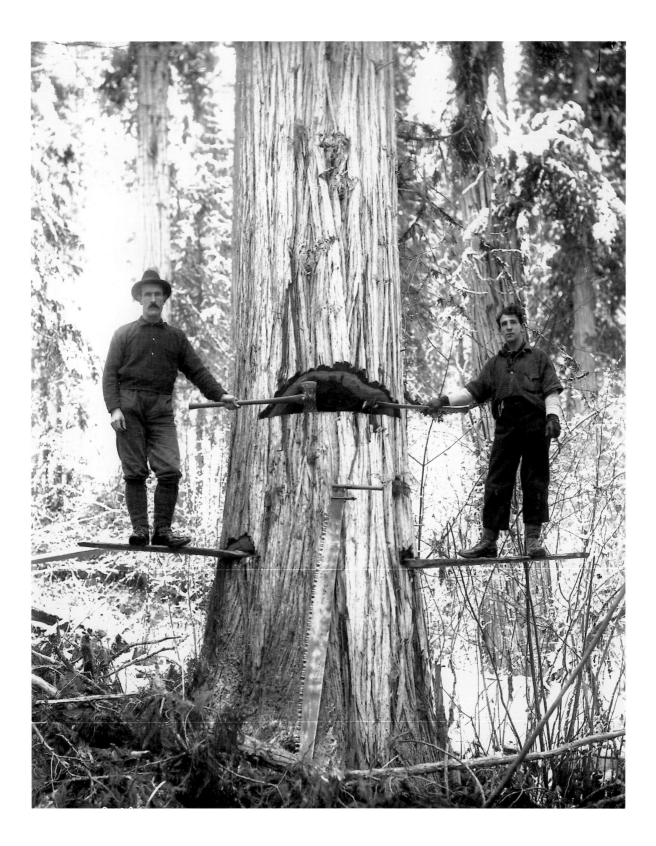

The Mountain Economy

ALTHOUGH the railways and tourism employed a great many people in the mountain region, there were other industries and activities that contributed to the constantly expanding economy. Ranching, one of the earliest industries in the British Columbia interior, was ideal for the open ranges of the Cariboo, in the Nicola and Thompson Valleys, in the Okanagan and Similkameen Valleys, in parts of the Kootenay Plains in the Windermere Valley, and even in the Crowsnest Pass. Ranchers supplied meat to the gold rush miners throughout the 1860s, and in the 1880s and 1890s they supplied the various railway construction camps. By 1891, roughly 24,000 head of cattle were being sent to packing houses annually from the ranges of the British Columbia interior. As more and more settlers moved in, however, the larger ranches began to be divided into farms and orchards.

Farming was established in several places by the 1860s, with large agricultural communities at Mission, Chilliwack, and Agassiz, the latter known particularly for its dairy farms. The Kamloops area produced wheat, alfalfa, and some fruit, while the Okanagan Valley turned out to be an agricultural gold mine. The soil, the lakes, and the weather were ideal for wheat, tobacco, and numerous kinds of fruit. Farming also secured a toehold in the Kootenays,

the Windermere Valley, and the Crowsnest Pass.

Logging was an obvious option throughout the mountain region. The first sawmill on the mainland was opened at Yale in 1858. While the initial impetus for the lumber industry came from Royal Navy contracts, these were soon superseded by the demands of the gold rush. Enormous quantities of lumber were needed for mine shafts, flumes, buildings, and sluices. In the 1880s, the logging industry received another boost from CPR construction crews, who used lumber for ties, bridges, scaffolding, bunk houses, and stations. For a time, in fact, the CPR ran their own logging operations. By the turn of the century, the market had broadened considerably, and by 1914 over ninety per cent of British Columbia lumber was being shipped east to build the houses of Alberta and Saskatchewan.

Initially, logging was done either near a body of water or near the rail line for easy transportation to a sawmill. Operations were located along the North Thompson River, Kamloops and Savona, the Shuswap–Adams Lake District, east and west Kootenay, all along the Crowsnest Pass, along the Moyie, White and Palliser Rivers, the Cranbrook–Lumberton area, and the Bow River Valley. As the British Columbia government opened up vast tracts of crown land for leasing, lumber companies constructed their own

OPPOSITE
Lumberjacks felling a tree with the springboarding technique, Adam's Lake district, BC
HARRY POLLARD / CA. 1910
PROVINCIAL ARCHIVES OF ALBERTA P.1026

railways. Many also established their own sawmills and lumberyards.

Gold was discovered on Perry Creek, Weaver Creek, and Wild Horse in the Kootenays in the 1860s. The small rush that resulted attracted 5,000 people to the area, and placer mines at Wild Horse are reputed to have produced over nine million dollars' worth of gold before the area was mined out. More people started to pour into the district after 1887 when copper and silver were discovered on Toad Mountain near Nelson. Further finds were staked out at Ainsworth on Kootenay Lake, and at Rossland.

The Slocan area was opened up by the Payne Mine in 1891 and the St Eugene Mine at Moyie. Mineral claims were staked out by the hundreds, and nearby towns sprung up like magic as a new rush started to Sandon, New Denver, Silverton, and Kaslo. Most of the newcomers were Americans, often from Spokane.

The first ore was shipped out of the Kootenays in 1892. It was moved in sacks by pack train to Kaslo, by boat to Bonners Ferry, then by the Great Northern Railway to Montana. After several years of using this inefficient and expensive method, several mine owners felt they could make greater profits by purifying their own ore before sending it to market. Thus, in 1896, Augustus Heinz built the first smelter in the Kootenays at Trail. The Hall Mines Smelter at Nelson followed shortly afterward. Other smelters were built in the nearby Boundary district at Grand Forks and Boundary Falls. Between 1889 and 1898, the Kootenay Smelting & Trading Syndicate operated a smelter at Revelstoke.

By 1895 the southern mountain economy was enjoying the economic effects of coal mining in the Crowsnest Pass. Vast seams of high quality bituminous coal ran from Fernie, British Columbia, east to Bellevue, Alberta. By the turn of the century there were twelve companies operating collieries in the pass, including the Canadian American Coal & Coke Co, the West Canadian Collieries Ltd, the Crows Nest Pass Coal Co, the International Coal & Coke Works, and the McGillivray Creek Coal & Coke Co.

There were three major markets for the coal: the railways first, for the CPR in Canada and the Great Northern in the United States both required huge amounts of coal to drive their locomotives. The burgeoning prairie communities, too, required coal to heat their houses and run their industries. Finally—when the coal was converted to coke in the ovens at Fernie and Passburg—it was used as fuel by the two Kootenay smelters, as well as smelters in nearby Washington.

OPPOSITE TOP
Lumberyard, Adam's Lake district, BC
HARRY POLLARD / CA. 1910
PROVINCIAL ARCHIVES OF ALBERTA P.1051

OPPOSITE BOTTOM
"Countergangway No. 2 Seam (old car)," Brazeau Collieries, Nordegg, AB
GEORGE FLEMING / 1914
PROVINCIAL ARCHIVES OF ALBERTA A.20065

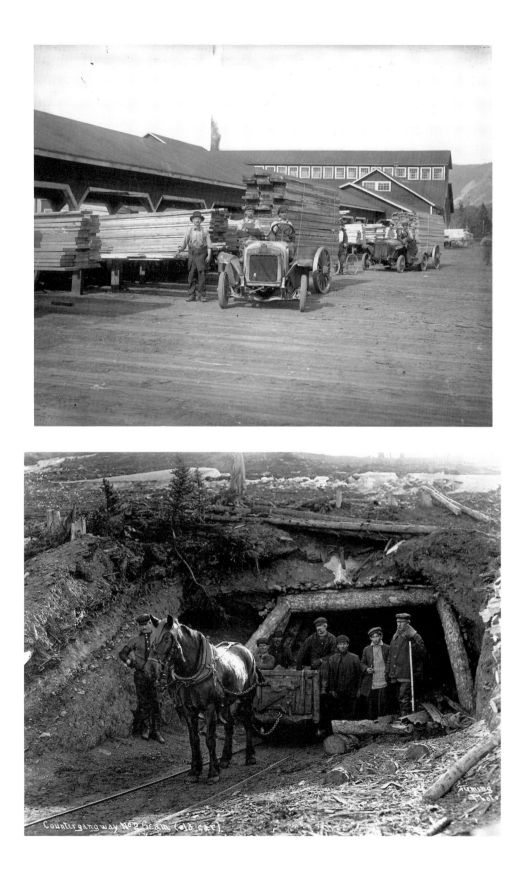

Countergangway No.2 Seam (old car)

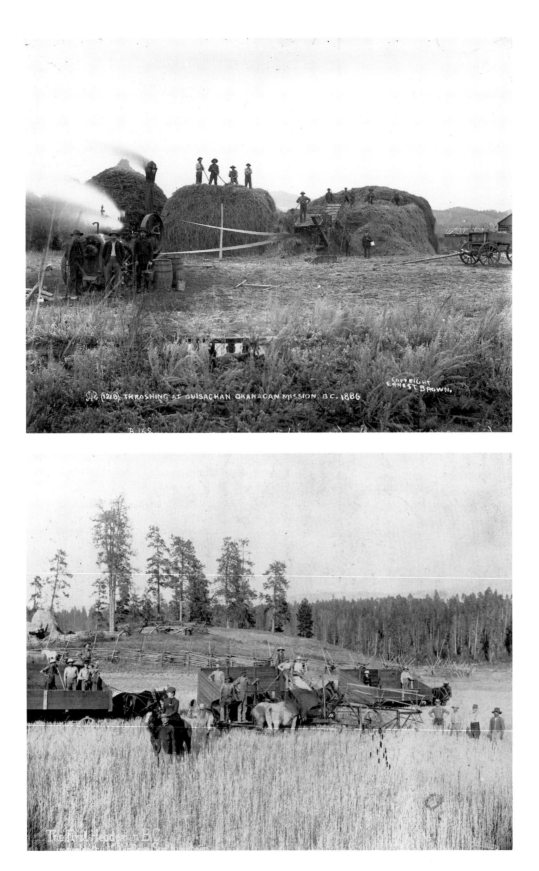

(1218) THRASHING AT GUISACHAN OKANAGAN MISSION. B.C. 1886

COPYRIGHT
ERNEST BROWN.

B 168

The First Harvest in B.C.

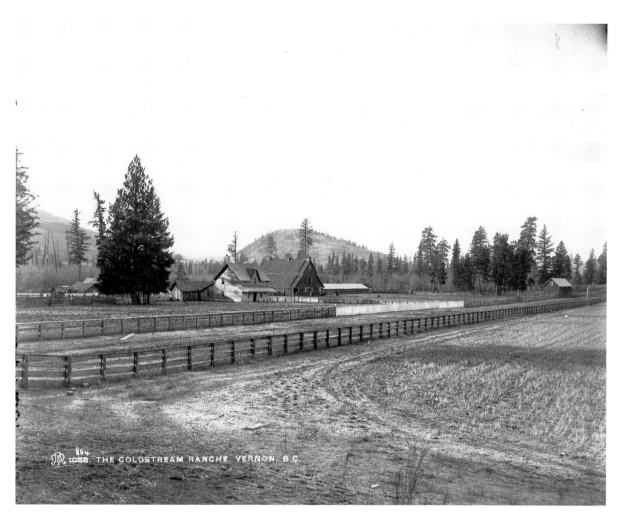

"The Coldstream Ranche, Vernon, BC"
Governor General and Lady Aberdeen owned the Coldstream Ranch in the Okanagan Valley. Managed by
Coutts Marjoribanks, Lady Aberdeen's brother, it was a highly successful cattle operation.
W. HANSON BOORNE / 1892
PROVINCIAL ARCHIVES OF ALBERTA B.6091

OPPOSITE TOP
"Thrashing at Guisachan, Okanagan Mission, BC"
Guisachan–"Place of the Firs" in Gaelic–was also owned by Governor General and Lady Aberdeen. Purchased in
1891, the farm experimented with numerous crops, eventually opting for apple and plum trees, a decision that
started the Okanagan fruit industry.
W. HANSON BOORNE / 1892
PROVINCIAL ARCHIVES OF ALBERTA B.168

OPPOSITE BOTTOM
"The First Header in BC–imported by M. Wallace, Spallumcheen," near Vernon, Okanagan Valley
PHOTOGRAPHER UNKNOWN / 1899
UNIVERSITY OF BRITISH COLUMBIA SPECIAL COLLECTIONS BC-816

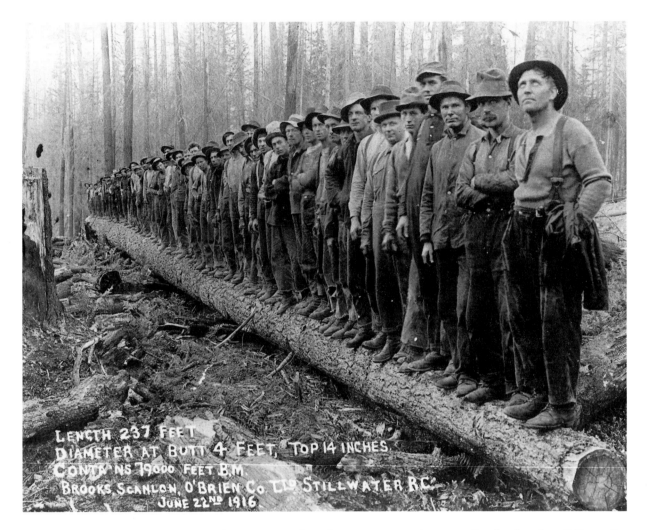

"Length 237 feet, Diameter at Butt 4 feet, Top 14 inches, Contains 79,000 feet B.M., Brooks, Scanlon, O'Brien Co. Ltd., Stillwater BC, June 22nd 1916"
PHOTOGRAPHER UNKNOWN
CITY OF VANCOUVER ARCHIVES LOG. P.42, N.26

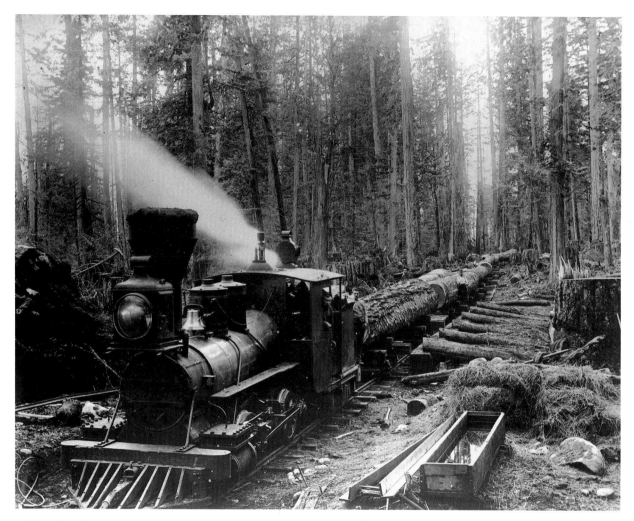

"Old Curly" was a locomotive used for hauling lumber. Originally used by the Canadian Pacific Railway on the Fraser Canyon run, it was purchased in 1887 by the Royal City Planing Mills. This image was produced in 1894 at Kensington Prairie near Cloverdale.

BAILEY BROS.

CITY OF VANCOUVER ARCHIVES CAN.P.49,N.31#1

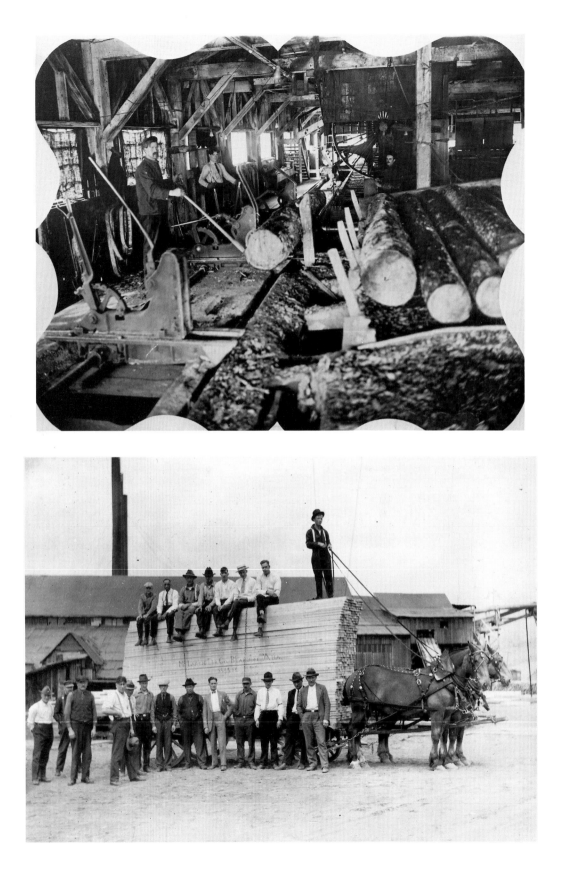

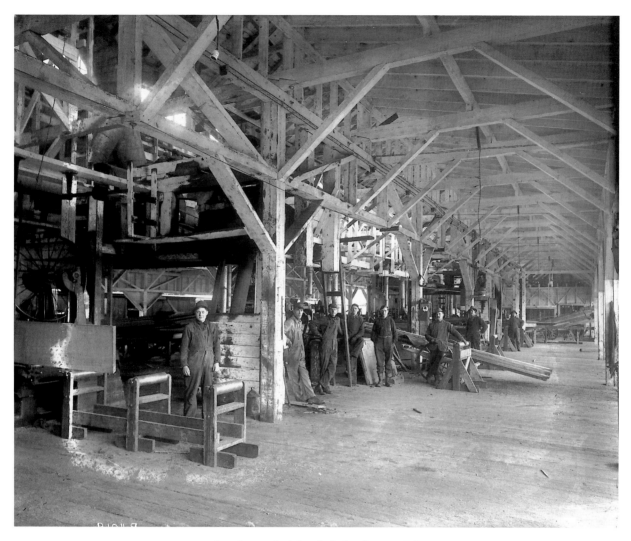

Lumberyard, Adam's Lake district, BC
HARRY POLLARD / CA. 1910
PROVINCIAL ARCHIVES OF ALBERTA P.1049

OPPOSITE TOP
Interior of Crows Nest Pass Lumber Co sawmill, Wardner, BC
It was built in 1902 and was one of the largest mills in BC at the time.
PHOTOGRAPHER UNKNOWN / 1910
GLENBOW ARCHIVES NA-1748-7

OPPOSITE BOTTOM
Load of timber from McLaren Lumber Yard, near Blairmore, AB
PHOTOGRAPHER UNKNOWN / 1925
GLENBOW ARCHIVES NA-3903-33

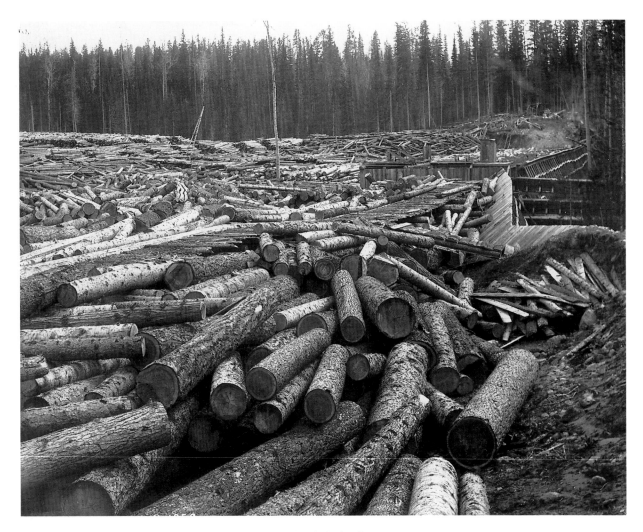

Log piles, Adam's Lake district, BC
HARRY POLLARD / CA. 1910
PROVINCIAL ARCHIVES OF ALBERTA P.1058

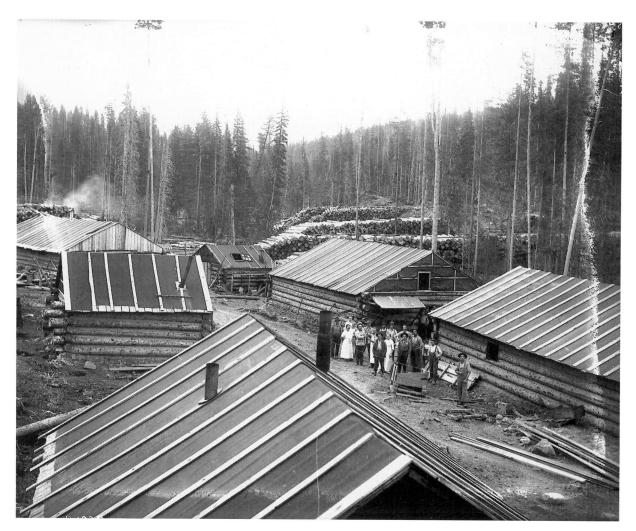

Lumber camp, southeast BC
HARRY POLLARD / CA. 1910
PROVINCIAL ARCHIVES OF ALBERTA P.1038

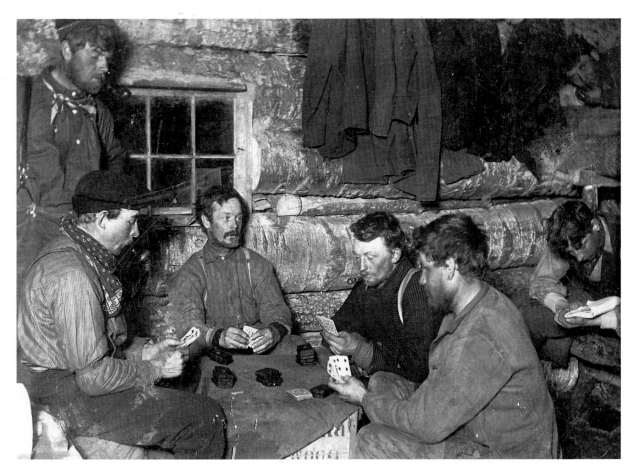

Whiling away the winter evenings at a lumbercamp—playing cards or reading
PHOTOGRAPHER UNKNOWN / CA. 1912
PROVINCIAL ARCHIVES OF ALBERTA A.10076

OPPOSITE TOP
Caterpillar hauling logs, White Spruce Mills Camp near Lumberton, BC
PHOTOGRAPHER UNKNOWN / 1928
GLENBOW ARCHIVES NA-1748-14

OPPOSITE BOTTOM
Horses hauling load of timber, BC
PHOTOGRAPHER UNKNOWN / CA. 1890s
GLENBOW ARCHIVES NA-3084-8

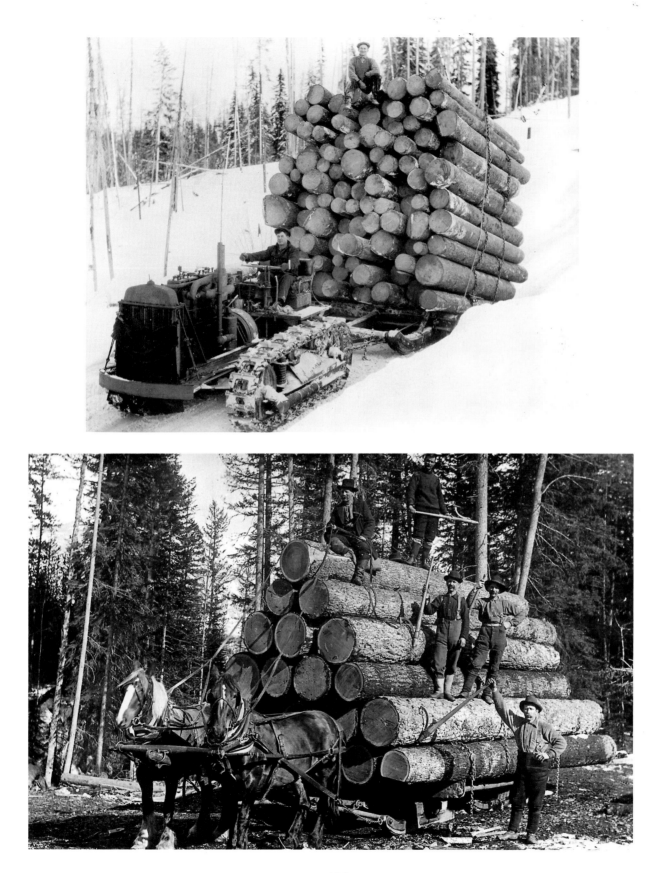

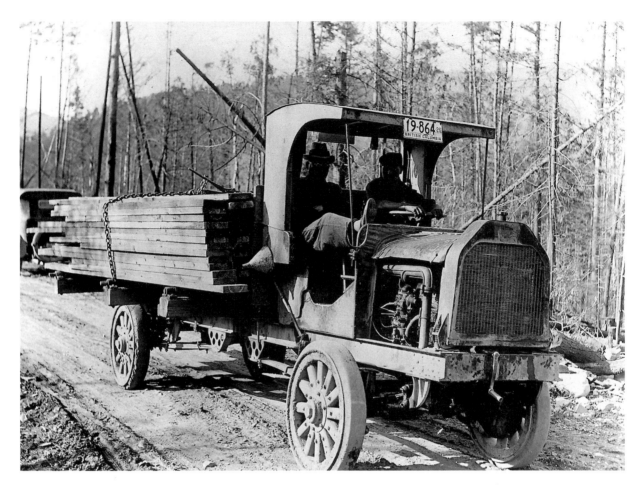

"First logging truck," driven by a Mr. St Denis of Canyon (near Creston), BC
PHOTOGRAPHER UNKNOWN / 1926
GLENBOW ARCHIVES NA-1748-11

OPPOSITE TOP
Entrance to Coal Mine #80, Bankhead, AB
PHOTOGRAPHER UNKNOWN / CA. 1905
GLENBOW ARCHIVES NA-437-4

OPPOSITE BOTTOM
Railway tracks, Greenhill Coal Mine, Blairmore, AB
PHOTOGRAPHER UNKNOWN / 1920s
GLENBOW ARCHIVES NA-712-16

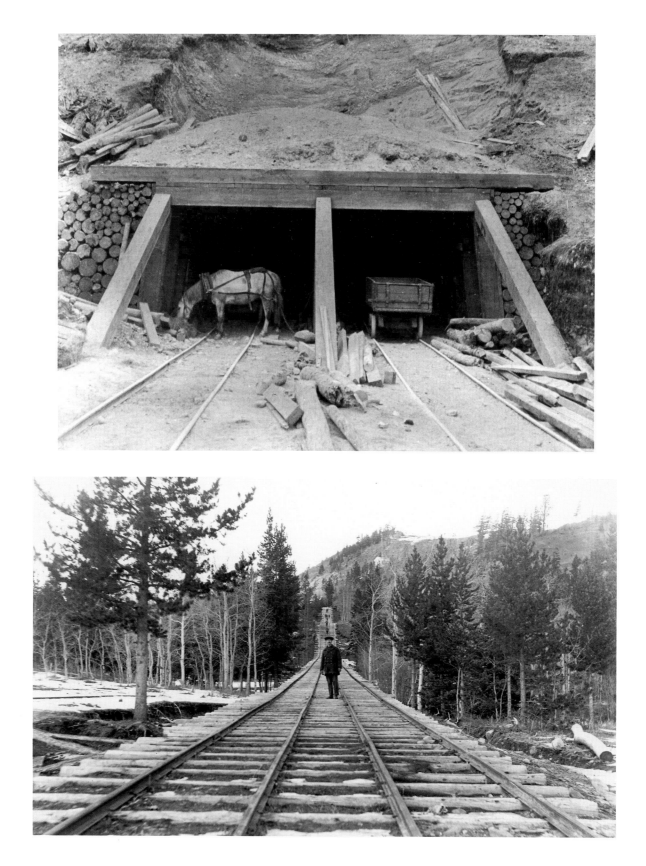

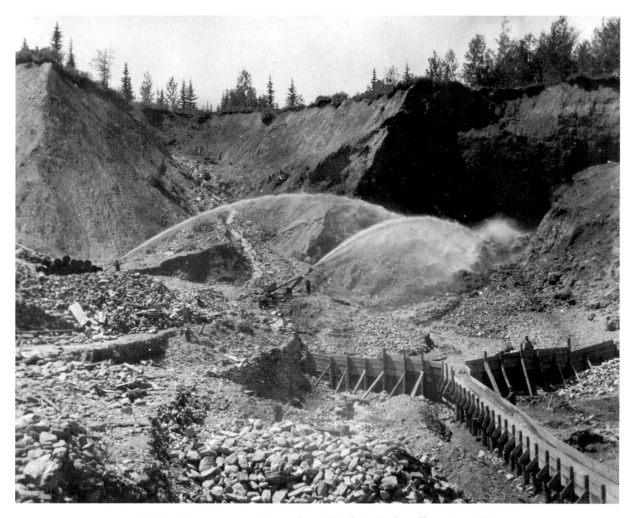

Hydraulic mining on Cunningham Creek in Barkerville region, BC
PHOTOGRAPHER UNKNOWN / 1920s
GLENBOW ARCHIVES NA-3050-10

OPPOSITE
Monarch Mine, Mount Stevens, BC
HARRY POLLARD / 1910
PROVINCIAL ARCHIVES OF ALBERTA P.6659

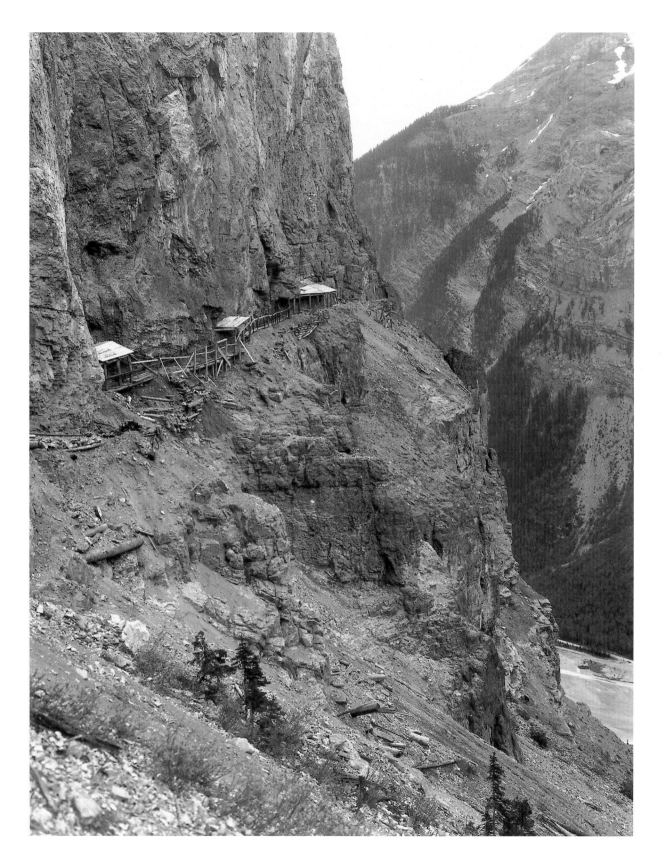

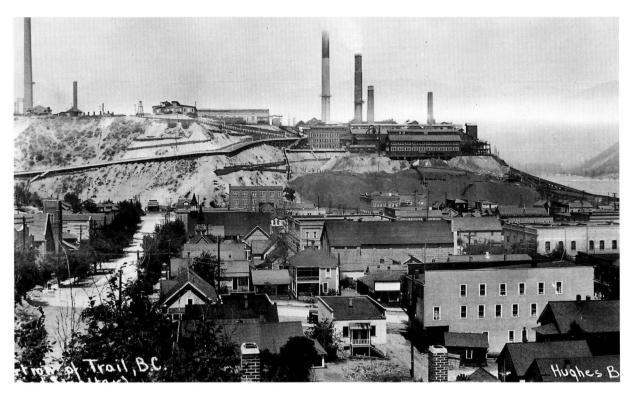

"Part of Trail, BC (and Smelter)"
The smelter, originally built in 1895 by F. A. Heinze, was bought out by the CPR subsidiary Cominco in 1898.
It refined the lead and zinc ores from Red Mountain and later the Sullivan mine at Kimberley. During
the 1920s, it was reputed to be the largest smelter in the British Empire.

HUGHES BROS / CA. 1912

GLENBOW ARCHIVES NA-2688-16

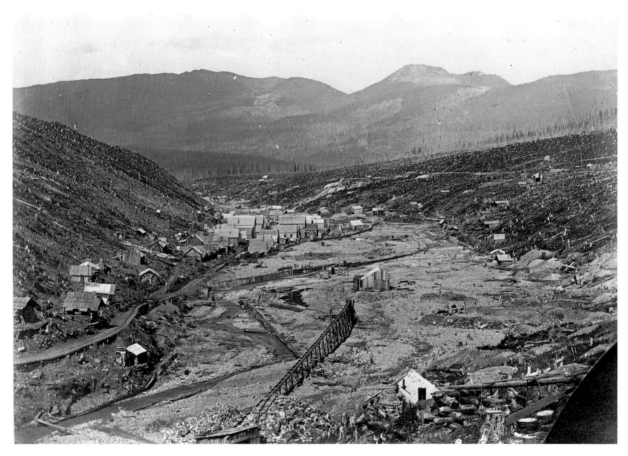

"Barkerville–Williams Creek, Cariboo, Gold Mines"
PHOTOGRAPHER UNKNOWN / N. D.
CITY OF VANCOUVER ARCHIVES OUT.P.165, N.53

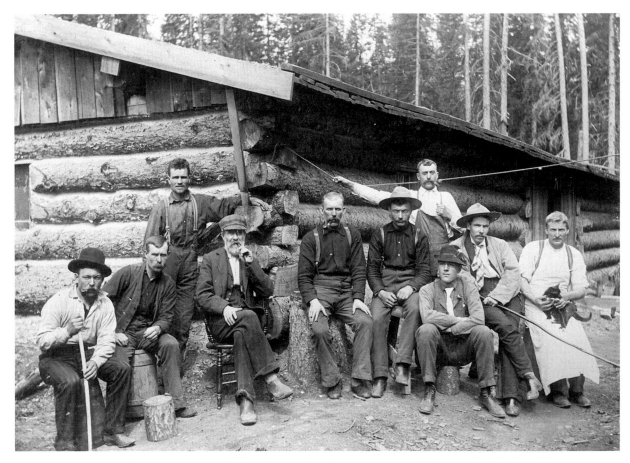

Group of men at opening of "Peter" seam, forty kilometres east of Fernie, Coal Siding, BC
PHOTOGRAPHER UNKNOWN / 1899
GLENBOW ARCHIVES NA-1465-20

OPPOSITE
"Draeger Outfit–A Level, Hosmer," BC
WILLIAM ROBSON / 1910
PROVINCIAL ARCHIVES OF ALBERTA A.2039

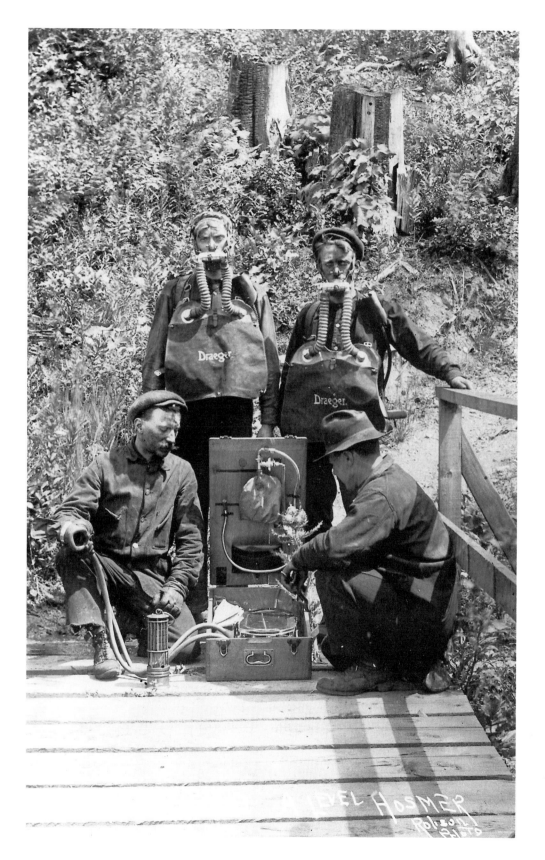

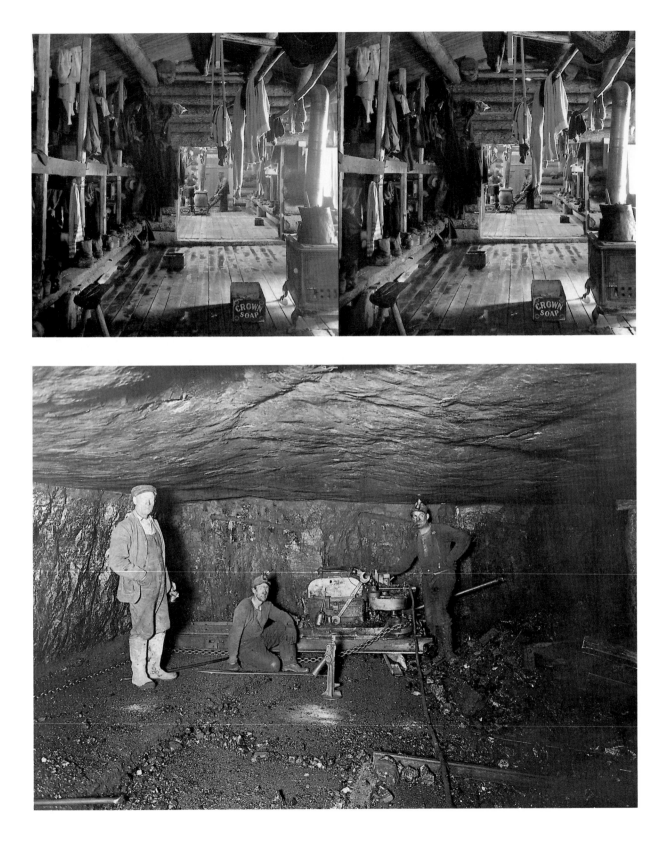

Coke oven in operation, Fernie, BC
PHOTOGRAPHER UNKNOWN / 1899
GLENBOW ARCHIVES NA-1465-10

OPPOSITE TOP
Interior of miner's wash area, Bankhead, AB–stereograph
Starting in 1903, Pacific Coal Ltd, a CPR subsidiary, operated mine #80 on the east face of Cascade Mountain,
harvesting a rich seam of hard anthracite coal. Strangely, it was mined upwards from the base of the mountain
rather than downwards to harness the force of gravity. At its peak in 1911, it employed 500 people, while a town of
900 grew up around it. A series of accidents and six major strikes finally closed the mine in 1922.
ELLIOTT BARNES / CA. 1906
WHYTE MUSEUM OF THE CANADIAN ROCKIES V48 NA-65-490

OPPOSITE BOTTOM
Interior of Leitch Collieries, Passburg, AB
PHOTOGRAPHER UNKNOWN / 1907-1915
GLENBOW ARCHIVES NA-3903-135

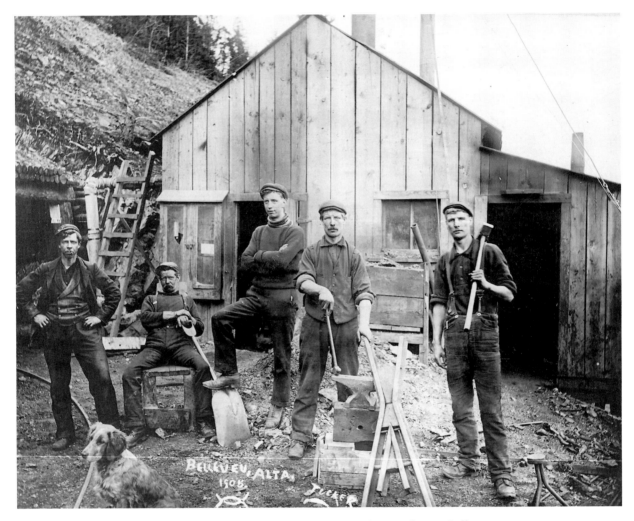

Entrance to West Canadian Collieries mine and power house, Bellevue, AB
PHOTOGRAPHER UNKNOWN / 1905
GLENBOW ARCHIVES NA-3903-11

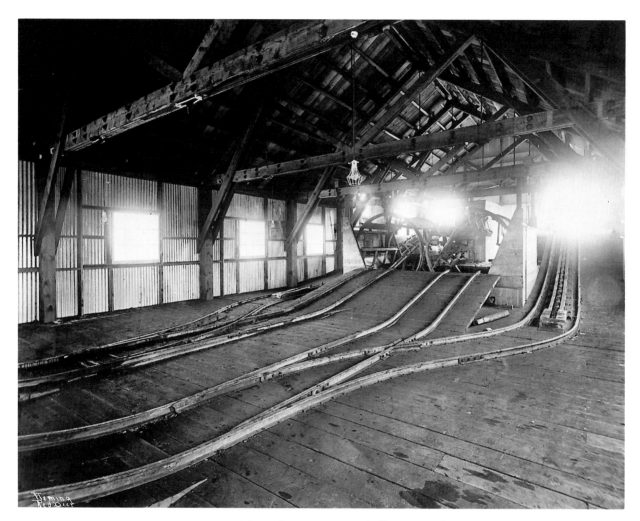

Interior view of dump house, Brazeau Collieries, Nordegg, AB
In 1914, Martin Nordegg, in partnership with the Canadian Northern Railway, established a town
(named after himself) and the Brazeau Collieries on the eastern slope of the Rockies.
GEORGE FLEMING / 1914
PROVINCIAL ARCHIVES OF ALBERTA A.20040

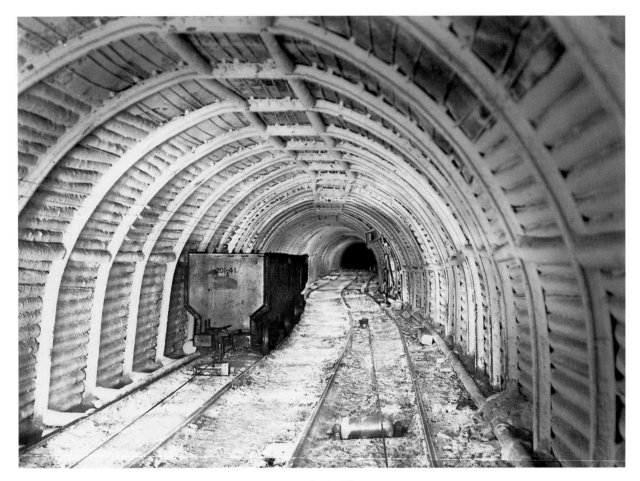

Interior of mine shaft, Blairmore, AB
THOMAS GUSHUL / 1941
GLENBOW ARCHIVES NC-54-2899

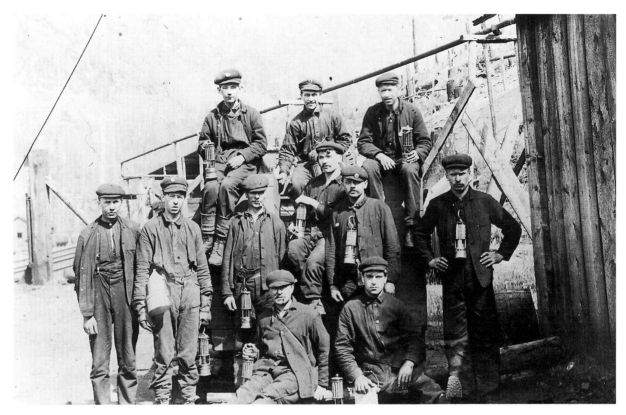

Miners with Davey safety lamps, Crowsnest Pass, AB
The lamp–named after the English inventor, Sir Humphrey Davey–was a welcome innovation in the world of mining. Before the Davey lamp, the only means of illumination down the mine shafts was a burning wick fuelled by benzene or naptha, which tended to set off explosions of coal gas. Davey's lamps enclosed the open flame in dual screens of wire mesh, thus eliminating the danger of ignition.
PHOTOGRAPHER UNKNOWN / 1910
PROVINCIAL ARCHIVES OF ALBERTA A.2038

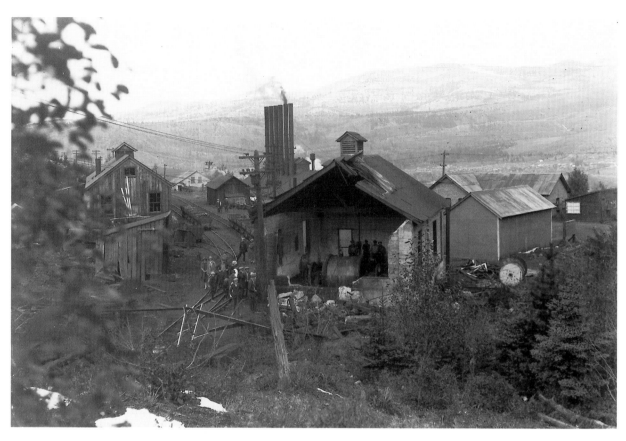

Awaiting bodies following the coal dust explosion at Hillcrest Mine, AB
One hundred and eighty-nine miners died in the Hillcrest explosion, the worst Canadian
coal mining disaster up to that point.
THOMAS GUSHUL / 19 JUNE 1914
GLENBOW ARCHIVES NC-54-2005

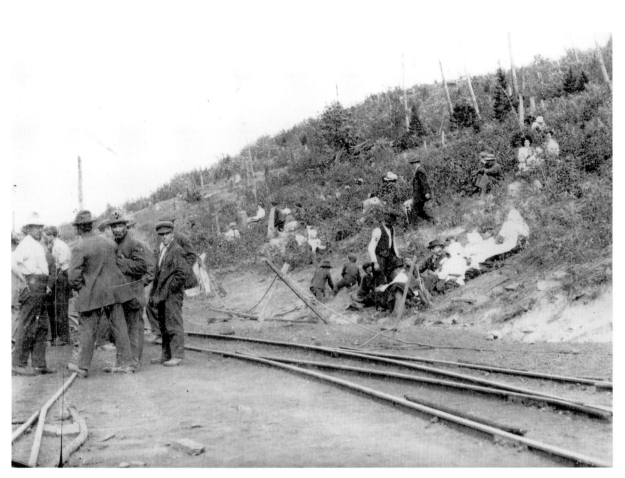

Families waiting on hillside after mine explosion, Hillcrest, AB
ATTRIBUTED TO THOMAS GUSHUL / 19 JUNE 1914
PROVINCIAL ARCHIVES OF ALBERTA A.1778

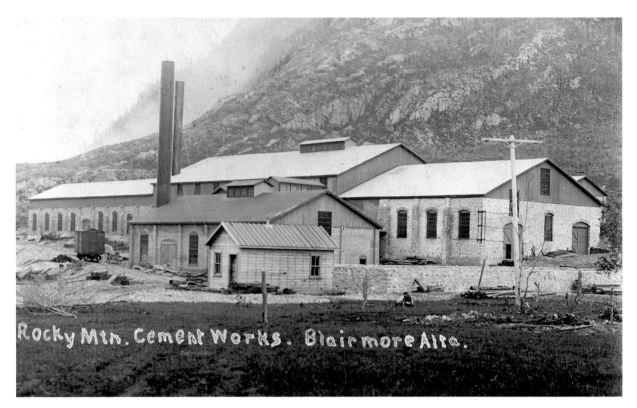

"Rocky Mountain Cement Works, Blairmore, Alta"
Established in 1907, the Rocky Mountain Cement Plant harvested the local deposits of limestone and clay shale.
By 1910, it was producing 6,000 barrels annually, employed ninety men, and sold cement as far away as Spokane.
An economic downturn forced the closure of the plant in 1914, and its buildings were later purchased by the
Canada Cement Company.
PHOTOGRAPHER UNKNOWN / 1920s
GLENBOW ARCHIVES NA-3903-32

OPPOSITE
Two hunters showing off a moose head in Jasper National Park.
The selling of game heads and animal hides was a small but profitable business.
PHOTOGRAPHER UNKNOWN / CA. 1920
B. SILVERSIDES COLLECTION

The production of movies was a relatively minor, but high-profile, segment of the mountain economy. This somewhat tongue-in-cheek production still from Cameron of the Royal Mounted shows an embrace by principal actors Vivienne Osborne and Gaston Class, as well as several extras kissing their horses. Produced by Ernest Shipman and directed by ex-NWMP Henry MacRae, the movie was filmed at Bankhead (near Banff) and released in December 1921. The world was fascinated with the Royal North-West Mounted Police and Cameron was only one of a long line of productions such as Andy of the Royal Mounted (1915), O'Garry of the Royal Mounted (1915), Darcy of the Northwest Mounted (1916), O'Malley of the Mounted (1921), McGuire of the Mounted (1923), Steele of the Royal Mounted (1925), and Moran of the Mounted (1926).

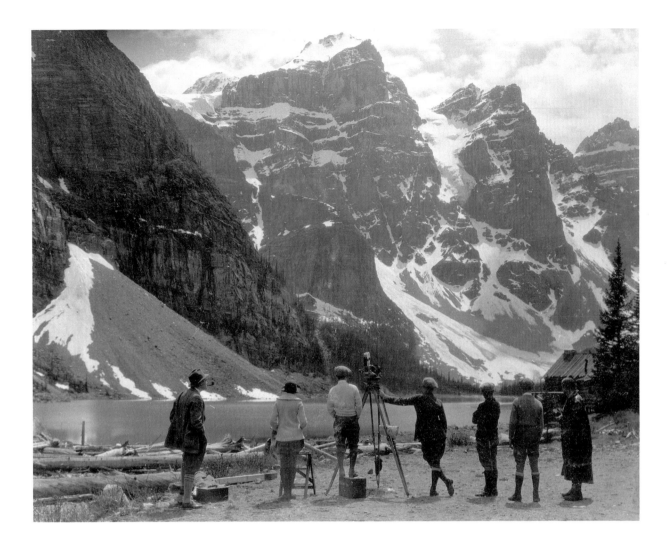

A film crew from the Famous Players–Lasky company during the shooting of The Alaskan, *a seven-reel feature (105 minutes) based on a novel by James Oliver Curwood. Although many of the interior scenes were shot in a Hollywood studio, the scenics were shot at Moraine Lake in Banff National Park.*

PHOTOGRAPHER UNKNOWN / SUMMER 1924

WHYTE MUSEUM OF THE CANADIAN ROCKIES V090/NA-66-2121

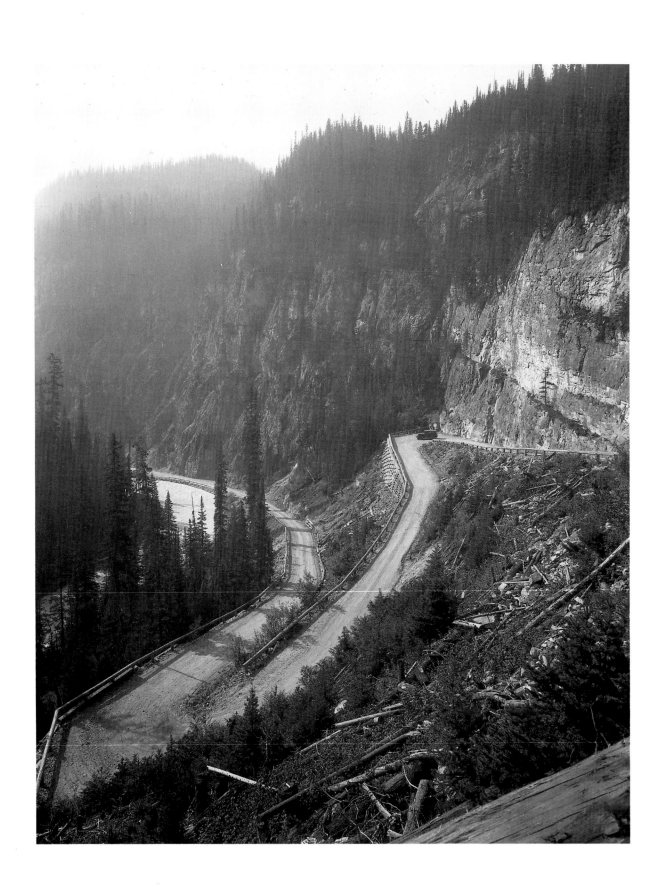

The Development of
Communities and Roads

THE Rocky Mountain region has always been equated in the popular imagination with uncharted wilderness. Through deliberate promotion, and various depictions of the mountains in literature, painting, and photography, the area would appear to be pristine and sparsely populated.

Large areas of the Rockies have indeed remained uninhabited, but the number of communities throughout the region is not insignificant. Most of them were founded as rail depots or temporary mining or lumbering centres. For a variety of reasons, many prospered and grew, developing community and civic institutions such as policing, utilities, a merchant class, a professional class, boards of trade, newspapers, trade unions, fraternal organizations, and sports leagues. While the railroads may have nudged the towns into existence, it was the roads and highways that either confirmed their existence or, by their absence, made towns unfeasible.

The railway system had proved its usefulness for travel and communication for thirty years. Now, with the growing popularity of the automobile in Canadian life, the desire for a transmontane highway started to grow. The earliest attempts to cross the Rockies by automobile were a mixed success.

The scarcity of roads meant that drivers had to piggyback on railroad flatbeds and steam ships, drive along the grades beside railway tracks, or attach flanged wheels to their axles to drive on the rails.

Calls for safe, continuous roads through the mountains increased in the period leading up to World War I. The private sector showed some interest initially, but it quickly evaporated with an appraisal of the costs and engineering problems involved. Enthusiasm was equally muted within the British Columbia government. Thus, most of the drive and activity came from east of the mountains.

The Banff-Windermere Highway, begun just prior to World War I, started at Calgary and ran along the Bow River Valley past Banff. From there it followed the trail explored by Dr. Hector south from Castle Mountain through the Vermilion Pass, down the Kootenay River past Radium Hot Springs to the confluence of the Kootenay and Columbia at Windermere.

The construction of the road was a major expense requiring the agreement of three governments—British Columbia, Alberta, and the Dominion of Canada—to share the burden. Alberta built

the road to the eastern boundary of Banff National Park, the Dominion constructed the portion from one park boundary to the other, and British Columbia took it from there to Windermere, a distance of 101 kilometres.

By 1914 the road was finished from Calgary to the Continental Divide, but all construction was brought to a halt during the war years. In 1922 the federal government finished the remainder of the BC segment in return for the transfer of provincial crown land which became the basis of Kootenay National Park.

The section of the road from Castle Mountain to Lake Louise, on what was eventually to become the Trans-Canada Highway, was begun in 1914, chiefly with the labour of internees from the Castle Mountain prisoner-of-war camp. It followed the route now taken by the Bow Valley Parkway, and was completed in 1920.

The early 1920s saw the establishment of "auto camps" (roadside campgrounds for motorists) and "bungalow camps" (a precursor to motels), and an unprecedented number of automobiles. In the west,

construction started on a new road up the Fraser Canyon, portions of which followed the old Cariboo Trail. By 1924, a passable automobile route connected Vancouver and Kamloops. The following year, it reached Revelstoke.

In the east, the Kicking Horse Trail was completed through the Kicking Horse Pass, down the Columbia Valley past Golden, and, by 1927, through to Glacier National Park. Large parts of the highway used abandoned CPR grades, especially near Golden and on the Big Hill above Field.

A frustrating gap between Revelstoke and Glacier prevented travellers from making the complete trip for over a decade, and was finally completed as a result of a federal make-work project during the Depression.

An offshoot of the mountain road system was started northward from Lake Louise toward Jasper in 1931, again as a make-work project. Construction on the 285-kilometre highway started south from Jasper at the same time. The new gravel road, officially called the Icefields Parkway (or Banff–Jasper Highway) was opened on Dominion Day, 1940.

OPPOSITE
Automobile in snow tunnel, Yoho Valley, BC
BYRON HARMON / 1930
WHYTE MUSEUM OF THE CANADIAN ROCKIES V263 NA-71-1707

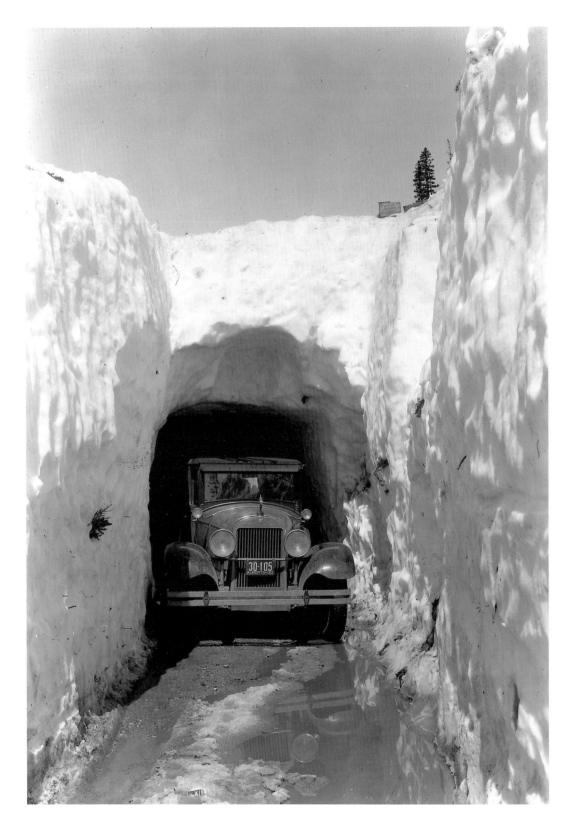

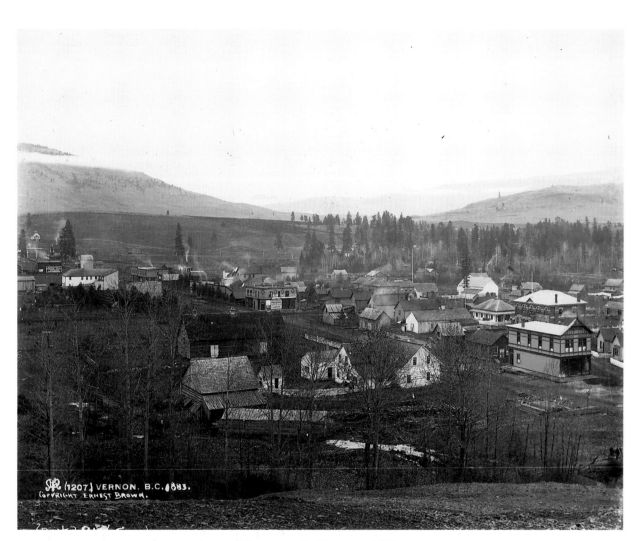

"Vernon, BC"–Okanagan Valley
W. HANSON BOORNE / 1886–1892
PROVINCIAL ARCHIVES OF ALBERTA B.2340

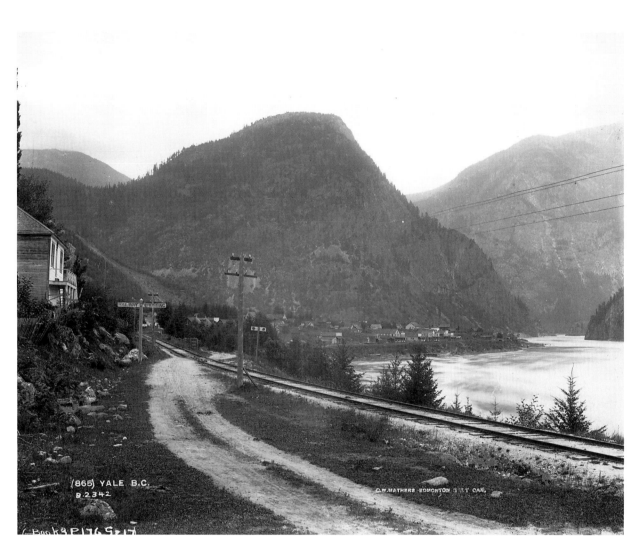

"Yale, BC"–Fraser Valley
W. HANSON BOORNE / 1886–1892
PROVINCIAL ARCHIVES OF ALBERTA B.2342

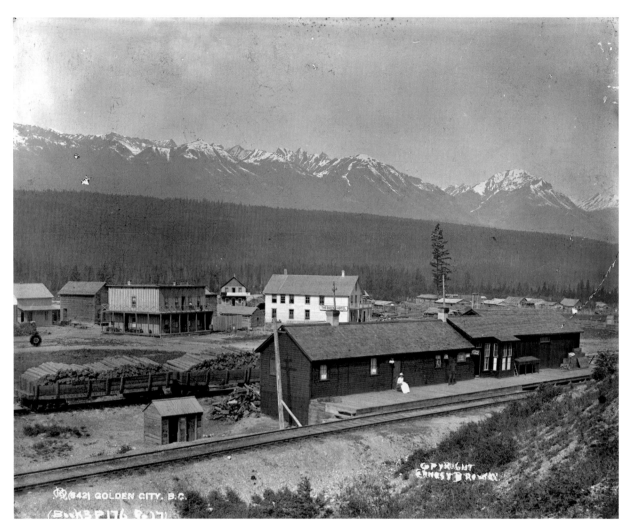

"Golden City, BC," now just Golden
The founders of this settlement in the Columbia River Valley wanted to "one-up" those of another settlement
down the CPR line–Silver City at the base of Castle Mountain.
W. HANSON BOORNE / 1886-1892
PROVINCIAL ARCHIVES OF ALBERTA B.2378

OPPOSITE
"Kamloops, BC, from the West"
Thompson's River Post was founded in 1812 by two competitors–Alexander Ross of the Pacific Fur Co, and Joseph
LaRogue of the North West Co. It had reverted to its original Indian name, Kamloops, by the time the railway
tracks were laid down its main street in the summer of 1885.
W. HANSON BOORNE / 1886-1892
PROVINCIAL ARCHIVES OF ALBERTA B.2382

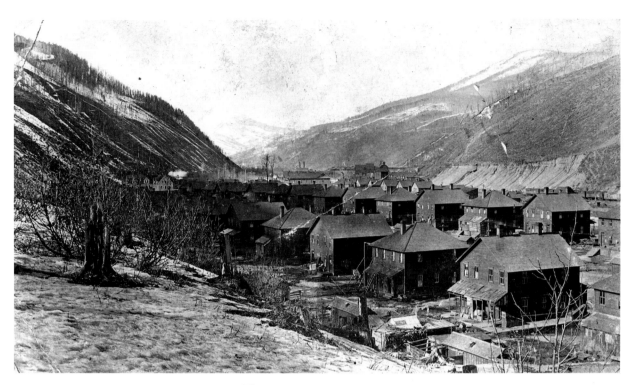

Blairmore, AB–Crowsnest Pass
PHOTOGRAPHER UNKNOWN / 1909
PROVINCIAL ARCHIVES OF ALBERTA A.19340

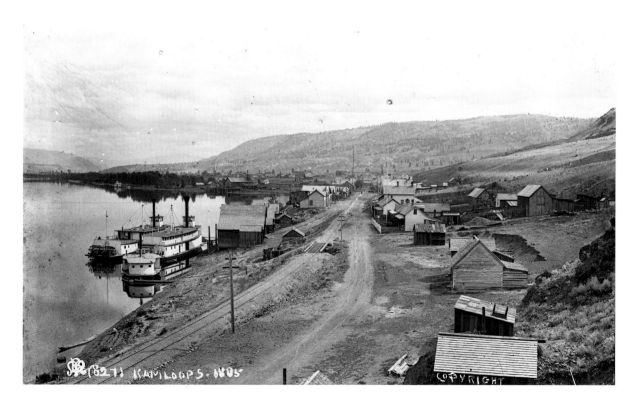

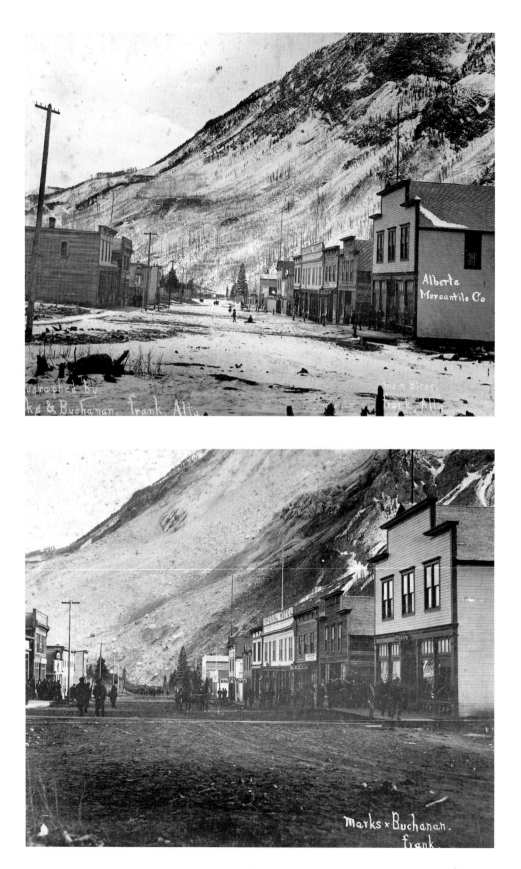

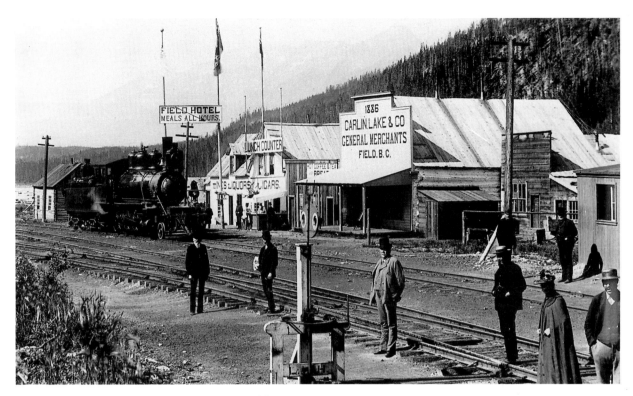

Field, BC–Yoho National Park
SYDNEY A. SMYTH / 1890
GLENBOW ARCHIVES NA-1931-4

OPPOSITE
These two images show the small town of Frank, AB, before and after the slide of 29 April 1903 which buried part of the town. Eighty-six people were killed, houses were crushed, and several kilometres of railway were buried when eighty million tonnes of rock dislodged from Turtle Mountain.
MARKS & BUCHANAN
PROVINCIAL ARCHIVES OF ALBERTA A.19639 / A.19640

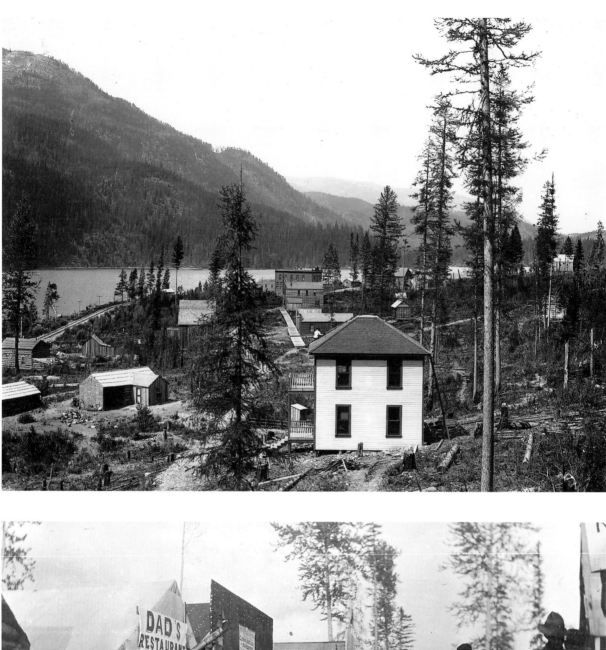

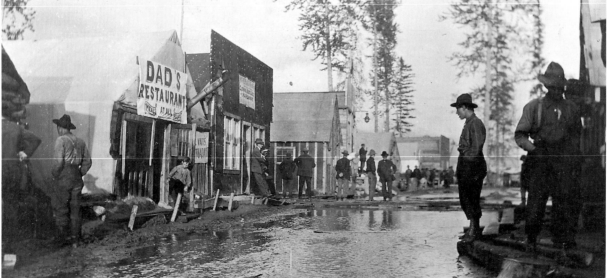

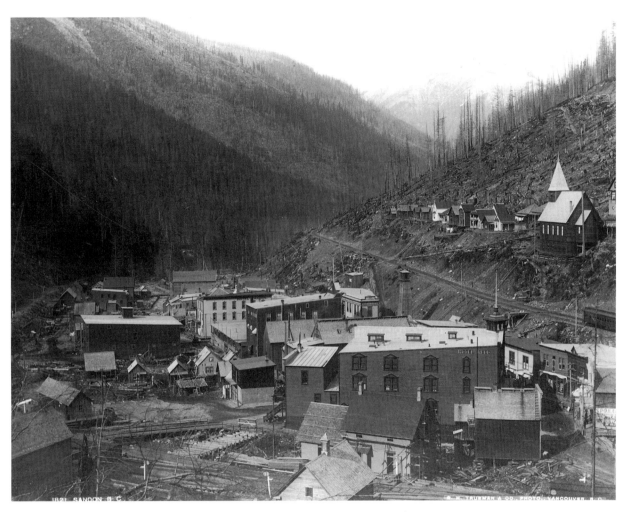

"Sandon, BC"—west of Kootenay Lake
RICHARD TRUEMAN / 1898–1899
CITY OF VANCOUVER ARCHIVES CVA 2–33

OPPOSITE TOP
"Looking North Up Lower Moyie Lake, BC, from Lake Shore Mine Trestle"
Moyie Lake is in the southern Purcell Mountains near Cranbrook, along the old Dewdney Trail.
FREDERICK STEELE / 1890s
SASKATCHEWAN ARCHIVES BOARD R–B.2268

OPPOSITE BOTTOM
Tete Jaune Cache, BC
It was named after a Native trapper in the service of the Hudson's Bay Company post at Jasper. He was called Tete Jaune because of his blonde hair. Regularly journeying between his caches here on the Upper Fraser River and at Jasper, Tete Jaune used only one mountain pass and thus his name became associated with it.
PHOTOGRAPHER UNKNOWN / 1913
GLENBOW ARCHIVES NA–3658–61

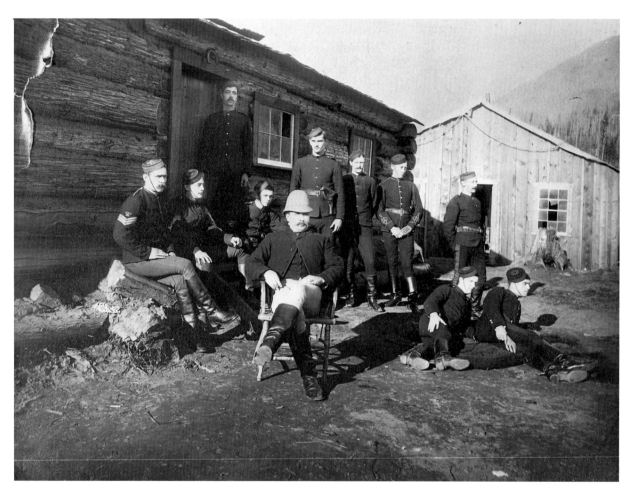

Colonel Sam Steele & North-West Mounted Police Detachment, Beavermouth, BC
ROSS, BEST & CO / 1885
GLENBOW ARCHIVES NA-294-1

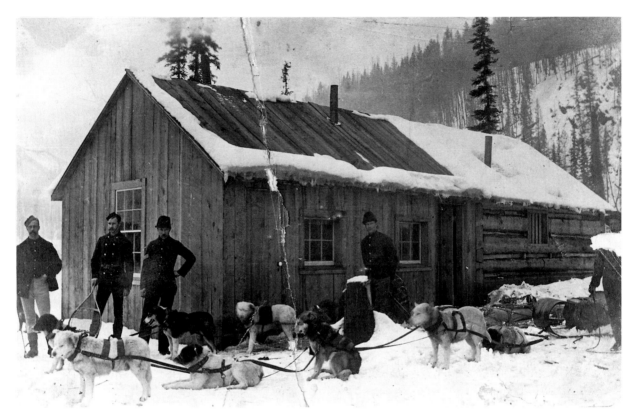

North-West Mounted Police Detachment, Banff, AB
PHOTOGRAPHER UNKNOWN / LATE 1880s
PROVINCIAL ARCHIVES OF ALBERTA A.16125

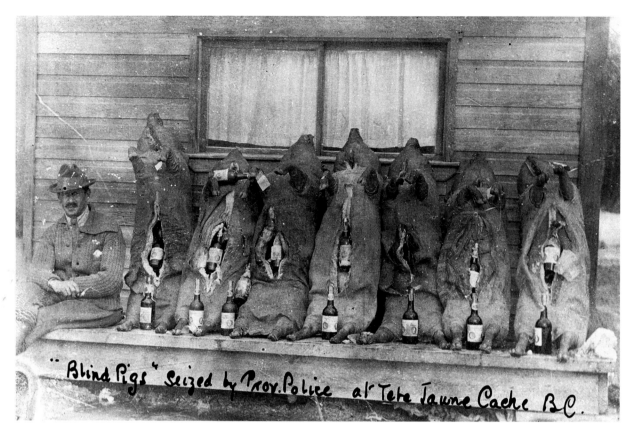

"Blind Pigs Seized by Prov. Police at Tete Jaune Cache, BC"
PHOTOGRAPHER UNKNOWN / CA. 1920
B. SILVERSIDES COLLECTION

OPPOSITE
These two images show how another imaginative bootlegger carried his product around with him.
TETE JAUNE CACHE, BC / CA. 1922
PROVINCIAL ARCHIVES OF ALBERTA A.20992 / A.20988

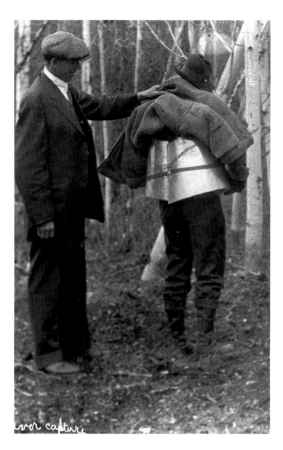

...ver capture

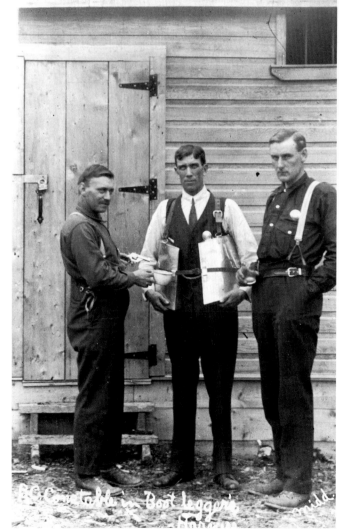

B.C. Constable in Boot leggers...

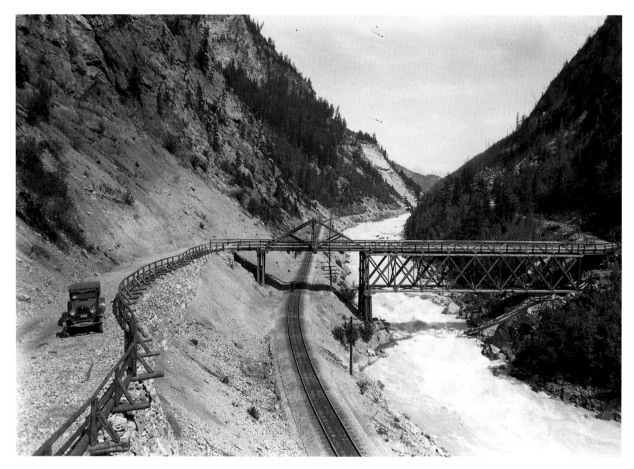

Highway and CPR line crossing, Kicking Horse River, BC
The two chief forms of mountain transportation shared many of the same mountain passes and valleys,
and coexisted comfortably.
BYRON HARMON / 1920s
WHYTE MUSEUM OF THE CANADIAN ROCKIES V263 NA-71-1678

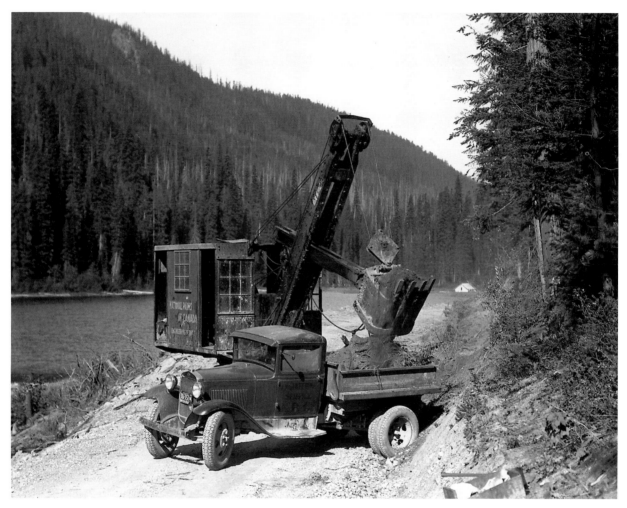

National Parks of Canada steamshovel at work, construction of Big Bend Highway, Columbia River Valley, BC
BYRON HARMON / 1932
WHYTE MUSEUM OF THE CANADIAN ROCKIES V263 NA-71-1724

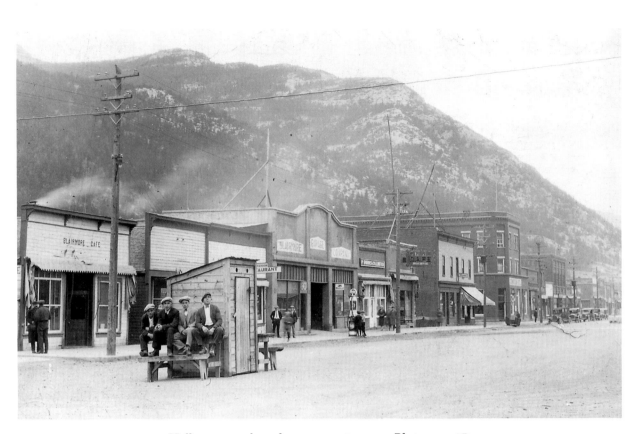

Halloween prank—outhouse on main street, Blairmore, AB
PHOTOGRAPHER UNKNOWN / CA. 1922–1923
GLENBOW ARCHIVES NA-3903-21

OPPOSITE TOP
Firefighters in front of courthouse, Blairmore, AB
THOMAS GUSHUL / MAY 1926
GLENBOW ARCHIVES NC-54-2269

OPPOSITE BOTTOM
Soldiers guarding a railway bridge in the Selkirk Mountains during World War I
BYRON HARMON / 1915–1916
WHYTE MUSEUM OF THE CANADIAN ROCKIES NA-71-1618

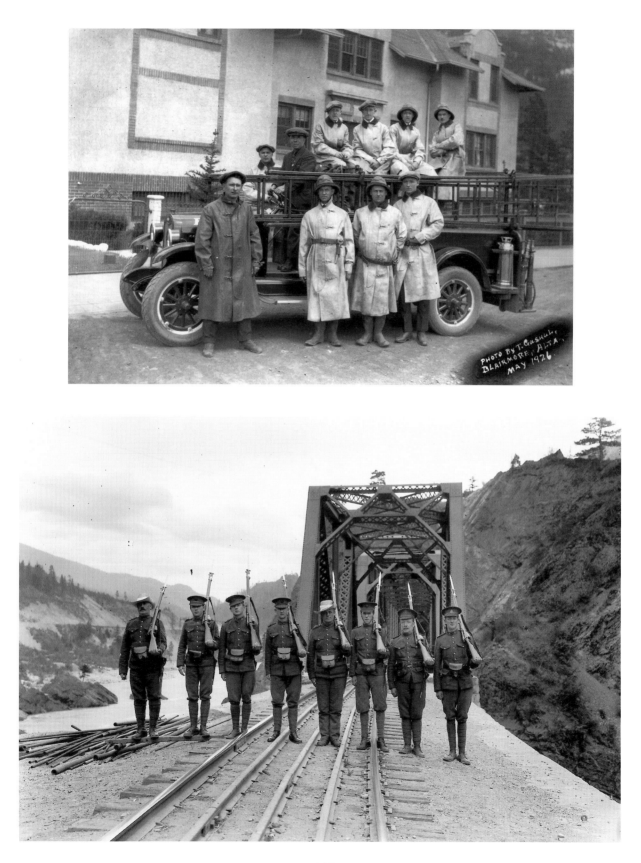

Photo By T. Gushul, BLAIRMORE, ALTA. MAY 1926

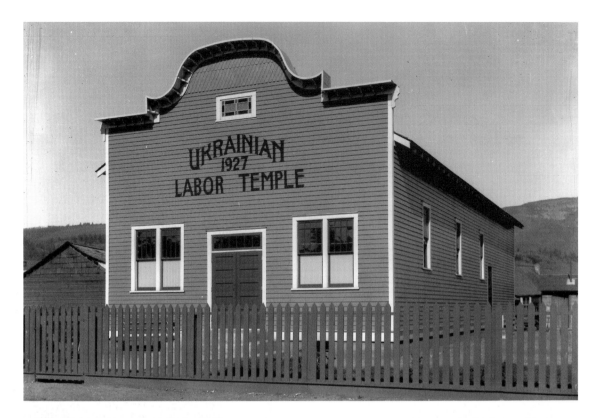

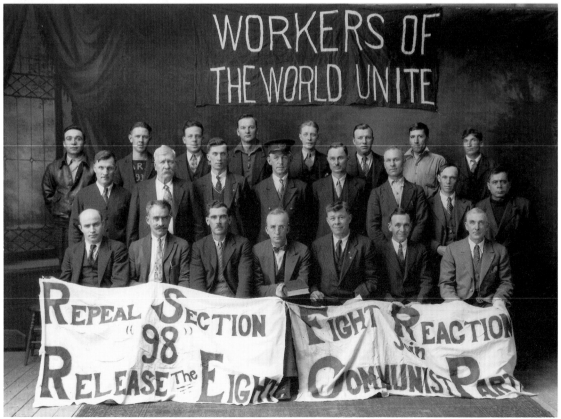

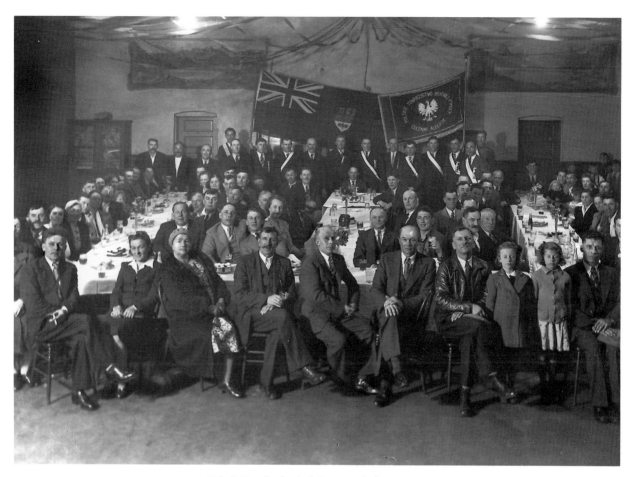

Polish Brotherly Aid Society, Coleman, AB
THOMAS GUSHUL / 1935
GLENBOW ARCHIVES NC-54-1990

OPPOSITE TOP
Ukrainian Labour Temple, Coleman, AB
Most of the miners in the Crows Nest Pass coal mines were from central and eastern Europe, in particular
Slovakia, Italy, Belgium, Russia, and Ukraine. They formed their own social and labour organizations.
THOMAS GUSHUL / 1927
GLENBOW ARCHIVES NC-54-1974

OPPOSITE BOTTOM
First Workers Administration, Blairmore, AB
THOMAS GUSHUL / FEBRUARY 1935
GLENBOW ARCHIVES NC-54-4345

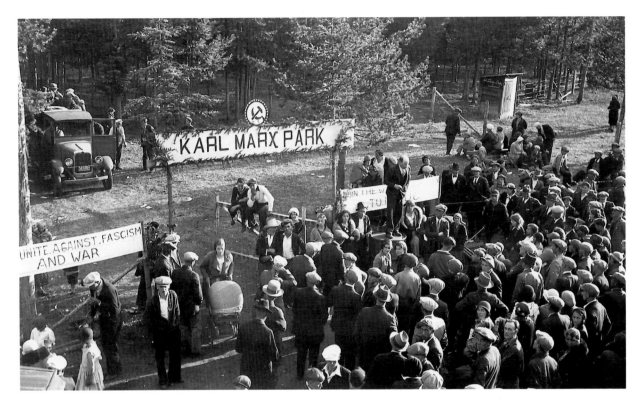

Harvey Murphy addressing workers' picnic, Natal, BC
Note the name of the park.
THOMAS GUSHUL / 1 MAY 1931
GLENBOW ARCHIVES NC-54-2008

OPPOSITE
Injured wives of striking miners, Corbin, BC
A strike by members of the radical Mine Workers Union of Canada was violently dealt with on 17 April 1935.
Stuart Jamieson described the incident in his book, Times of Trouble: Labour Unrest
and Industrial Conflict in Canada, 1900-1966:

The miners and their wives, 250 in all, paraded to the mine, where they were met by a large detachment of police and strike-breakers on a narrow ledge from which there was no escape. When the women formed themselves into a picket line, the police drove a bulldozer into the gathering, breaking the limbs of several women. Further violence ensued, in which it was reported that 16 policemen and 25 strikers were injured. Seventeen strikers, including the president and secretary of the union, were arrested.

THOMAS GUSHUL / 17 APRIL 1935
GLENBOW ARCHIVES NA-3479-2

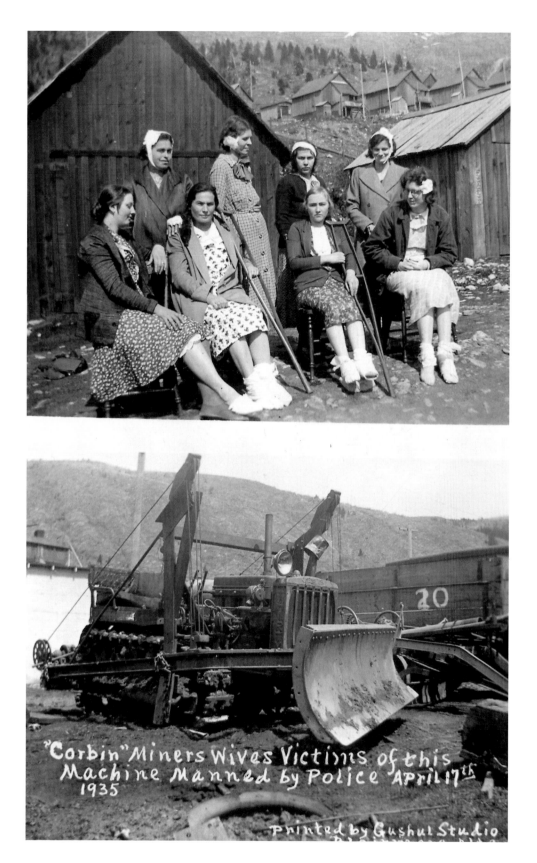

"Corbin" Miners Wives Victims of this
Machine Manned by Police April 17th
1935

Printed by Gushul Studio

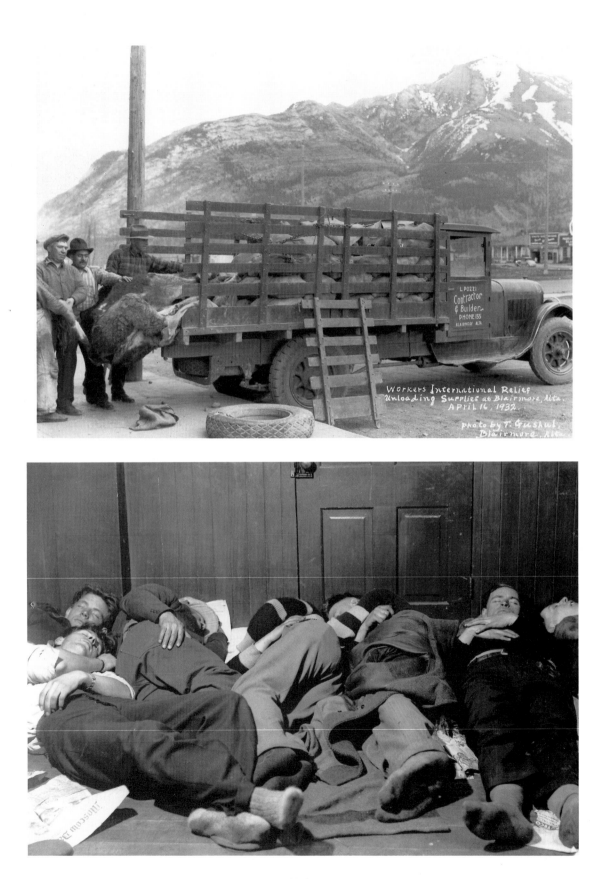

Workers International Relief
Unloading Supplies at Blairmore, Alta.
APRIL 16, 1932.

photo by T. Gushul
Blairmore, Alta.

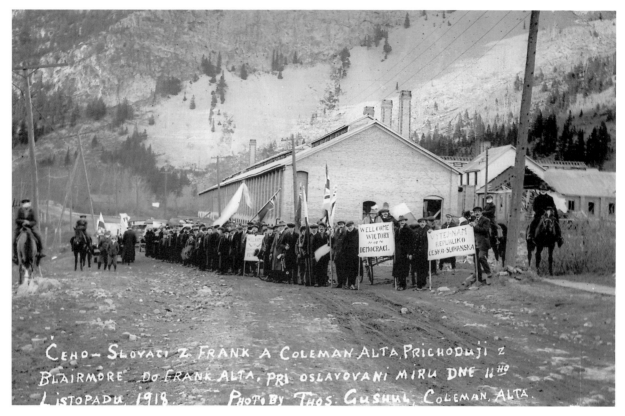

Czechoslovakian miners from Frank, Coleman, and Blairmore celebrate Armistice Day, 1918
As central and eastern Europeans were under suspicion throughout the Great War, these workers–all from a former province of the hostile Austro-Hungarian Empire–decided to demonstrate their loyalty to the Canadian war effort.
THOMAS GUSHUL / 11 NOVEMBER 1918
GLENBOW ARCHIVES NC-54-1587

OPPOSITE TOP
"Workers International Relief, Unloading Supplies at Blairmore, Alta, April 16, 1932"
THOMAS GUSHUL
GLENBOW ARCHIVES NC-54-4340

OPPOSITE BOTTOM
Depression transients, Blairmore, AB
Riding the rails was just as common in the Crowsnest Pass as it was on the Prairies, and the cash-starved municipalities could do just as little to feed and shelter the homeless.
THOMAS GUSHUL / 1930s
GLENBOW ARCHIVES NC-54-4078

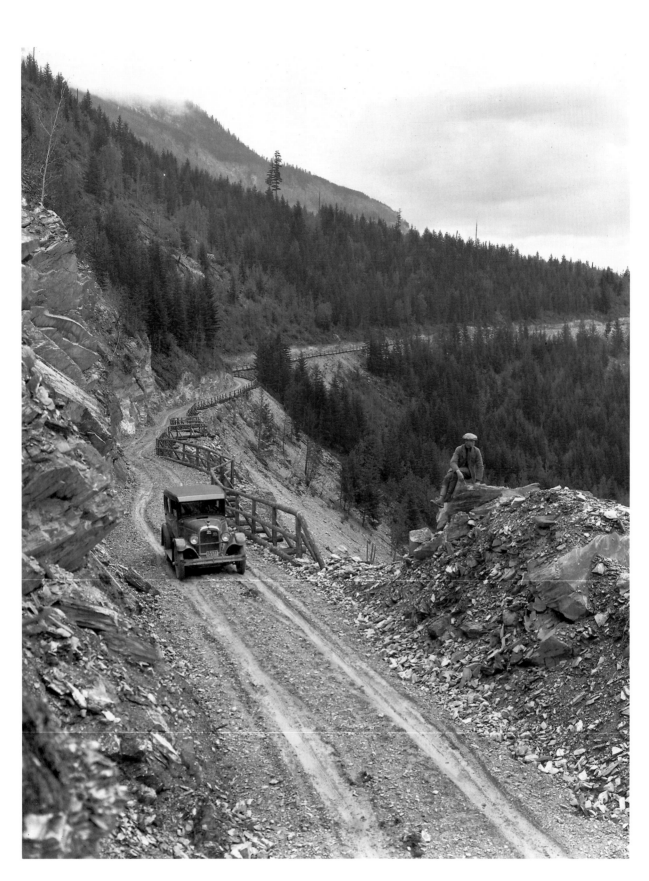

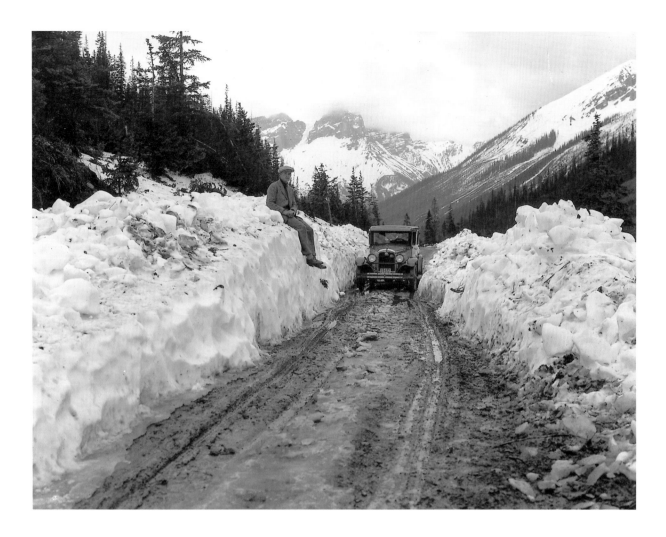

These two shots are from the first trip taken on the Banff-to-Golden Highway on 9 June 1927.
The intrepid soul who completed the trip was photographer Harry Pollard of Calgary.
HARRY POLLARD
PROVINCIAL ARCHIVES OF ALBERTA P.10368 / P.10369

Captain Ernest C. Hoy in aeroplane, Calgary, AB
Captain Hoy piloted the first flight over the Rocky Mountains when he flew from Vancouver to Calgary in 16 hours
42 minutes in August 1919. On his return trip, he crashed his Curtis IN–4 at Golden, BC, but escaped unharmed.
PHOTOGRAPHER UNKNOWN / 1919
GLENBOW ARCHIVES NA-3890-13

OPPOSITE TOP
Mr and Mrs Charles J. Glidden, driving the first automobile to cross the Canadian Rockies, arrive in Vancouver, BC
STEPHEN J. THOMPSON / 18 SEPTEMBER 1904
CITY OF VANCOUVER ARCHIVES TRANS.N.62, P.96

OPPOSITE BOTTOM
First automobile in Crowsnest Pass, AB
Owned by Fred Wolstenholme, the Tudhope-McIntyre had a two-cylinder engine and a modified buggy chassis.
PHOTOGRAPHER UNKNOWN / 1907
GLENBOW ARCHIVES NA-3903-81

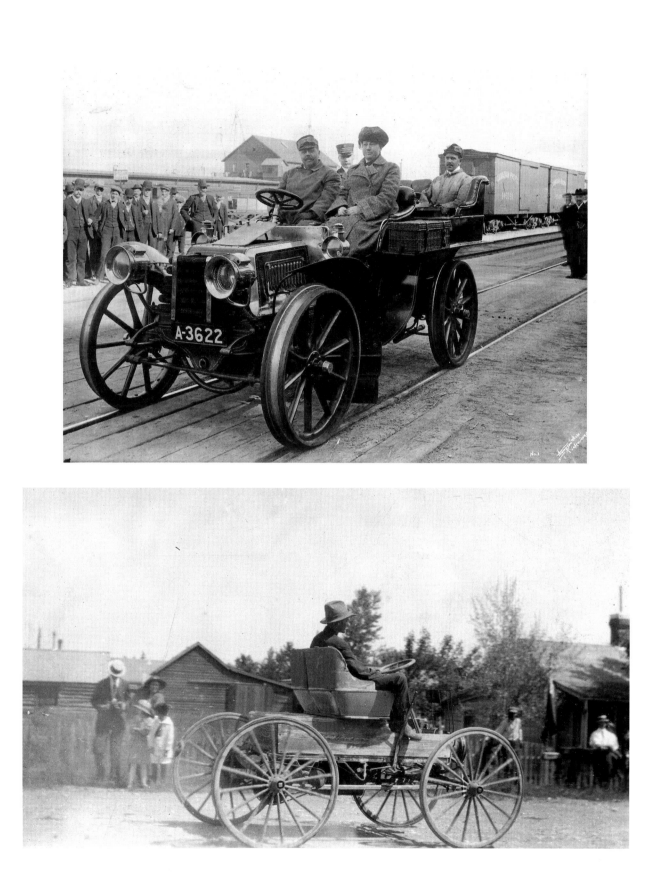

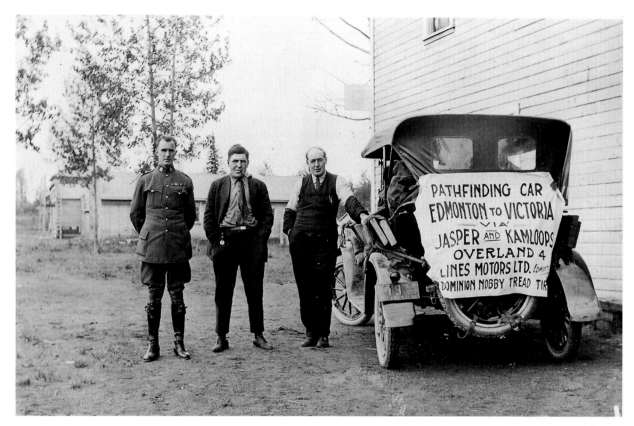

Frank Silverthorne and Charlie Neimeyer of Lines Garage, Edmonton, were the first to drive an automobile from Edmonton to Victoria by way of the Yellowhead Pass in the summer of 1922. The trip was undertaken in order to publicize the route and gain public support for the building of a highway.
Needless to say, the return trip was not by automobile.
PHOTOGRAPHER UNKNOWN
GLENBOW ARCHIVES NA-2336-1

OPPOSITE
Further views of the Silverthorne/Neimeyer journey
GLENBOW ARCHIVES NA-2336-13 / NA-2336-7

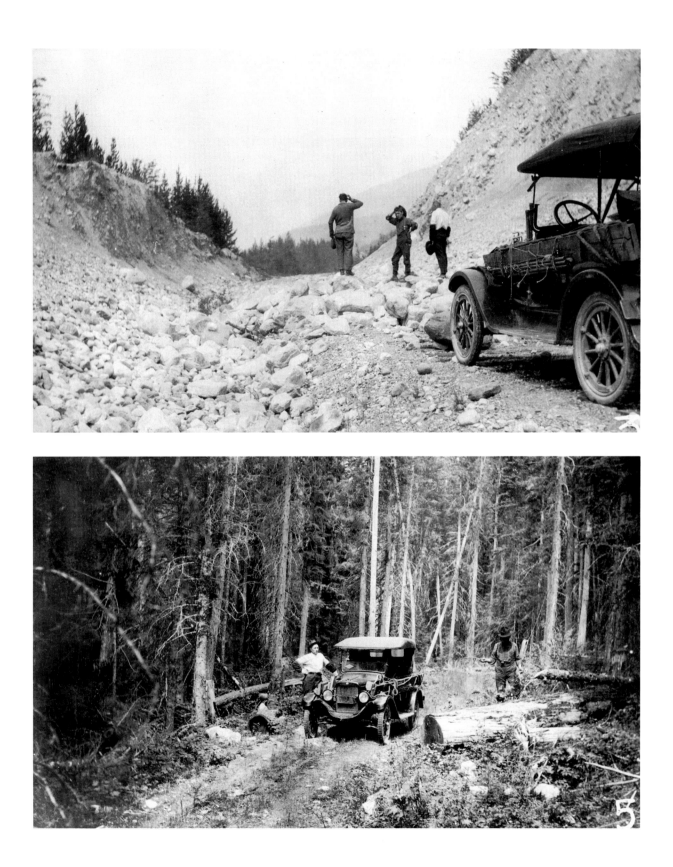

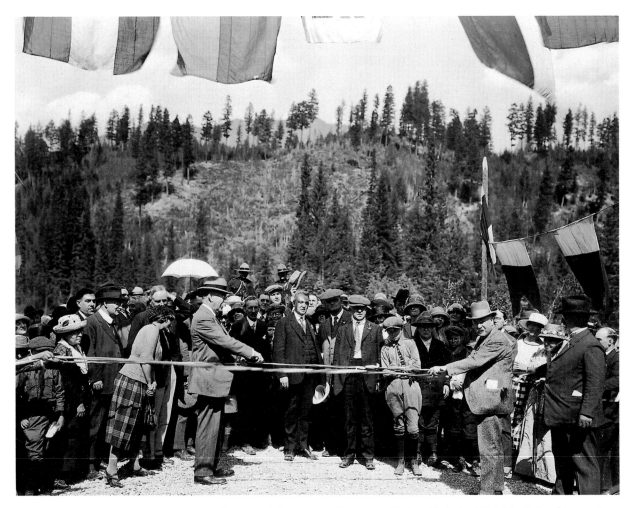

Lieutenant-Governor R. G. Brett of Alberta and Lieutenant-Governor Walter Nichol of British Columbia cutting ribbon to officially open the Banff–Windermere Highway at Kootenay Crossing, Kootenay National Park, BC
PHOTOGRAPHER UNKNOWN / 30 JUNE 1923
B. SILVERSIDES COLLECTION

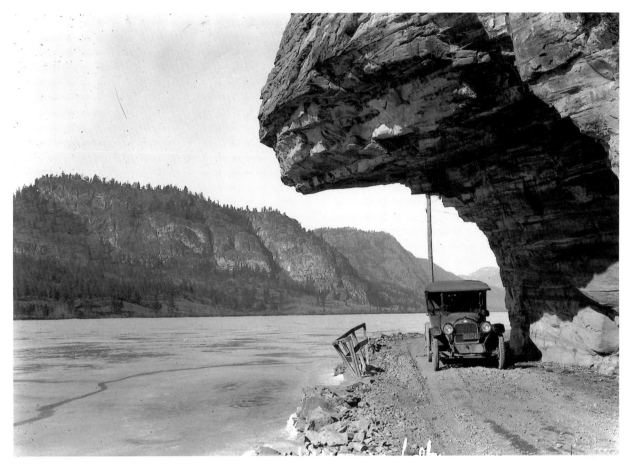

Rock overhang beside Vaseux Lake, Okanagan Valley
Just south of Penticton, the overhang was called Canopy Rock. Owing to the fact that it was continually dropping
small boulders on passing automobiles, it was blasted out of existence in the 1930s.
BYRON HARMON / 1925
WHYTE MUSEUM OF THE CANADIAN ROCKIES V263 NA-71-1568

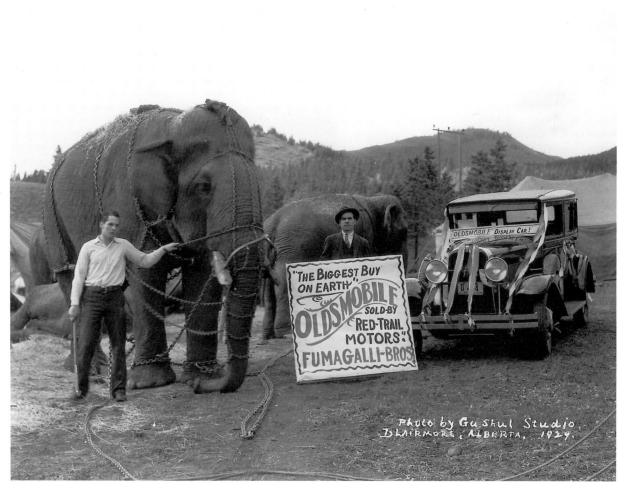

Red Trail Motors Oldsmobile promotion with two elephants, Blairmore, AB
Mountain retailers have never been hesitant to use unorthodox advertising to bring attention to their merchandise.
THOMAS GUSHUL / CA. 1930
GLENBOW ARCHIVES NC-54-2223